HISTORY OF GERMAN ART

History of German Art

Painting Sculpture
Architecture

Gottfried Lindemann

Translated by Tessa Sayle

PRAEGER PUBLISHERS
New York · Washington · London

Published in the United States of America in 1971

Praeger Publishers, Inc.
111 Fourth Avenue, New York, N. Y. 10003, U. S. A.
5 Cromwell Place, London, SW 7, England

Published in German as *Deutsche Kunst*
© 1971 by Georg Westermann Verlag, Brunswick, Germany
Translation © 1971 by Pall Mall Press Limited

Library of Congress Catalog Card Number: 79-89605
All rights reserved

Printed in Germany by Georg Westermann Druckerei, Brunswick

CONTENTS

CAROLINGIAN AND ROMANESQUE ART

The beginnings of German art can be traced back to a time when Germany as a nation did not exist. What is now known as Germany was then part of the Frankish kingdom, which, at the height of its power, extended from central Spain to the Elbe, and from the North Sea to Italy. This vast kingdom, united by Charlemagne, was the result of his unwavering determination to gain supremacy in order to build an Imperium Romanum under the sign of the cross. To achieve these ends Charlemagne did not always use humane and peaceful means; where negotiations failed he imposed his will by the sword.

Charlemagne's ambitious aims could only be attained by using superior force. The northern part of Central Europe, split up into countless tribal territories, was in danger of being crushed between two power blocks: the strong Eastern tribes and the Arabs who had penetrated as far as Spain. Only by united action could this danger be averted, and it was only through force that Charlemagne was able to convince the jealous and independent-minded tribal rulers from the Pyrenees to the Elbe that they must unite in order to protect their common interests.

As a result the Carolingian empire was not a homogenous state like the Roman and Byzantine empires. It was basically an unstable group, unified by force, which disintegrated as soon as its creator, Charlemagne, king of the Franks and subsequently emperor, died in 814. Although much of what he had created collapsed in the confusion arising from the struggle over his succession, there remained a political, economic and cultural framework on which later generations could build. Charlemagne had laid the foundations of a Northern European civilization which for the first time in history represented an alternative to the Mediterranean civilization. He had planted the seeds of a Western culture which, although based on earlier cultures, developed individual characteristics from the start that were to come to full fruition in later centuries.

Charlemagne encouraged these developments during his long reign. As emperor he became his people's political and cultural leader and by forcing the subjected tribes to accept Christianity, he gave them not only a new religion, but also a new cultural framework that encompassed all aspects of the arts, literature and science. He modelled his ideas on the Roman Empire;

7

1 Connecting Passage
2 Corridor
3 Gateway and Judicial Hall
4 Emperor's Hall
5 Solarium
6 Granus Tower
7 Palatine Chapel
8 Westwork
9 Narthex
10 Atrium
11 North Annex (Metatorium)
12 South Annex (Lateran)
13 Altar Chamber
14 Curticula
15 Wooden Aisle
16 Apartments
17 Apartments

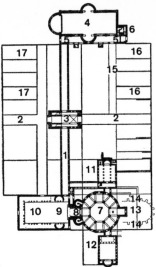

Aachen, Charlemagne's Palatine Palace Ground-plan

that was the concept he wanted to revive by imbuing his empire with a new spirit of Christianity. Charlemagne was the first to introduce the idea of *renascitur*, rebirth, and of *aurea Roma*, Golden Rome, into Western civilization and this concept of renaissance was to reappear in later revolutionary art movements in the subsequent intellectual history of Europe.

Charlemagne, although unlearned himself, was thus a key figure in the history of art. As a patron of the arts he made great demands on his subjects, shaking them out of their lethargy and awakening the talents that lay dormant. His achievements were backed up by the instinctive good taste and the bold ideas of his creative mind. He ordered the first German grammar to be written, thereby giving the language form and validity. But he also sought to restore the Latin language, which had degenerated over the centuries, to its original classical form. He summoned scientists and artists from all parts of the then known world to his court at Aachen (Aix-la-Chapelle), which became a centre of learning; he had convents built and these developed into places of education and culture. It was largely through his personal initiative that Northern Europe for the first time produced its own architecture.

The principal example of Carolingian architecture is the Palatine Chapel at Aachen (see p. 8 and p. 9), which originally formed part of a large palace. Built between 790 and 805, it is one of the first monumental stone structures north of the Alps; the architect, Odo von Metz, successfully translated Charlemagne's idea of a Roman-Byzantine renaissance on German soil into architectural terms.

Right: Aachen, Charlemagne's Palatine Chapel, built by Odo von Metz, about 800, now part of Aachen Cathedral

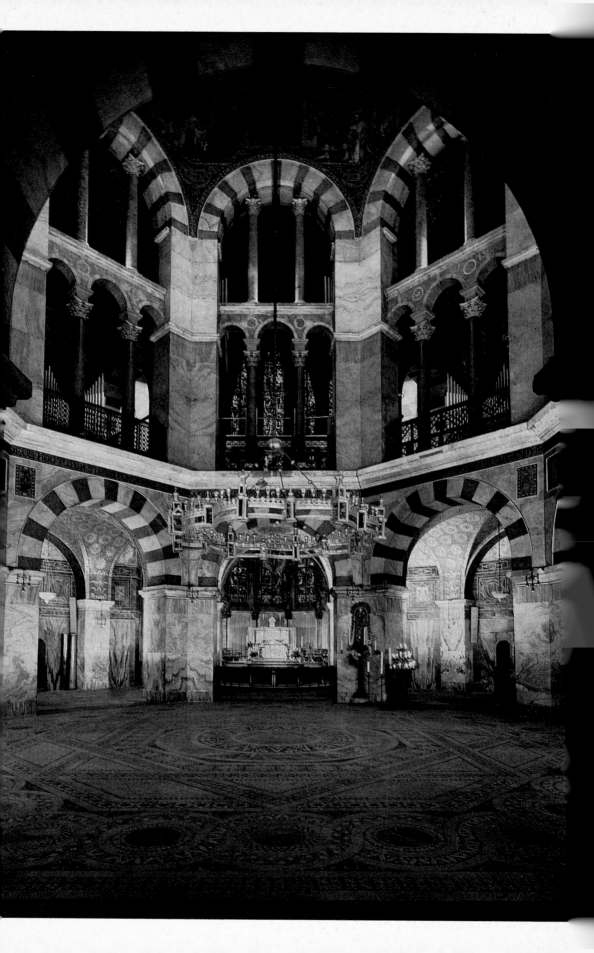

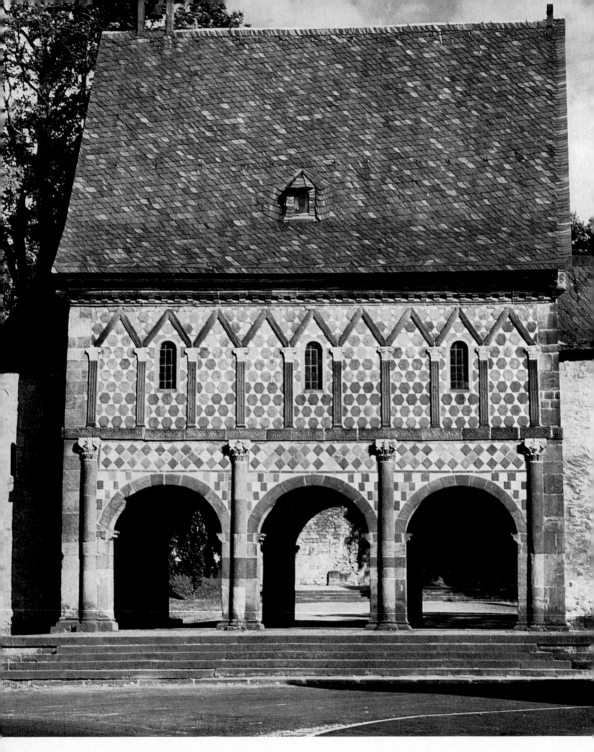

Lorsch Abbey, Gatehouse, about 774

Right: Gernrode Abbey, Romanesque Church, tenth century

Maulbronn, Refectory of Cistercian Monastery, twelfth century

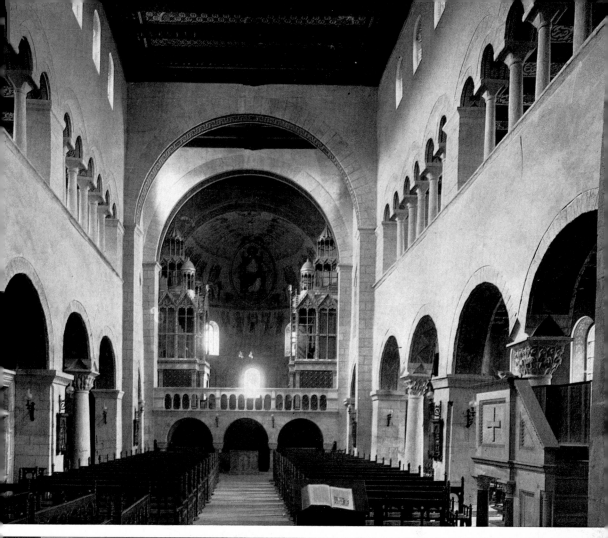

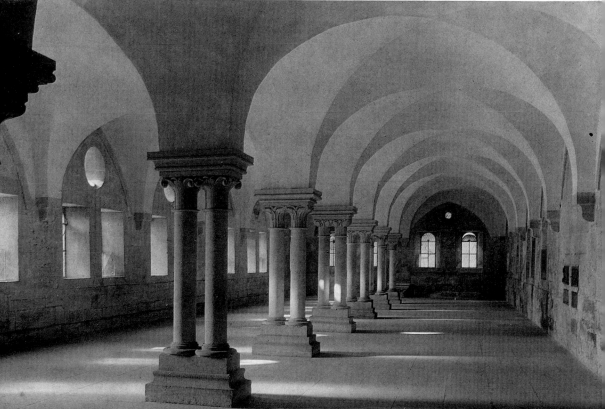

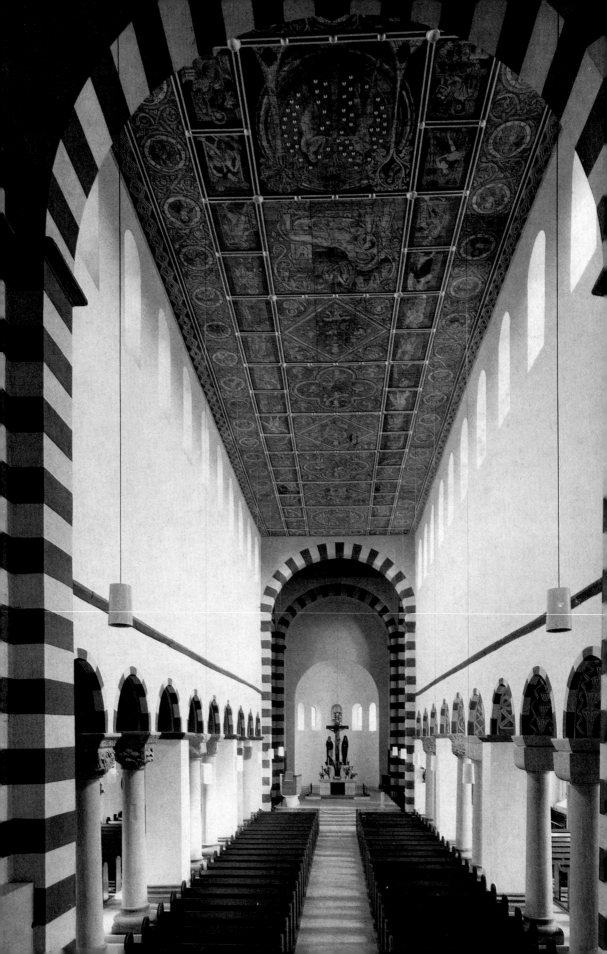

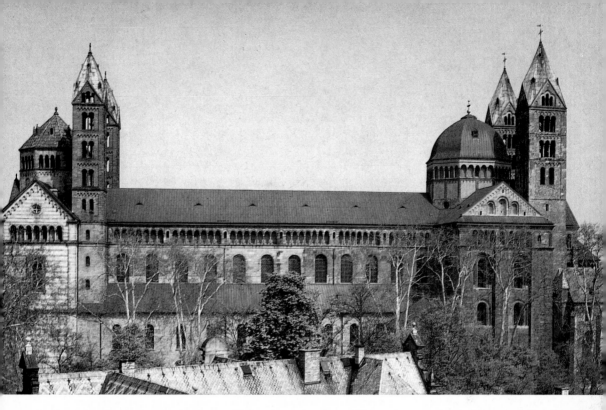

Speyer Cathedral, eleventh and twelfth centuries
Left: Hildesheim, St. Michael, eleventh century. Interior with painted wooden ceiling
Maria Laach, Benedictine Abbey, consecrated 1156

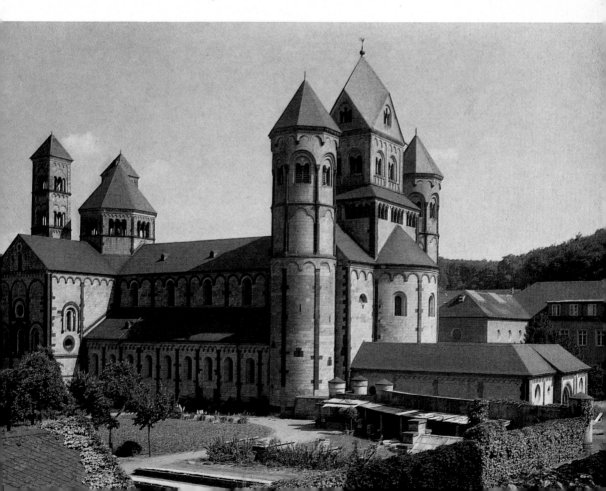

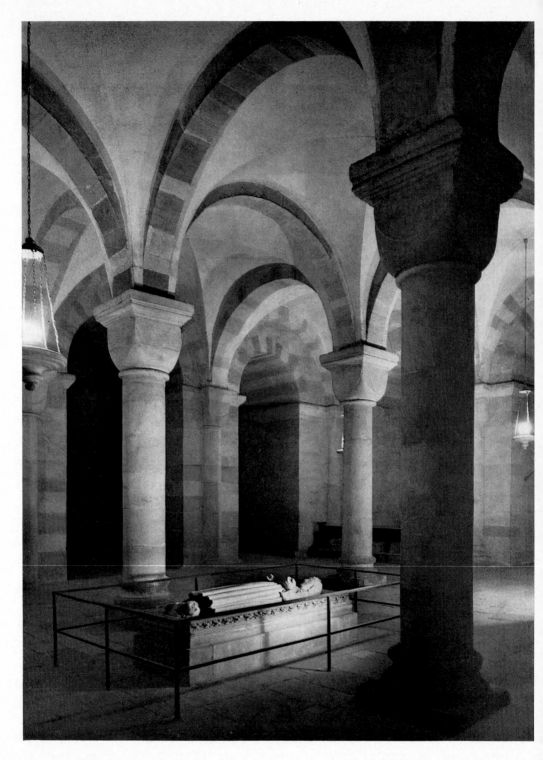

Speyer Cathedral, Crypt. Here most Salian emperors are buried, including Rudolf von Habsburg, who died in 1291

Right: Worms Cathedral, twelfth century

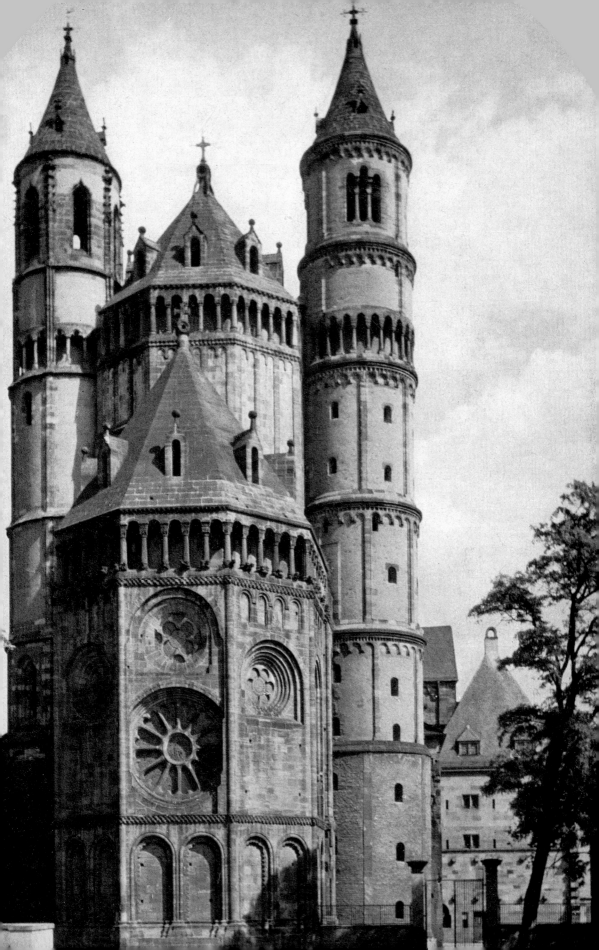

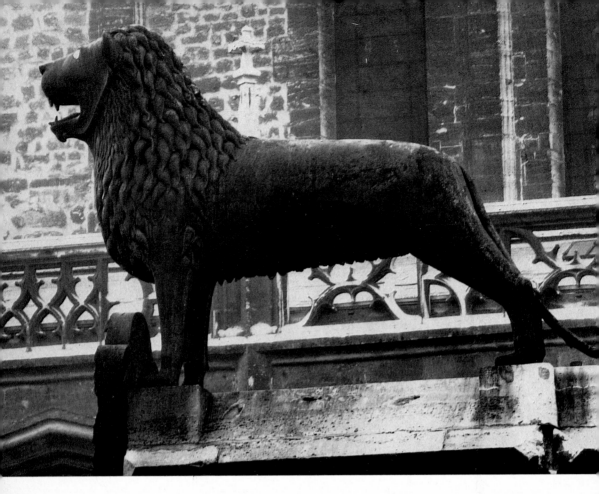

Brunswick, Bronze Lion, 1166

Hildesheim Cathedral, Bronze Doors, completed 1015. Detail: Adam and Eve

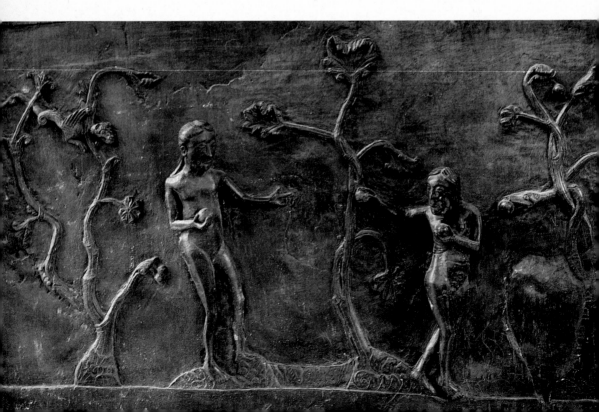

The inspiration came undoubtedly from San Vitale at Ravenna, a centrally planned structure which combines Byzantine stylistic elements with those of the Late Classical period. However, the spatial arrangement is more consistent and powerful at Aachen, where the octagonal central area is clearly divided from the surrounding sixteen-sided ambulatory by two rows of superimposed arches. At Ravenna the transition from the octagon to the ambulatory has semi-circular niches. And whereas at Ravenna these semi-circular niches are screened by two-tiered columnal arches, the vertical plane at Aachen indicates a clear tendency towards simplification: the lower arches remain open and support the gallery above, thus creating a second level. On the upper floor high arches and columnar screens are reminiscent of Ravenna; they divide the gallery from the central space and at the same time provide a view to the lower floor for members of the court in the gallery.

The Palatine Chapel at Aachen has an additional feature of note that is missing in San Vitale and other Byzantine circular buildings: a two-tiered porch flanked by cylindrical turrets, giving the structure a sense of movement towards the altar. The impression created on the outside is that of three closely spaced towers, a motif which reappears later in Northern European architecture. The central and the longitudinal structures, the two basic types of sacred buildings since Early Christian times, are here combined, though hesitatingly, for the first time. Although subsequent attempts at this integration are more successful, here was a basis on which future architecture could build.

The gatehouse at Lorsch (see p. 10) is another of the few Carolingian monuments which have been preserved. It once stood in the outer court-yard of one of the oldest churches on German soil, of which only the ground-plan is known today. The gatehouse, later transformed into a chapel, represents an interesting example of the revival of Classical forms. On the ground floor three big arches are flanked by engaged columns, a design that is taken from the Roman arena. These heavy engaged columns support the upper storey, which seems disproportionately slender compared to the powerful supports; its façade is divided by pilasters and these are surmounted by triangular arcades, thus creating a framework design. This demonstrates the stylistic uncertainty of the period: Classical forms are imitated but no satisfactory integration has as yet been achieved. Elements of monumental architecture—engaged columns and pilasters—are combined with framework motifs and together these are applied, with little comprehension of the principles, to a modest building. As a result the gate-house is more like a Germanic wooden structure than a Classical stone building. It was the absence of architectural traditions that restricted the practical application of the Classical revival as it had been envisaged by Charlemagne.

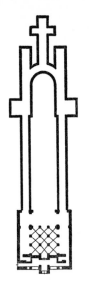

Corvey Monastery,
Carolingian Church,
ninth century. West-
work dates from 873

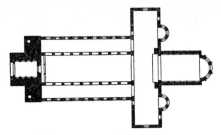

Hersfeld Monastery, Romanesque
Church, ninth and tenth centuries

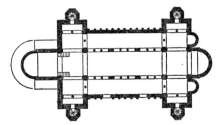

Hildesheim, St. Michael, Romanesque
Church, consecrated 1033

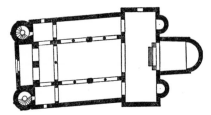

Gernrode Abbey, Romanesque Church,
tenth century

The post-Carolingian period is characterized by the general chaos caused
by the struggle over Charlemagne's succession among his grandsons. The
resulting division of the empire brought with it a period of political, eco-
nomic and cultural decline. The conquered tribes used these internal con-
flicts to liberate themselves from Frankish sovereignty and to avenge
themselves on their former oppressors. The Normans advanced from the
north and devastated large parts of France and Germany, the Saracens
robbed and plundered in Italy, and the Hungarians conquered much of
the eastern part of the old empire. But with the return to political stability
under the firm rule of the Saxon Emperor Otto I in the middle of the
tenth century, Europe recovered and new artistic developments began to
emerge. After a gap of more than a century, a period of great architectural
activity began. But these hundred years had sufficed to loosen the ties
between Northern Europe and the traditional Mediterranean cultural
centres: architects and their patrons no longer felt compelled to follow
the traditional Roman-Byzantine ideals.

Whereas Carolingian art had been the last flowering of Late Classical forms, the emergence of the Romanesque style represented a true new beginning. During the early period the architecture remained rough and crude with little attention to detail, but it was therefore all the more vigorous and capable of further development. The forms and concepts of earlier cultures were no longer accepted without criticism. Architects developed their own structural concepts and sculptors created their own forms; these, along with the early manuscript illuminations, were often extremely primitive, but they nevertheless displayed compelling expressiveness. Romanesque buildings and sculptures manifest the newly awakened self-confidence of the young nations north of the Alps which, as a political power, were about to dominate Western Europe. Just as the bishops and princes of the north rejected the established tutelage of Rome—a process which brought with it many political and ideological conflicts—so did the arts increase their independence. But political ties with Rome were never completely severed and as a result neither were the links connecting the artistic developments in the north and south ever totally dissolved. It was the rivalry between the Classical artistic traditions of Rome and the impetuous new ideas of the Germanic people which gave medieval art its strength, its originality and its inexhaustible wealth of creativity. While traditional forms continued to be preserved in Italy during the Middle Ages, important artistic developments were taking place in Germany and France.

In Germany the development of Romanesque architecture falls into three phases, named after the ruling dynasties of the period:

Ottonian Art	950—1050
Salian Art	1050—1150
Hohenstaufen Art	1150—1250

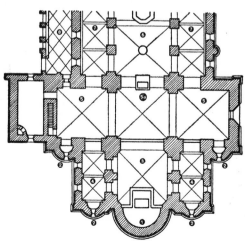

Königslutter Cathedral, begun 1135.
Ground-plan of chancel and transept

1. apse, 2. side apse, 3. chancel, 4. side chancel, 5. transept, 5a. crossing, 6. nave, 7. aisle, 8. cloister

Early Romanesque Ottonian architecture expresses the desire of the time to achieve simplicity in design and monumentality by rearranging the structural elements of the traditional ground-plan. Ottonian sacred buildings, as well as all later medieval ones, were based on the Classical basilica form: longitudinal structures divided by arcades into a central nave and two aisles, whereby the nave rises above the aisles. The basilica, a modification of the Classical temple, was used in Early Christian architecture. The first of these Early Christian basilicas were essentially one-directional; later a transept was added to the east, making the basilica T-shaped, and the semi-circular central apse, indicating the position of the altar, projected from the transept. During the Early Romanesque period a further structural element was added, the chancel, an extension of the nave between the transept and apse. This clear intersection of nave and transept transformed what had been a flowing spatial concept into a tighter, more complex structure, and the point of intersection, the crossing, acquired special significance by providing a clearly defined unit on which to base the ground-plan (see ground-plan of Königslutter, p. 19).

A significant step towards a fully ordered ground-plan was the adoption of equal widths for nave and transept which made the crossing into a square. By extending the use of this square unit to the dimensions of chancel and transept, a geometrical pattern of squares emerged at the eastern end of the basilica. In order to stress the sequence of square units along the nave, those columns standing on the corners of the squares were replaced by pillars, thus creating a system of alternating supports, which is a characteristic feature of Early Romanesque churches. At Gernrode the rhythm is pillar—column—pillar, at Hildesheim pillar—column—column —pillar (see ground-plans, p. 18).

Another important innovation of Ottonian architecture was the introduction into the Classical aisled basilica of the so-called westwork, the idea for which can be traced back to the two-tiered porch and cylindrical turrets of the Palatine Chapel at Aachen. This wide extension on the west side of the basilica established an entirely new balance between the east and west sides. The design of the westwork can differ considerably; at Gernrode it remains a massive porch flanked by cylindrical turrets; at Hildesheim (see p. 18) a west transept with apse was added and two identical groups of towers rise to the east and west, consisting of one central tower and two octagonal turrets, one at each end of the transept.

Above: Romanesque Block Capital (Alpirsbach Abbey Church, early twelfth century)

Below: Romanesque Figured Capital (Hildesheim, St. Michael, early eleventh century)

Two reasons can be given for this enlargement of the westwork: the position of the church at the time was that of a defence stronghold and the number of towers and turrets impressively demonstrated her power and strength; at the same time the gallery of the extended westwork provided a permanent seat for the emperor or local ruler and thereby effectively showed the equality of the political and spiritual powers (see p. 18, Corvey). The double apsidal form of Romanesque churches symbolizes the productive co-operation as well as the bitter rivalry that existed between the two authorities during the Middle Ages.

An example of early Ottonian architecture is the Abbey at Gernrode (see p. 11 and p. 18) founded in 961 by the Markgraf Gero, who died in 965 before the Abbey was completed. An unusually short basilican nave and aisles stand at a slight angle to the massive transept and chancel, and are terminated by a westwork flanked by circular stair-towers. The exterior of ashlar masonry conveys an impression of stark severity; a few deeply cut windows provide an elementary articulation and the portal is set straight into the thickness of the wall. The striking austerity of the interior serves to accentuate the fine rhythm of the alternating supports. The functional simplicity of all aspects of the structure lends it a dignity and strength which cannot be found in Byzantine or Early Christian basilicas.

The Benedictine Abbey of St. Michael at Hildesheim (about 1020; see p. 12 and p. 18) is considerably less austere. It was designed by Bishop Bernward, who had spent more than ten years at the court of the Empress Theophano and from there had travelled to Rome, Paris and Cologne. His intimate knowledge of every important architectural development from Byzantium to the Rhine found expression at Hildesheim. The ground-plan immediately reveals a wealth of new ideas. The nave is composed of three crossing squares and is flanked to the east and west by symmetrical transepts which are terminated by galleries. Powerful arches single out the crossing and thereby transform the intersection of nave and transept into a focal point from which chancel, nave and transept radiate. The long stretch of wall between clerestory and nave arcade is left undivided to accentuate a feeling of verticality and to counter the horizontally orientated alteration of supports.

The Benedictine Abbey of Maria Laach (1093—1156; see p. 13) provides an interesting example of architectural developments during Salien times. The ground-plan is similar to that of St. Michael at Hildesheim, inasmuch as an apse at either end gives equal weight to east and west terminations, but various innovations appear at Maria Laach: a richer design and a stronger articulation of wall surfaces eliminate the former severity. The windows of the main elevation are separated by pilaster strips, and arcaded string courses provide a smooth transition from roof to wall. A variety of towers with differently shaped roofs further animates the structure: to

Brunswick, Henry the Lion's Palatine
Palace, about 1175. Reconstruction

1. cathedral, 2. palace, 3. St. George's chapel,
4. belfry, 5. women's apartments, 6. cloister, 7.
large gate, 8. bailiff's office and courtroom, 9.
stables, 10. outhouses and administrative buildings,
11. granary and storagehouse, 12. bronze lion

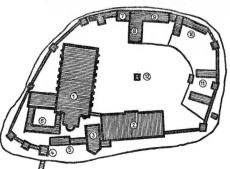

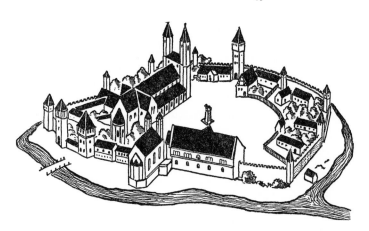

the east two square towers with pyramid-shaped roofs stand between transept and apse-ended aisles and flank an octagonal central tower with tent-shaped roof; to the west a square tower with rhomb-shaped roof is flanked by two round turrets with octagonal tent-shaped roofs. The towers are decorated by double and triple windows, grouped together between small columns, or by single windows placed in funnel-shaped openings.

This animation and articulation of wall surfaces were taken a step further on the exterior of Speyer Cathedral (see p. 13), where flat pilaster strips are linked by arcades and dwarf galleries are set into the thickness of the wall, under the eaves of the conically roofed apse, below the line of the chancel gable and under the eaves of the transept.

The construction of Speyer Cathedral began under the Salien emperor, Conrad II, in 1030, but it took nearly one hundred years to complete and during this time several changes were introduced which greatly influenced the further architectural development of medieval sacred buildings. The most important of these was the construction, around 1090, of the first vaulted nave in medieval Europe. Until then the monumental interiors of Romanesque cathedrals had been covered by flat timber ceilings. Although these were satisfactory in appearance and design they had one distinct disadvantage: they burnt easily.

22

After several Romanesque churches had burnt down, some more than once, the desirability of stone ceilings became generally apparent. But stone ceilings had to be vaulted and the art of vaulting, mastered in Roman times, had been forgotten along with other skills. Medieval craftsmen had to start anew in this field, experimenting and learning from their experience. At Speyer some knowledge had been gained during the construction of a vast groin-vaulted crypt (see p. 14). The groin vault is formed by the intersection of two tunnel vaults at right angles and its stresses are concentrated on the four points of intersection, the groin lines. This sort of vaulting was executed in the monastery refectory of Maulbronn, too (see p. 11), but in a very low-ceilinged room. The difficulty of applying this vaulting technique to the height and span of the nave of Speyer lay in dealing with the problem of side thrusts; it became necessary to reinforce those points of the wall on which the groin lines would rest. Therefore every alternate pier was strengthened with shafts and dosserets to supply adequate support for the weight of the vault and conduct its thrusts and stresses down to the foundations. This bold experiment in vaulting at Speyer later proved to be a failure. In relation to its vast span the vaulting surface was too thin and the vault collapsed in 1159. The Salien dynasty lost power at about the same time—a fateful parallel.

The cathedral at Worms, built in the early thirteenth century (see p. 15), represents one of the great architectural achievements of the Hohenstaufen period. Whilst incorporating all the characteristic features of the Romanesque style it also shows the first signs of Gothic influence. Compared with earlier Romanesque cathedrals the structure is considerably taller, there is modern Gothic rib vaulting, and the west chancel has a typically Gothic circular window. The articulation of the walls is even richer than

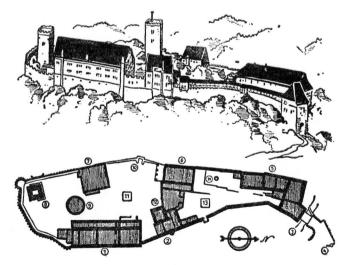

Wartburg near Eisenach, the Landgraf of Thuringia's castle, one of the largest and best preserved medieval castles in Germany

1. palace, 2. women's apartments, 3. drawbridge, 4. guard house outside the gates, 5. vassals' quarters, 6. servants' quarters, 7. stables, 8. tower, 9. cistern, 10. garden, 11. inner castle precinct, 12. belfry, 13. outer castle precinct, 14. cistern in outer precinct

at Speyer. Dwarf galleries, arcaded pilaster strips and arched string courses decorate towers and walls and create a lively interplay of projecting and receding masonry.

The familiar balance between east and west, almost anachronistic in this towering cathedral, is established by the disposition of four turrets and by the harmony of contrasting horizontal and vertical elements. But the westwork at Worms represents the first step towards a dynamic new structural concept: two turrets closely flank an octagonal central tower and seem to lift it upwards. The solid, earthbound, archaic monumentality of Romanesque architecture had reached its limits. In order to continue the dramatic new upward movement, it was necessary to break with tradition, a step that had already been taken in France with the development of Gothic.

Early medieval sculpture complements the architecture and the two are fused into an indissoluble unit. The ornamental carvings of capitals (see p. 20 and p. 54), the mouldings of arches, and the sculptured figures on Romanesque porches form an integral part of the structure. The severity and functional simplicity of Ottonian architecture did not lend itself to elaborate ornamentation and only Ottonian church doors display the full sculptural wealth and ingenuity of this age.

The first and most famous pair of these elaborately decorated bronze doors was completed in 1020 at Hildesheim. They represent a truly remarkable accomplishment of Ottonian sculpture as well as an astonishing technical advance in the art of bronze casting. Bishop Bernward modelled his design on the doors of S. Sabina, an Early Christian basilica in Rome, but while earlier bronze portals had been constructed of flat panels affixed to wood, the doors at Hildesheim were cast in one piece, a considerable achievement at a time when no previous technical knowledge of large scale bronze casting was available.

The portrayal of scenes from the Old and the New Testaments on sixteen broad panels displays a wealth of narrative detail. No attempt is made to create a background perspective, but the figures convey a dramatic expressiveness. The panel depicting Adam and Eve (see p. 16) shows stylized trees of paradise on neutral ground from which the figures are made to stand out by a difference in relief. Highly expressive gestures tell the story in the medieval convention of simultaneity for the portrayal of consecutive events. The serpent offers Eve the apple from the tree of knowledge, Eve holds the apple in her left hand and with her right hand she passes it to Adam, who hesitates to accept it; his hesitation is expressed by the way he

Right: Christ Enthroned. Godescalc Gospels
Aachen, Charlemagne's Palace School, between 781 and 783

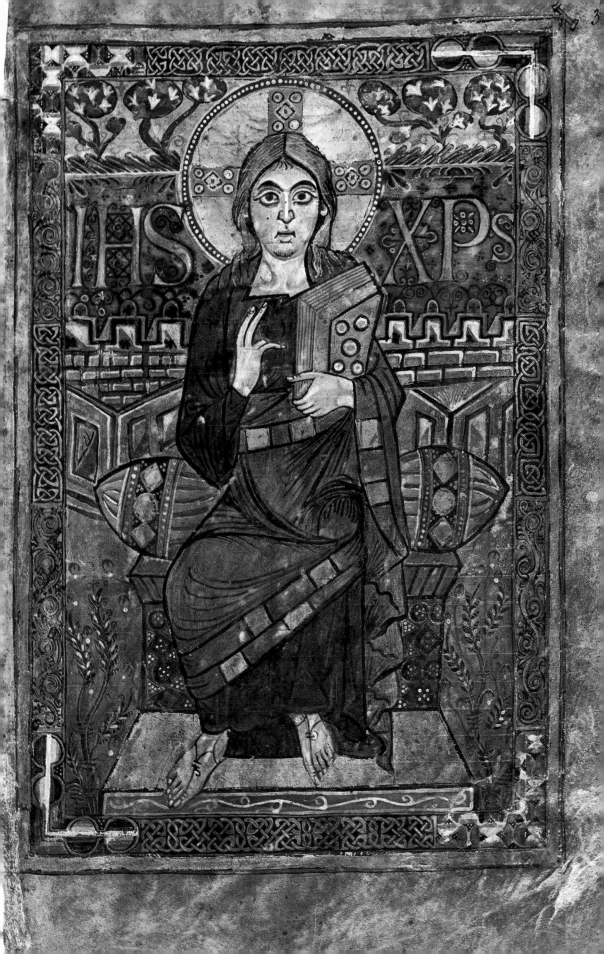

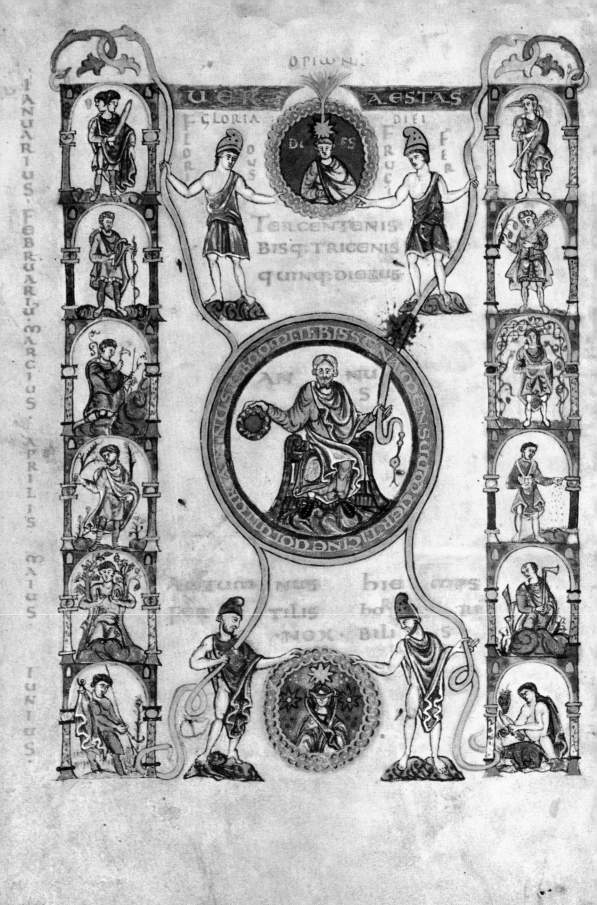

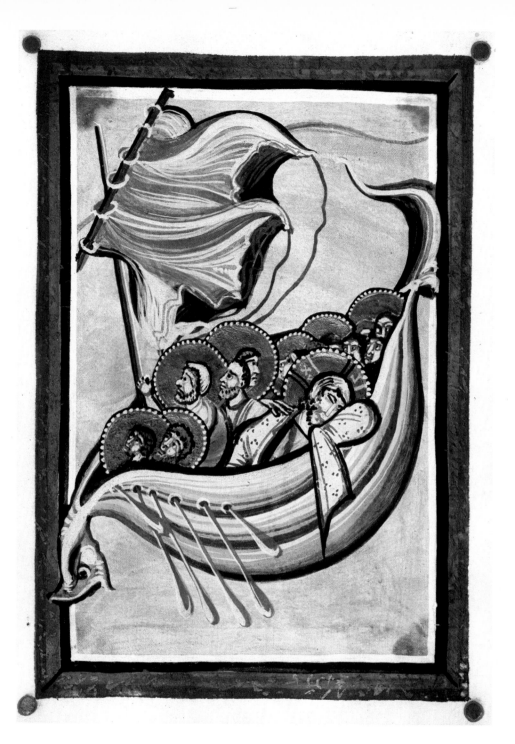

The Storm on the Sea. Codex of Abbess Hitda of Meschede. Cologne, about 1000

Left: Calendar Page. Fragment of a Sacramentary. Fulda, third quarter of tenth century

Page 28: Parable of the Rich Man and Lazarus. The Golden Gospels of Echternach, about 1030

Page 29: Christ's Entrance into Jerusalem. Pericopes of St. Erentrud. Salzburg, about 1140

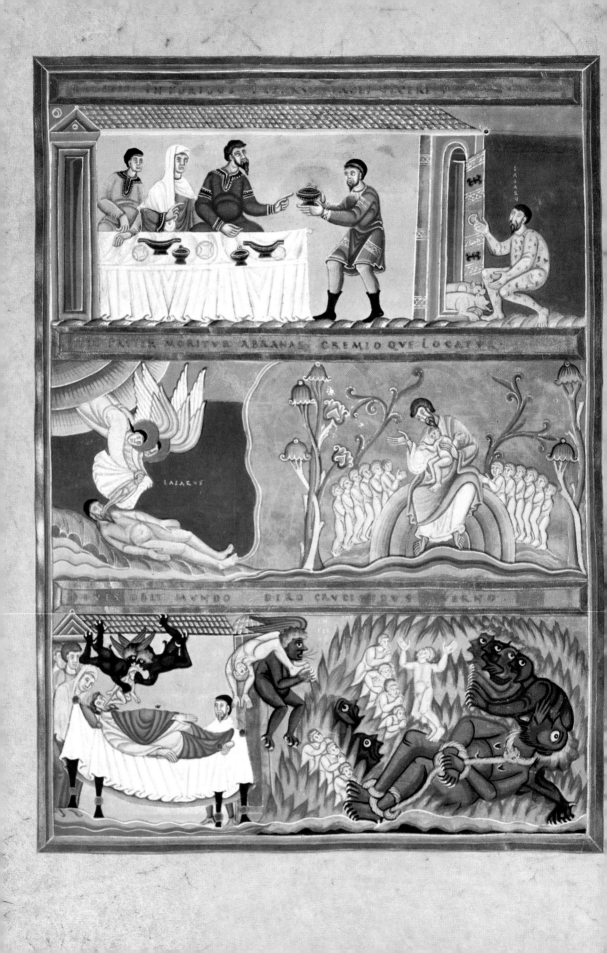

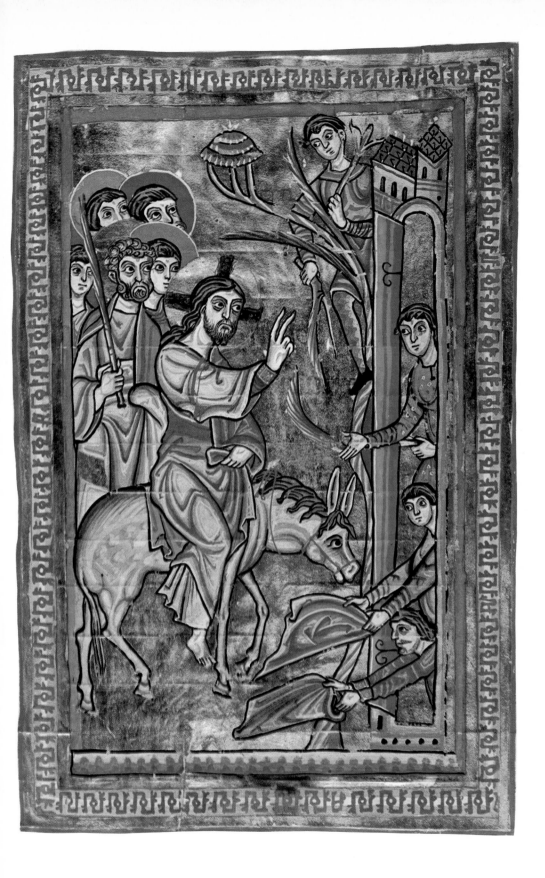

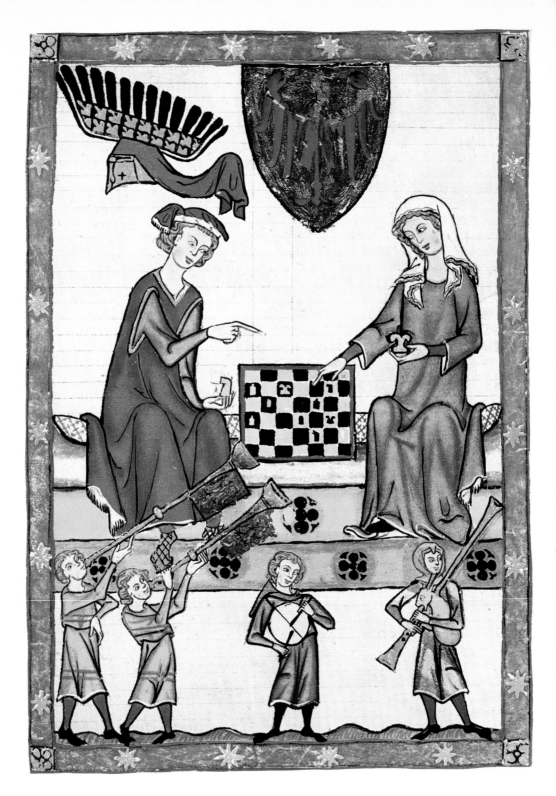

Markgraf Otto von Brandenburg. Minnesänger Manuscript of the Manesse Family. Zürich, early fourteenth century

Right: Annunciation of Gospels. Magdeburg, third quarter of thirteenth century

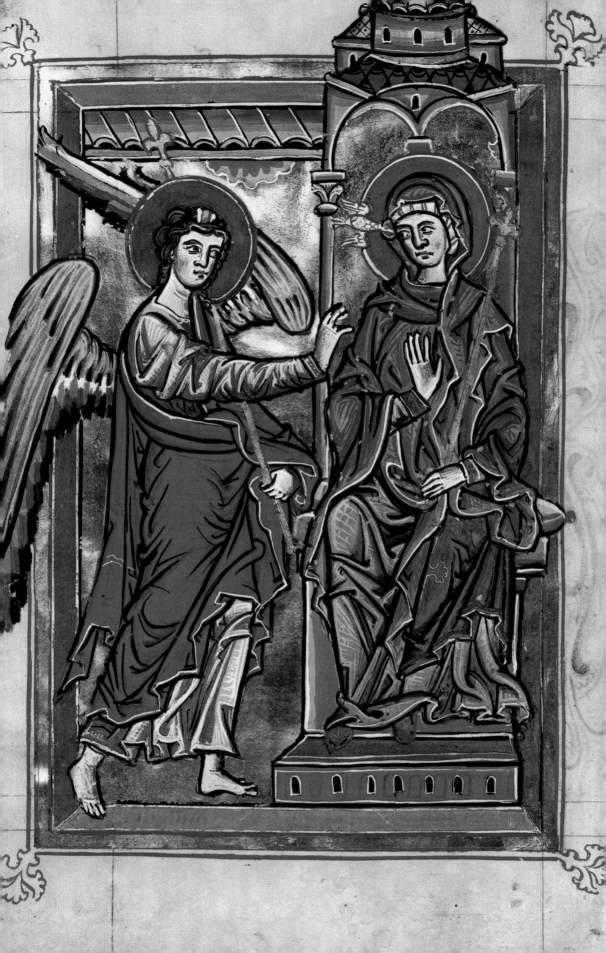

heuser vnd die geswelle irer erberkeit behalden · Ein abgelostes
sthik entstunde ünner die besorgnüsse des meres wan es alweg
an seiu port stude vnd gieng mit in kreude ende · Sunder du
helena du hast begeret zu lassen dem königliche maiestet vnd

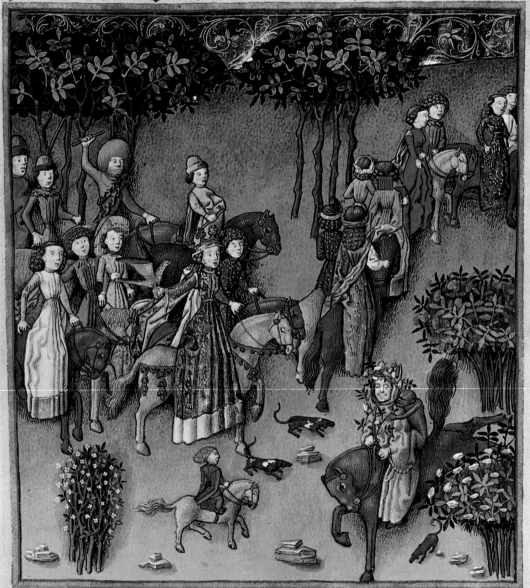

zu lehen Cithaxeā das du vntt dem gewurcke dem gelub zu gel
den möchtest lehen einem kreunde man · vnd vntt dem zurlich
en gewurckte zu den vnbillichē dich naigetzt · Wan sr gelichte
des was ein gift durch welch das gantz kriechelandt vergibet

leans back and thereby increases the distance between himself and Eve, while the apple in his right hand shows that he has partaken of the forbidden fruit. The figures, their bodies and facial expressions, bear no resemblance to Classical models. The artist's aim is no longer to create a pleasing picture of balanced beauty but to convey an emotion. For the first time in Western art the emphasis has moved from form to content.

This emphasis on content, first evident in Hildesheim, characterizes subsequent Romanesque sculpture. The lion monument in front of the castle and cathedral at Brunswick (see p. 16) was meant to be a symbol of the power of the duke Henry the Lion, who was the opponent of the emperor Frederick Barbarossa. At Bamberg Cathedral the figures on the choir screen (about 1230) are un-Classical and dramatically expressive in gesture and attitude, and the slender sculptures on the famous Fürstenportal (princes' portal), as well as the naïve, nearly grotesque figures on the tympanum portraying the Last Judgement, are characteristic of German sculpture of that period.

The art of painting began to be practised in Germany during Carolingian times, when Irish monks, summoned to Charlemagne's palace at Aachen, brought with them the art of manuscript illumination. They set up scriptoria at the palace and at convents across the empire, and the Irish tradition of ornamenting initials with abstract patterns was enriched by the introduction of figural representations, taken from Classical models, which the Carolingian renaissance had made available.

Charlemagne established the Palace School at Aachen and invited the great theologian, Alcuin of York, to preside over this cultural effort. Under Alcuin's direction the Palace School soon became famous and excelled earlier Irish and English schools by the craftsmanship of its scribes and illustrators. In 796, after eight fruitful years at Aachen, Alcuin continued his work as the abbot of Tours. He revised Latin texts that had been corrupted through successive copying, and reformed the Latin script which had degenerated in the illiterate centuries preceding. Under his direction many accurate copies of Classical and theological texts were transcribed at the scriptorium of Tours and thereby preserved for posterity. A major work of the period still bears his name: the Alcuin Bible.

Among the earliest illuminated manuscripts of Carolingian times are the Godescalc Gospels, said to have been commissioned by the emperor for his sister and completed between 781 and 783. In the miniature of Christ Enthroned (see p. 25), which in the Godescalc Gospels appears in addition

Left: Queen Helena and her Court on their way to the Temple of Venus. Martinus Opifex's History of the Trojan Wars. Vienna, about 1450

to the usual miniatures of the four evangelists, Irish ornaments are intermingled with the naturalistic representation of Classical imagery. The fantastic interlacing of coloured bands and flat, stylized foliage in the border contrasts strangely with the graphic, nearly perspective representation of the throne and the battlemented architecture of the background. The figure of Christ is based on Late Classical and Early Christian models and shows the artist's endeavour to give the body a more plastic character: the feet extend to the forefront of the picture and the left foot even projects beyond the throne; the face too is delicately modelled and the use of different colours creates an impression of light and shadow. These early Carolingian miniatures incorporate a great many unassimilated foreign ideas and therefore lack creative originality, but the attempt to assimilate those ideas represents the first decisive step towards an independence which German painting was to reach in the years to come.

During the ninth century the development of manuscript illumination centered around the Ada School and there, more than at the international metropolis of Aachen, indigenous characteristics began to assert themselves. The illustrations in the Codex of Trier, for instance, are less elegant, less complex and less ornate than contemporary illuminations from the Palace School, but for that very reason they provided a more suitable basis for further developments. In this respect the Sacramentary from Fulda, copied and illustrated in the tenth century, forms an interesting link between Carolingian and Ottonian illuminations. One of its calendar pages (see p. 26) shows allegorical figures representing the Twelve Months, the Four Seasons, and the Year. Far from suggesting a crowded feeling, their arrangement in ornamental patterns on an empty background creates a sparse and well-balanced composition. The plastic character of the figures, their elegant movements and the allegorical theme of the picture suggest a knowledge of Late Classical paintings, while the ornamental interlacing of various elements to an attractive unit indicates a more recent, Carolingian influence. It is the lack of background perspective, however, which hints at impending changes in the art of manuscript illumination.

At the turn of the millenium this innovation which appeared in the Calendar Page of the Fulda Sacramentary, a setting of symbolic figures against a plain neutral ground, developed into the first truly independent pictorial style in the history of European painting. Late Classical naturalism and descriptive realism were abandoned and the expression of abstract ideas in a timeless fashion became the sole purpose of the illustration. Simplified figures with lively gestures are set against a neutral background and the composition is often severely symmetrical. The vigorous expressiveness of this new style is effectively demonstrated by an illumination from the Codex of the Abbess Hitda of the Storm on the Sea (see p. 27). The boat, reduced to a mere nutshell, is placed diagonally against a

plain background, but the wildly flapping sail and the fearfully protruding eyes of the apostles in the boat vividly express the idea the artist wanted to convey: that of threatened humanity and hope of divine help.

Expressiveness in movement and colouration characterizes the Parable of the Rich Man and Lazarus from the Golden Gospels of Echternach (see p. 28). A sparing but extremely effective use of symbolism conveys the narrative on three panels in a rich and lively fashion: the home of the rich man and outside his gate poor Lazarus with dogs licking his sores, the death of Lazarus and removal of his soul to the bosom of Abraham, and finally the death of the rich man and removal of his soul to hell.

These archaic and primitive Ottonian miniatures continued to be perfected during the twelfth century and, at the time of the Hohenstaufen, had become a highly accomplished artform. Compared to earlier manuscripts, the illuminations from the Pericopes of St. Erentrud (see p. 29) show a notably stronger differentiation of colour and more elegant lines, without any resulting loss in expressiveness of attitude and gesture. The big penetrating eyes are still in the tradition of earlier miniature painting, but the artistic vertical arrangement of the delicately drawn figures into an upright format suggests an evolution parallel to that of contemporary architecture.

The book painters' principal occupation for nearly five hundred years had been the illumination of religious manuscripts—gospel books, pericopes, sacramentaries and psalters (see p. 31)—but when the monasteries lost their cultural monopoly towards the end of the Middle Ages and laymen started to take up artistic pursuits, historical tomes and books of secular poetry began to be copied and illustrated. The most famous secular manuscript of late medieval times is the Minnesänger Manuscript of the Manesse Family (see p. 30), now the property of the University Library at Heidelberg. It contains 137 full-page illustrations of songs by 140 poets. Pictures of knights and troubadours, of splendid tournaments and noble ladies conjure up the world of delicate court social life and confirm the most romantic ideas of the Middle Ages. The Markgraf of Brandenburg was a well-known figure of this epoch.

A growing interest during the late Middle Ages in the literature of Ancient Greece and Rome, stimulated no doubt by the Italian Renaissance, also found expression in manuscript illumination. Towards the middle of the fifteenth century a comprehensive German translation of Latin texts appeared in Vienna with 334 illustrations by a painter known as Martinus Opifex. A scene from the *History of the Trojan Wars* (see p. 32) shows the artist's considerable skill.

The invention of the printing press brought the demise of the art of manuscript illumination. A way had to be found to add illustrations to the type matter so that picture and text could be printed in one process. Handpainted miniatures disappeared and were replaced by the woodcut.

GOTHIC ART

The second great artform of the Middle Ages was derisively called 'stile Gotico' by the Italians, a style introduced by the Goths, the barbarians from the dark north, and foreign to the balance and harmony of established architectural forms. The upward flow of these new structures—so alien to the romanesque basilicas—seemed not only to contradict the current ideas of taste but to challenge the divine order of things. And indeed, the arrival of the Gothic movement marked a complete break with tradition. Although Romanesque architecture had spread all over Western Europe by 1200, its characteristic features were not taken over by the Gothic style, which introduced entirely different spatial concepts.

The new heavenward urge contrasted sharply with the massive, earth-bound motifs of Romanesque structures. The round arch, an expression of closed, self-contained movement, was replaced by the pointed arch, a symbol of the surge upward, the striving towards an unattainable goal. In Romanesque times the walls of the church stood as a solid bulwark against the forces of evil; the Gothic concept opened them up by enormous windows and reduced their significance by an intricate pattern of slender shafts, delicate traceries, buttresses and flying buttresses. The westwork was abandoned in favour of a richly decorated façade with one or two towers. Romanesque sacred structures expressed the equality of worldly and spiritual power, whereas Gothic churches symbolized a longing for the hereafter. The massive simplicity of Romanesque architecture represented a sum of its units; Gothic cathedrals tended towards spacial concentration, their inert masses of masonry were enlivened by a wealth of individual designs, and slender arches, ribs and vaults rose to impressive new heights. The proportions of width and height in Romanesque churches were 1 : 1.8 or 1 : 2, while those of French Gothic cathedrals were 1 : 3, or even 1 : 3.3.

By the end of the twelfth century Gothic architecture was flourishing in France, but in Germany Romanesque concepts had taken such deep root that the new upward flow of the French Gothic was not immediately

Right: Strasbourg Cathedral. West front with rose window, begun 1276 by Erwin von Steinbach. Originally planned with two towers

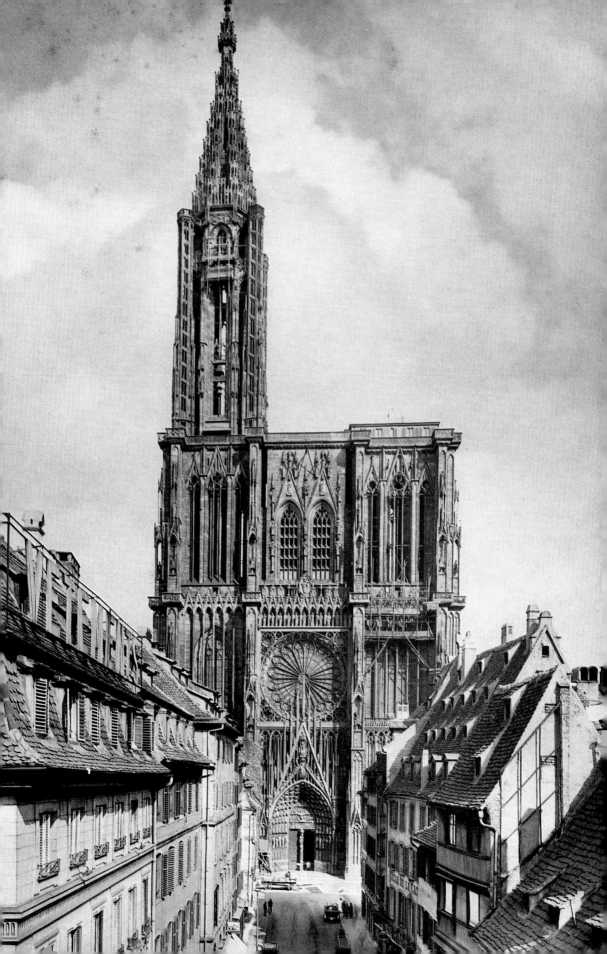

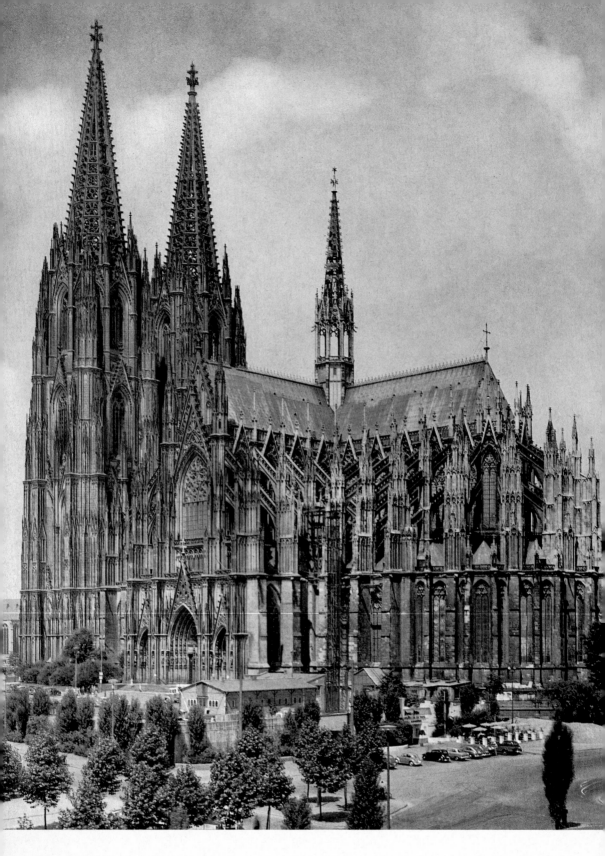

Cologne Cathedral. Chancel, 1248—1322

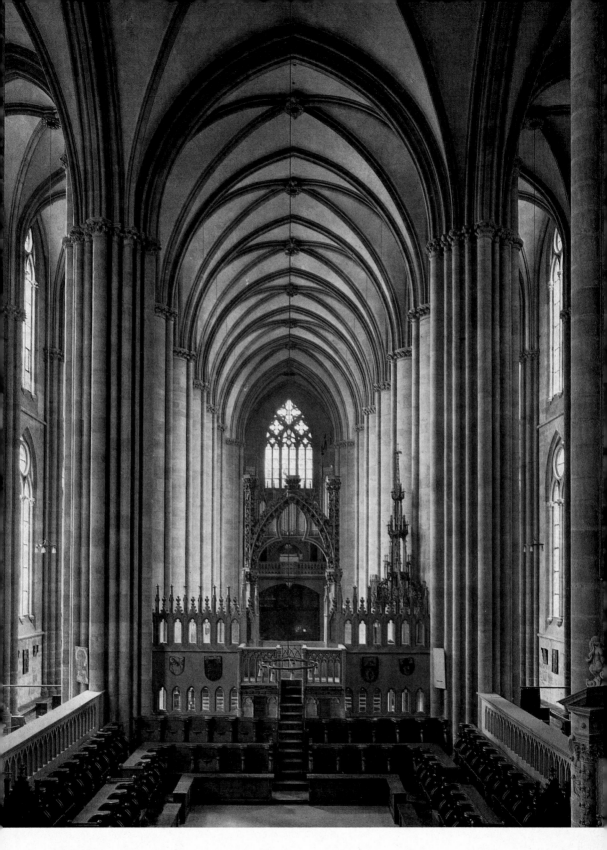

Marburg, St. Elisabethkirche, 1235—1283

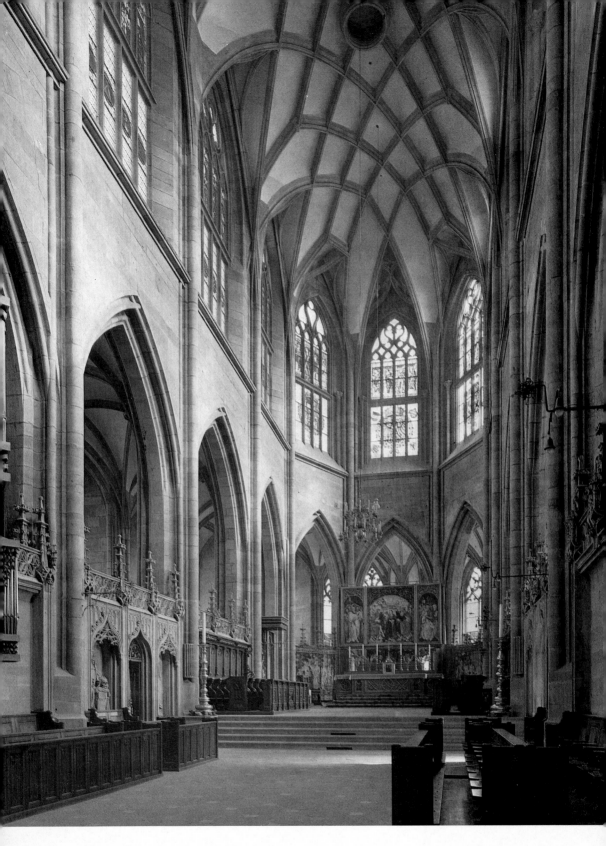

Freiburg Cathedral. Nave thirteenth century, chancel begun 1354, completed sixteenth century

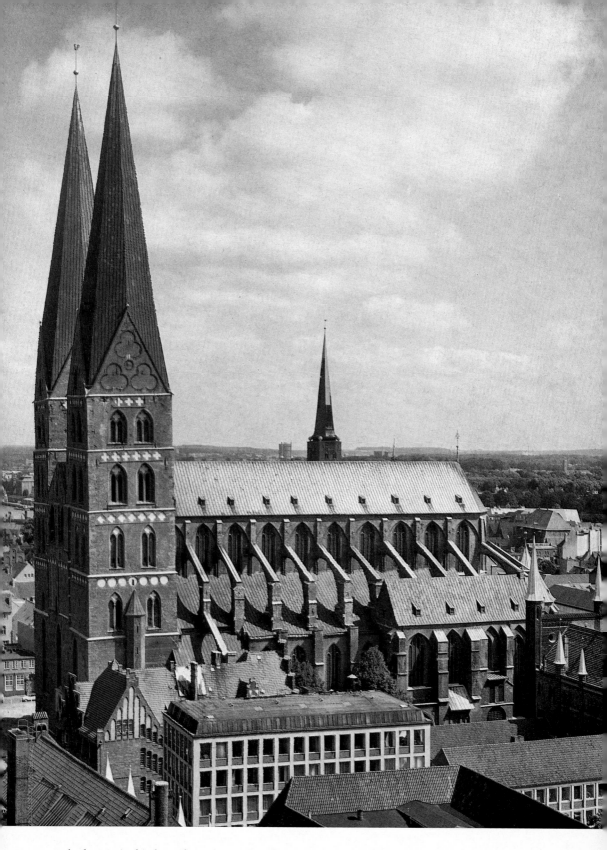

Lübeck, Marienkirche. Chancel completed 1291, nave completed early fourteenth century

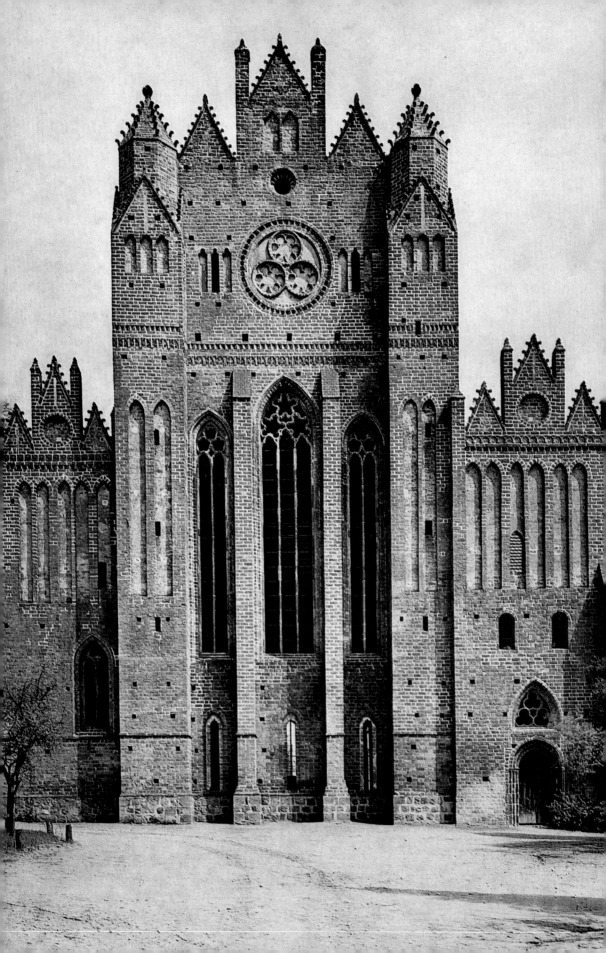

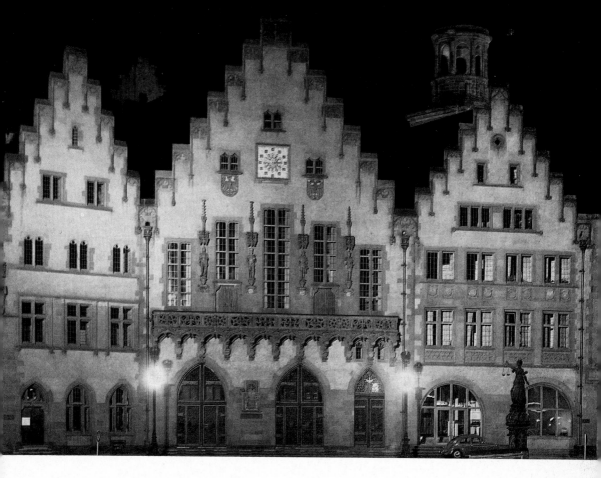

Frankfurt, Town Hall (Römer), 1405

Left: Chorin, Cistercian Monastery. West view of brick church, begun about 1300

Lübeck, Hospital Zum Heiligen Geist, thirteenth century

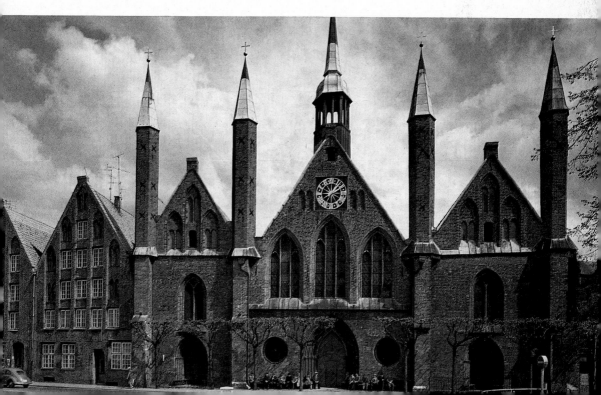

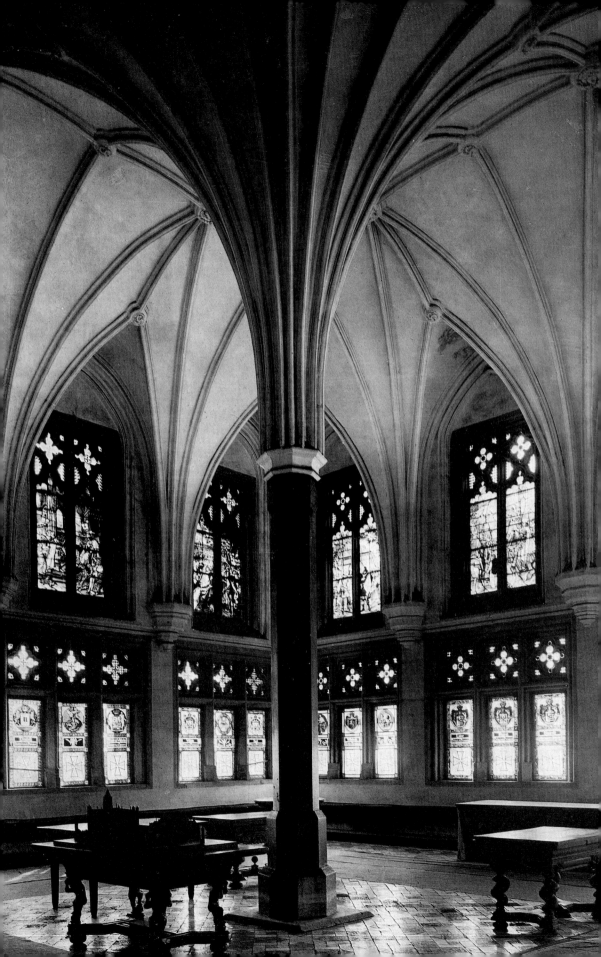

accepted, and Romanesque cathedrals continued to be built east of the Rhine. Some comparative dates illustrate this point: the first French Gothic cathedral at St. Denis was completed in 1157, the Benedictine Abbey at Maria Laach was consecrated in 1156, the chancel of Notre Dame in Paris was completed in 1170, the cathedral at Chartres in 1220, the cathedral at Worms in about 1230, and the westwork at Mainz in 1239.

While the perfection of Romanesque designs remained for a time the main preoccupation in Germany, certain Gothic features began nevertheless to be introduced from France: the circular window of the westwork at Worms was modelled on the French rose window and Gothic rib vaulting was used at Worms and at Mainz. Only very gradually, and not until the Romanesque style offered no further possibilities of development, did Gothic structural concepts find general acceptance in Germany.

The first major Gothic cathedral in Germany was built in Strasbourg during the second half of the thirteenth century (see p. 37 and p. 46). Although originally planned as a Romanesque structure, upon completion of the chancel the decision was taken to follow the challenging example of neighbouring France and construct the nave in Gothic style (1250). The walls were opened up by large Gothic windows but the interior remains predominantly Romanesque; the piers are widely spaced and the proportions of the nave are 1 : 2.5. The design for the western façade by Erwin von Steinbach (1276) combined horizontal and vertical elements in accordance with earlier ideals. This was abandoned after completion of the lower storeys, and the present façade and north spire date from the fourteenth century. The earlier heavy substructure is surmounted by a slender third storey of high lancets, an arrangement of free-standing tracery elongates the effect of the broad second storey windows, and an open-work gable with pinnacles over the massive main portal further emphasizes the purely vertical rhythm of the façade.

Cologne Cathedral (see p. 38) was started in 1248 by Master Gerhard who is thought to have modelled it on the cathedral at Amiens, but he developed the Gothic concept further and reached an unrivalled level of technical achievement. French Gothic elevations consist of arcade, gallery and clerestory (see Amiens Cathedral, p. 55) but at Cologne the gallery and clerestory are combined to form gigantic windows which are separated by slender piers.

The construction of Cologne Cathedral extended over many centuries. The chancel was consecrated in 1322 and work proceeded with frequent interruptions until 1560, by which time the western façade, with the exception of the spires, had been completed. In the nineteenth century the

Left: Marienburg Castle. Refectory, second half of fourteenth century

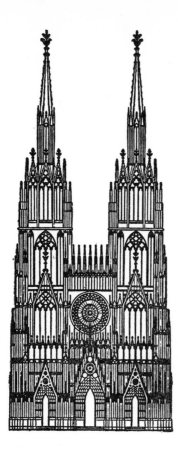

Design for the west façade of Strasbourg Cathedral. The south tower was never realized

Romantic movement brought a resurgence of interest in medieval culture, and upon the discovery of the original plans construction work was taken up again and the cathedral was eventually completed in 1880.

The influence of French Gothic made itself felt most strongly at Strasbourg and Cologne. Further east of the Rhine the combination of Gothic structural concepts with certain Romanesque elements resulted in a number of national developments which count among the most interesting contributions made by German architecture.

The cathedral at Freiburg (see p. 40) provides an excellent illustration of a specifically German development in the Gothic style. Construction began around 1200 with the erection of a purely Romanesque chancel and transept. During the thirteenth century a Gothic nave was added, modelled on that of neighbouring Strasbourg, but the architectural possibilities of the Gothic style remained largely unexploited: the nave, although higher than the Romanesque transept, is low compared to French Gothic naves; the clerestory windows are relatively small so that the wall continues to be a structural element in its own right; buttresses and flying buttresses are almost provincially plain and in no way shroud the rigidity of the struc-

46

ture. In about 1350 the Romanesque chancel was replaced by one of High Gothic design with radiating chapels and net vaults. These three stages of development, Romanesque transept, Early Gothic nave and aisles, and High Gothic chancel, can be easily identified to this day by their differing heights. Another fourteenth-century addition was a massive tower erected over the western end of the nave; its pyramidal octagonal spire is decorated with open-work tracery of exceptional beauty.

The single-tower façade soon spread in southern Germany. At Ulm and Landshut as well as at Freiburg a steeply rising tower counters the horizontal element of nave and aisles. The structure no longer flows organically towards the east like French Gothic cathedrals, but becomes once again the sum of its units.

The second important development of German Gothic is the hall-church. Its origin can be traced to France but it was completely abandoned there during the Gothic period. The distinguishing feature of the hall-church is the equal height of nave and aisles. Two parallel arcades continue to divide the interior but the spatial impression has changed radically; the nave is lit from the aisles and the arcades rise like massive trees into the sweeping expanse of space, which seems less high because three parallel aisles of equal height are seen as one homogenous unit. Thus the Romanesque ideal of equilibrium between vertical and horizontal lines is applied to the Gothic structure. In this return to a structural harmony of contrasting elements the regular flow of light plays an important part. Low aisle windows and high clerestory windows create a mystical interplay of light and darkness in the Gothic basilica, while the unbroken and even flow of light gives the hall-church an open, almost worldly character.

The first Gothic hall-church in Germany, begun in 1235, was the St. Elisabethkirche at Marburg (see p. 39). The Gothic character of this church is apparent from the outside. Two slender towers rise at the west front and the walls are entirely taken up by rows of high windows. Solid buttresses and delicate window tracery provide a characteristic ornamental pattern,

Vaults

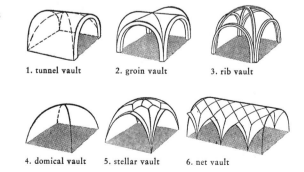

1. tunnel vault 2. groin vault 3. rib vault

4. domical vault 5. stellar vault 6. net vault

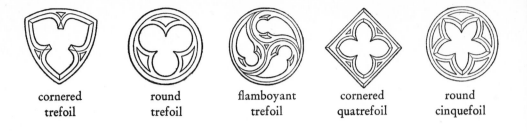

| cornered
trefoil | round
trefoil | flamboyant
trefoil | cornered
quatrefoil | round
cinquefoil |

one which nevertheless differs considerably from that of Gothic basilican churches; buttresses fail to turn into flying buttresses and remain heavily and solidly attached to the walls. A rich system of piers and rib vaults animates the interior where step and vision are no longer directed unequivocally towards the altar but, because of its spaciousness, equally into breadth as into depth. Chancel and transept form a trefoil pattern (see ground-plan p. 53), a favoured motif of Early Romanesque and one which evokes the old concept of the centrally planned structure.

At about the same time the only Gothic circular structure, the Liebfrauenkirche at Trier, was built on the other side of the Rhine (about 1240). The ground-plan is based on the Greek cross (see p. 53); a clever disposition of radiating side chapels transforms it into a circle from which the chancel projects to the east. This central plan, which has been combined with the characteristic elements of Gothic architecture, is undoubtedly modelled on the Palatine Chapel at Aachen.

Germany's most important contribution to European Gothic, apart from the single-tower façade and the hall-church, is the brick structure. It originated in northern Germany where an absence of natural sandstone, combined with the lack of efficient transport to ensure a regular supply of natural stone from the centre of Germany, made it necessary to build in brick in order to satisfy the demand created by the rapid growth of the Hanseatic towns. The structural advantages of brick were soon recognized and at the beginning of the thirteenth century sacred and civil architecture developed brick construction in a highly original way. The simplicity of brick structures, dictated by the building material, proved to be better suited to the northern German plains than the splendour of sandstone structures (see p. 41, p. 42 and p. 43).

The principal example of a thirteenth-century North German brick structure is the Marienkirche at Lübeck (see p. 41). Originally planned as a hall-church it was later modelled on French cathedrals and built as a

Right: Bamberg Cathedral, Royal Horseman, about 1240

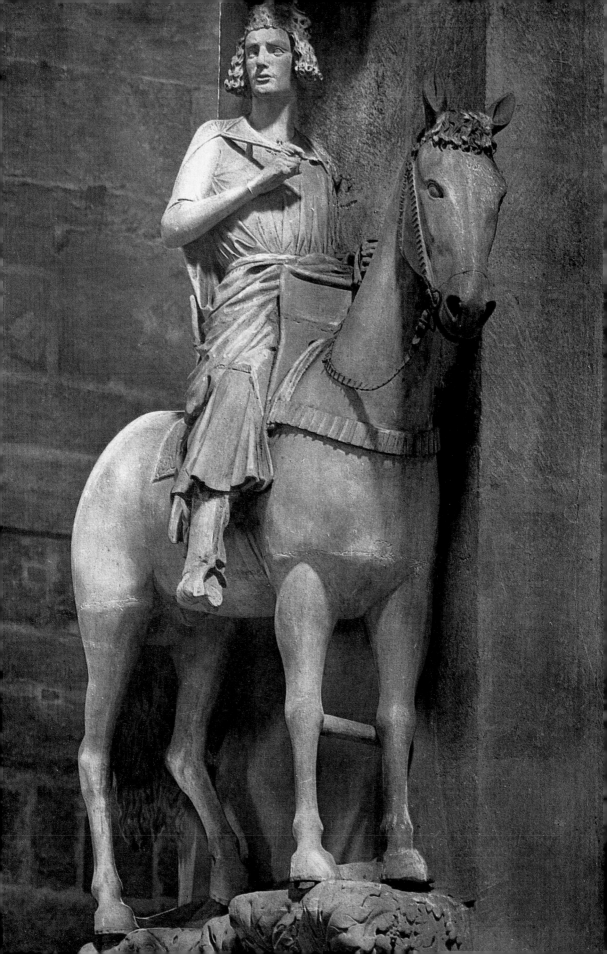

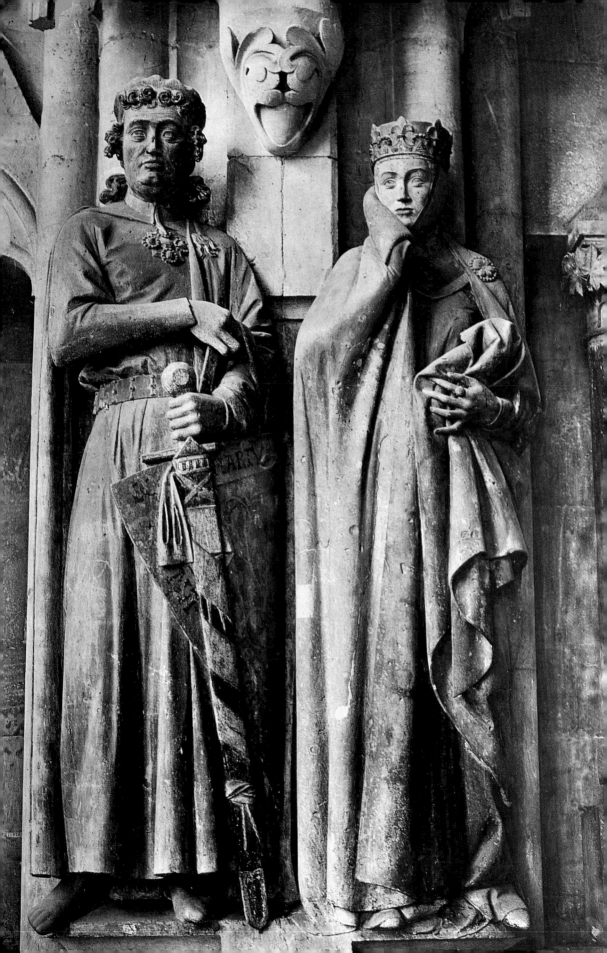

Veit Stoss (1445—1533): Virgin and Child, about 1500. From the artist's house in Nuremberg

Left: Naumburg Cathedral, Ekkehart and Uta, about 1260

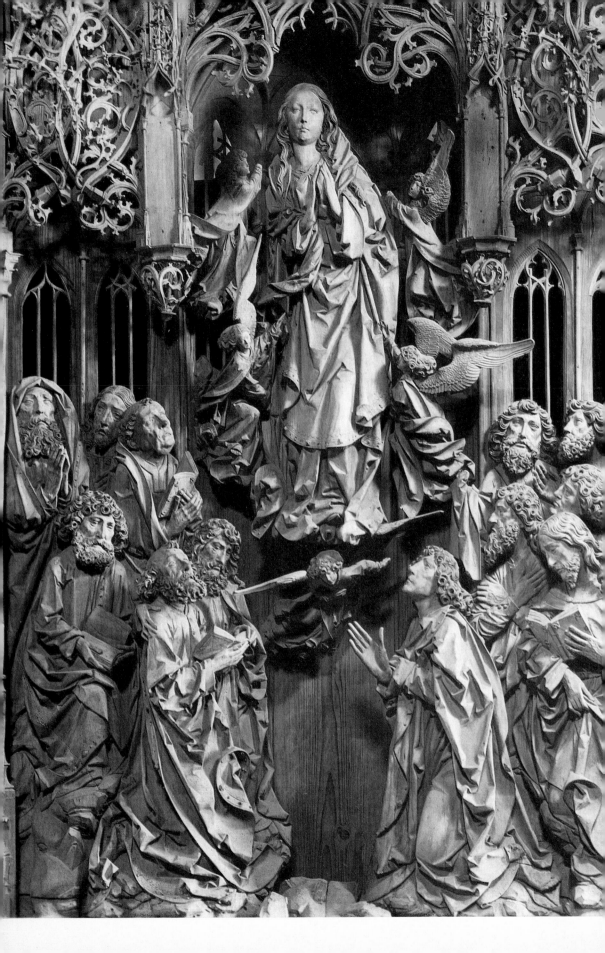

Marburg, St. Elisabethkirche, begun 1235. Ground-plan

Trier, Liebfrauenkirche, 1240—1260. Ground-plan

basilica. A nave and two aisles are terminated by a chevet and the vaulting of the ambulatory is combined with that of the radiating hexagonal chapels to create a single spatial unit. The transept as such has been omitted but the aisles, which are considerably lower than the nave, are enlarged by one bay to form the chevet. Neither complex traceries nor crockets and mouldings can be executed in brick and consequently the intricate variety of delicate designs which shroud the structural severity of Gothic sandstone cathedrals is absent from brick churches. However, the solidity of their structure, their massive shape and the clarity of their overall design are characteristic features of German medieval architecture in general.

The influence of French Gothic made itself felt not only in German architecture, but also in sculpture. The famous Royal Horseman of Bamberg (see

Left: Tilman Riemenschneider (1460–1531): Assumption of the Blessed Virgin. Carved centre piece of altar at Herrgottskirche, Creglingen, about 1505. Wood

Gothic Crocket
Capital
(Gelnhausen,
Marienkirche,
about 1225)

Gothic Foliated
Capital
(Naumburg
Cathedral,
early thirteenth
century)

p. 49) represents the first departure from Romanesque concepts and the first approach towards the French ideal of beauty and harmony; it does not follow the traditions of German Romanesque sculpture but shows a definite stylistic similarity with the royal figures at Reims Cathedral. This suggests a lively artistic exchange between France and Germany, but there can be no doubt that the Royal Horseman is the work of a German. The similar figure at Reims portrays a worldly-wise monarch who is familiar with political intrigue and with the cunning games of diplomacy. The Royal Horseman on the other hand radiates a solemn idealism combined with steadfastness and an indomitable will-power. It is not known whom the youthful monarch was intended to portray, but he now stands as a symbol of that glorious period in history, the age of medieval chivalry.

With the portraits of the founders at Naumburg Cathedral, realism in Gothic sculpture reached its height. Ekkehart and Uta (see p. 50) are not shown as idealized figures in timeless classical garments, surrounded by saints and angels, but as lifelike human beings, dressed in the everyday costume of their time. No heavenly aura surrounds them, they are not theology turned to stone, they are men and women who carry the burden of life on their shoulders, the burden of their humanity; they are German figures, solid and strong, proud and dignified. Uta seems to reject all superficiality as she protectively raises her cloak, and her gaze towards an uncertain future expresses the melancholia of the outgoing Middle Ages. The brilliant era of German knighthood was passing, and the dark clouds of political conflicts were rising on the horizon.

Towards the end of the fifteenth century, when the Renaissance was flourishing in Italy, the Late Gothic style continued to prevail in Germany and a number of remarkable artists raised German sculptural achievements to new heights. Tilman Riemenschneider was active at Würzburg where he created a wealth of large and small-scale sculptures and carved a number of wooden altar-pieces of great formal beauty. His delicate portrayal of the maidenly Virgin for the altar at Creglingen (see p. 52) revives the transcendental character of earlier sculptures and surpasses them with a new radiant splendour and an unequalled perfection.

At about the same time another eminent German artist, Veit Stoss, created a carved altar-piece for the Marienkirche at Cracow. In 1496 Stoss

settled in Nuremberg, where his genius reached its greatest maturity. His Virgin and Child (see p. 51) is closely linked to the beautiful madonnas of French Gothic, but in its quiet reticence expressed by the simple contours and the self-contained forms, this sculpture transcends the mannerism and spiritual emptiness of the Late Gothic style. The works of Tilman Riemenschneider, Veit Stoss and some of their contemporaries such as the Austrian Michael Pacher and the North German Bernt Notke, sum up the artistic wealth and experience of the Middle Ages and create a worthy ending to this era.

During the Late Romanesque period the richer articulation of wall surfaces provided less space for large-scale frescoes and when, with the advent of Gothic, wall space was further diminished by columns and pillars, the art of fresco painting was almost forgotten. But the transcendental tendency of Gothic architecture and the ever increasing size and ornamental importance of the windows brought with it the need for colourfully painted glass. The art of glass painting was developed and, predictably, reached its heights in France, where Gothic architecture offered the widest scope.

In Germany a different form of painting, independent of architecture, developed during the fourteenth century: that of panel painting. The basic idea of a painted panel came from Byzantium, where the icon had always occupied a traditional place in the church. During the thirteenth century, for liturgical reasons, the importance of panel painting increased, in

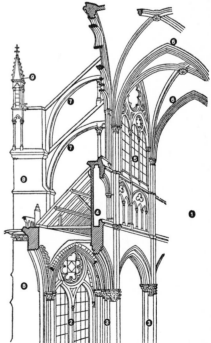

Typical Gothic Structure (Amiens Cathedral)

1. nave, 2. aisle, 3. pillars and arches, 4. gallery, 5. clerestory, 6. rib vault,
7. flying buttress, 8. buttress, 9. pinnacle with crockets and finial

Italy particularly. Ecclesiastical reforms had changed the rites of the holy mass, and the priest, who hitherto had stood behind the altar facing the congregation, now stood in front of it with his back to the people. Whereas before the altar could only be decorated by an altar frontal, the antependium, it was now possible to erect a high altar-piece, the retable.

Towards the middle of the fourteenth century Prague, a favoured residence of the German emperor Charles IV, became the centre of German panel painting. The emperor's close connection with the Papal court at Avignon and with humanist circles in Italy furthered the rapid dissemination of new ideas and artistic forms. Artists of the fourteenth-century Bohemian school combined the mannered style of French book illuminations and the hard, realistic style of the Italian Giotto in a most original way and exercised a decisive influence on subsequent developments in German painting.

Around 1350 an unknown master painted an altar-piece consisting of nine panels for the Cistertian monastery at Hohenfurth in southern Bohemia. The Nativity (see p. 57) clearly shows the different stylistic elements that influenced the painter. The gold background is Byzantine and so is the representation of the stable with Mary lying on the bed, while the strangely cubical rocks are reminiscent of Giotto. The long-limbed figures with almond-shaped eyes also suggest an Italian influence, whereas the loving treatment of details is taken from Burgundian and German book illustrations, which abound in painstaking representations of flowers, plants and trees. The attention lavished on the idyllic presentation of scenes from everyday life, such as Joseph and the nurse preparing the bath, is a characteristic feature of German medieval painting.

Since Giotto had introduced the third dimension to painting, European artists had become preoccupied with the problem of space. In the Resurrection by the Master of Wittingau (see p. 58), the diagonal position of the stone coffin gives added depth to the foreground of the picture which is carried to its logical conclusion by the mountain silhouettes in the back. The vivid presentation of the Resurrection shows the figure of Christ as a supernatural apparition, seemingly floating without gravity above the sarcophagus, and the untouched seals on its edge prove that a miracle has taken place. The faces of the guards in the background express horror, uncomprehending curiosity and complete disinterest; only the knight in the foreground, for whom the gesture of blessing seems to be intended, watches with spellbound interest. Compared with the picture-book effect of the Nativity by the Master of Hohenfurth, the unity and spiritual intensity of this painting represent a remarkable achievement.

At the turn of the century the Westphalian Conrad von Soest was active in Dortmund where, in 1422, he completed an altar-piece for the Marienkirche, which suggests that the artist was acquainted with French book

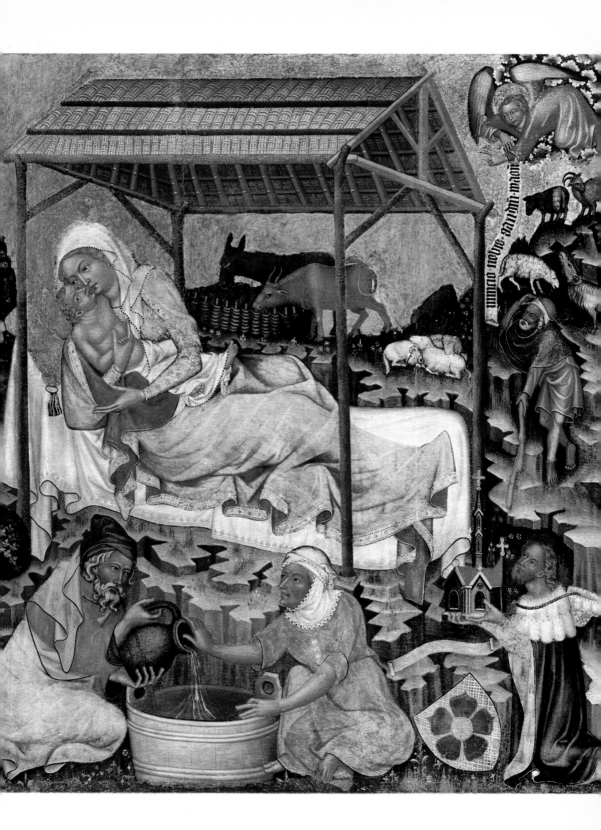

Master of Hohenfurth (active about 1350): Nativity

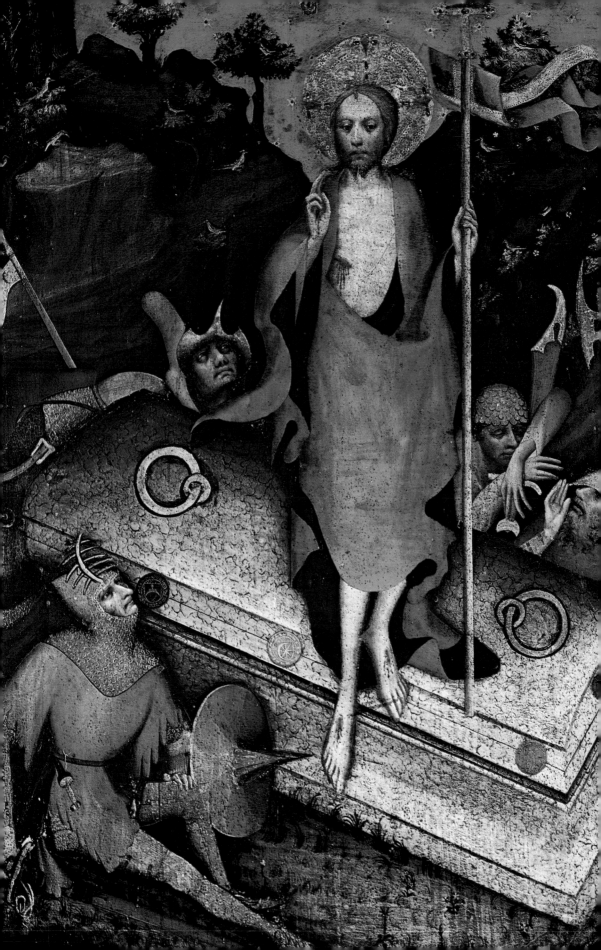

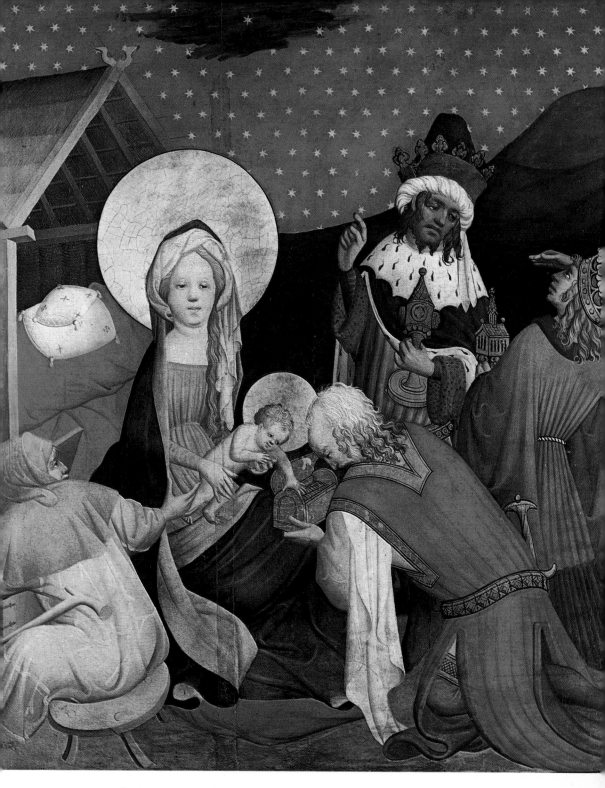

Master Francke (active in Hamburg early fifteenth century): Adoration of the Magi. Panel from the St. Thomas Altar painted for the Company of Traders with England, about 1424

Left: Master of Wittingau (active in Bohemia about 1380—1390): Resurrection

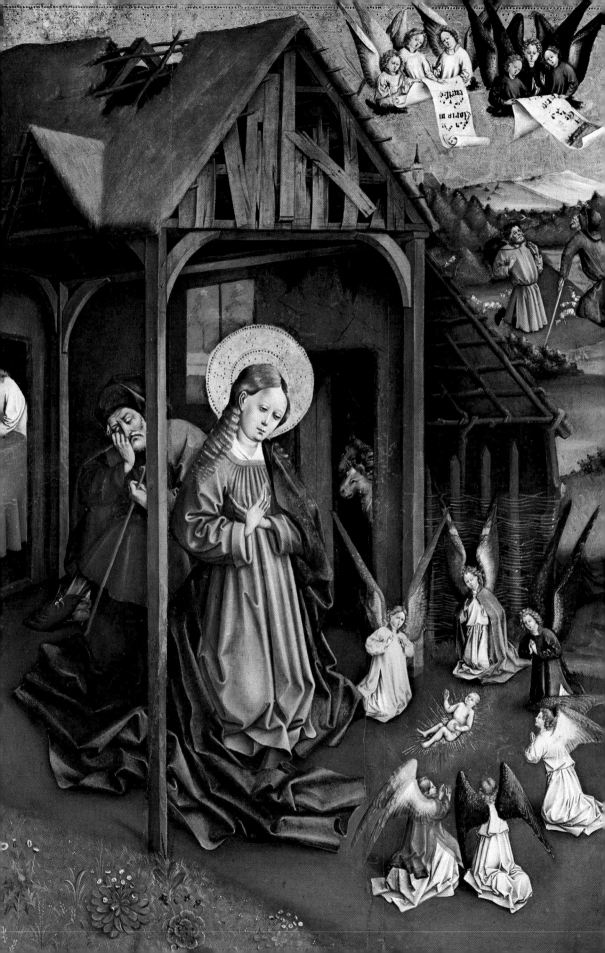

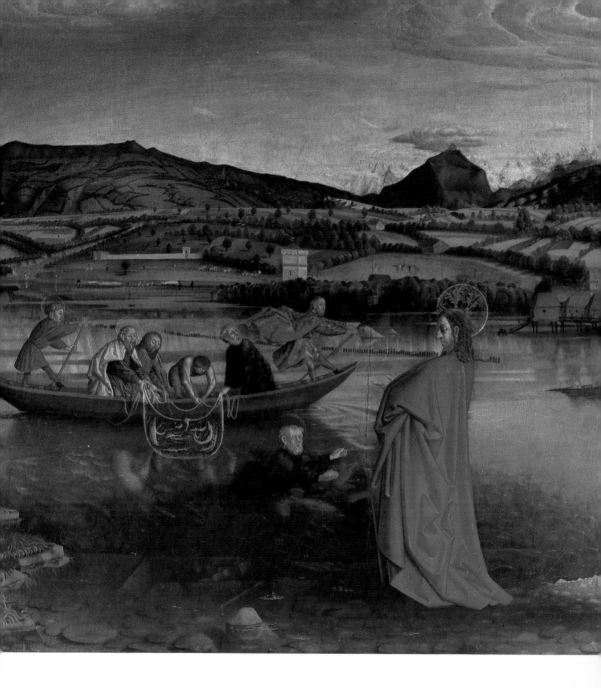

Konrad Witz (about 1400/1410—1445): The Miraculous Draught of Fishes.
Left wing of the St. Peter Altar, Geneva, 1444

Left: Johann Koerbecke (second half of fifteenth century): Nativity.
Detail from the Marienfeld Altar, about 1457

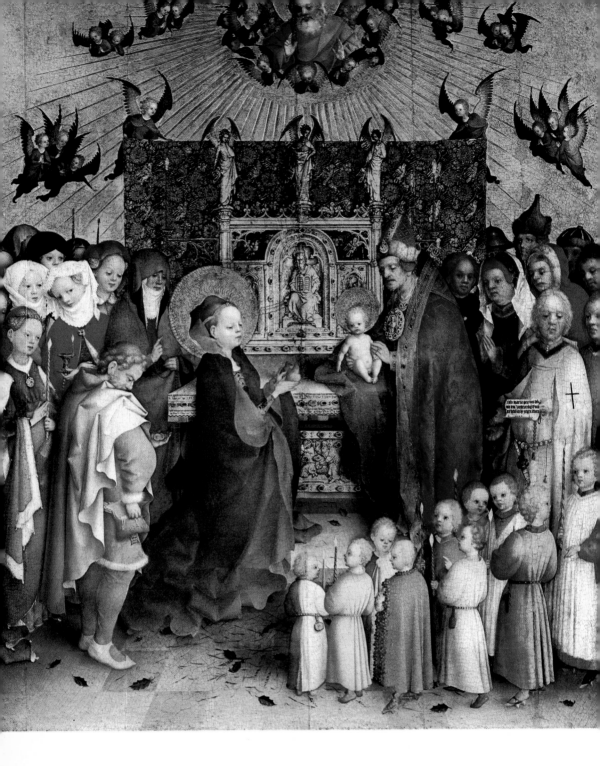

Stefan Lochner (1405/1415—1451): Presentation at the Temple, 1447

Right: Swabian School: Bride and Bridegroom, about 1470

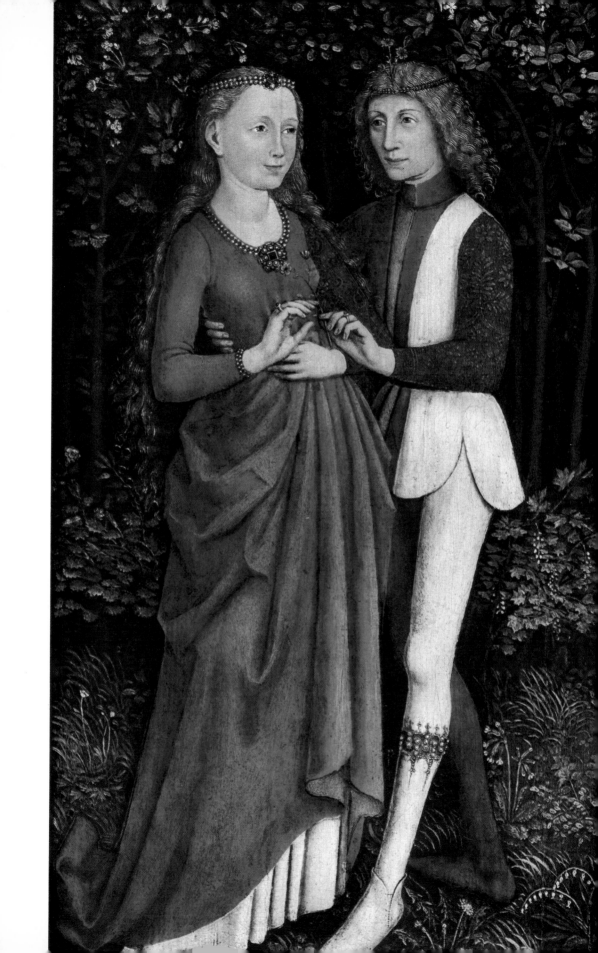

illustrations and with paintings from the Bohemian school. The fame of Central European artists spread from Westphalia to the Hanseatic towns of North Germany. Hamburg and Lübeck developed into important art centres and from there German paintings soon began to travel along the trade routes to neighbouring Scandinavian countries and across the Baltic. Since the founding of the Hanseatic towns, North Germany had become the political, economic and cultural link between Central Europe and Scandinavia, a role which they continued to play until well into the seventeenth century. During the Middle Ages North German brick architecture was adopted by the countries along the Baltic and as a result Gothic brick churches can be found not only in Lübeck, Wismar, Stralsund and Danzig but also in Copenhagen, Odense and Turku (Finland). When the art of panel painting spread across Europe it was once again the North German coastal towns which provided the link between Scandinavia and the rest of Europe. Pictures by North German masters were sent to Denmark, Sweden, Norway, Finland and further east. At first these were merely intended for the Hanseatic trading stations abroad, but when they aroused interest and admiration among the indigenous population, the merchants discovered that a painting was as profitable a commodity as wheat and spices and soon a lively trade in pictures began to develop.

Two artists in particular established the fame of North German painting: Master Bertram and Master Francke. Because of the methodical bookkeeping of Hamburg clerks their names are well documented by numerous invoices of the city's finance department. Master Bertram came from Westphalia and although nothing is known of his artistic development it is generally assumed that he learned his trade in Bohemia. Master Francke was born in Hamburg. His main work, the St. Thomas altar-piece, was commissioned by an association of Hamburg merchants, the St. Thomas Company of Traders with England. The Adoration of the Magi (see p. 59) shows Francke as a typical representative of the soft Gothic style which developed at the turn of the century in reaction to the hard monumentality of Italian and Bohemian masters. The soft flowing lines of the pensively quiet figures extend to the rich folds of their luxurious robes and create a magical effect. Majestic dignity without a trace of pathos characterizes the figure of the Virgin and makes her the spiritual centre to which the other figures relate in posture and gesture. No interfering movements disturb the tranquility of the scene, or of the gentle hills and the star-covered sky in the background. And yet the picture does not lack human warmth. With clumsy fingers the Infant Jesus reaches into the open treasure chest, while Joseph is concerned with removing the valuable gift to safety.

Left: Hans Holbein the Elder (about 1465—1524): Virgin and Child, about 1505 65

The Nativity by the Westphalian artist Johann Koerbecke (see p. 60) is more worldly and realistic and clearly demonstrates the influence of the Netherlandish school on German painters. The spatial depth of the richly graduated landscape, the detailed description of the old, weatherworn roof, the little patch of grass in the foreground and the pointedly graphic technique, are all features modelled on the realism of Van Eyck and his followers. But in Koerbecke's painting this striving towards reality remains in conflict with older conventions. The realistic landscape is set against a traditional gold sky and the figures of the Virgin and the angels in particular remain isolated from their surroundings. Their transcendentalized existence as well as the decorative lines of the richly flowing folds of their garments belong to the Late Gothic tradition.

This charming fusion of new trends with medieval concepts can be observed in all German paintings of the mid fifteenth century. One of those most successful at reconciling tradition and progress was Stefan Lochner, a master of the Cologne school who originated from Lake Constance. His Presentation at the Temple (see p. 62) is a magnificent assembly of celestial and human figures who are brought closer together by the idealization of the human figures and an earthly portrayal of the heavenly ones. The children carrying candles emanate a more angelic aura than the circle of fluttering angels against a gold ground, and the Virgin Mary can only be distinguished from the rest of the lovely and radiant ladies by her more luxurious robes and her halo. She is no longer portrayed as an emissary from heaven but as one chosen from the people. Another very human touch has been added: the holy rites at the altar seem to be forgotten while everybody glances at the endearing procession of children; not only the figures to the left and right of the altar but Mary herself is momentarily distracted. The barrier between heaven and earth seems reduced.

The strength of Late Gothic painting lay not in its monumentality or in its bold intellectualism, but in its poetic fantasy and its loving treatment of detail, through which all formal contradictions were resolved. It hardly seems to matter that the stylized figures of the bride and bridegroom in the picture by an unknown Swabian Master (see p. 63), painted about 1470, stand in a naturalistically portrayed woodland where the ground is covered by a rich carpet of plants, which are drawn with botanical precision: ranunculis, clover, dandelions, lilies of the valley, primroses, valerian and others. In these very earthly surroundings the mannered movements and postures of the bride and bridegroom, which correspond to Late Gothic concepts, make them appear almost unreal, but this juxtaposition of reality and transcendentalism creates a magical effect and gives the scene a delightful harmony of its own which is characteristic for German paintings of this epoch. In other countries painting had long ago wholeheartedly adopted a worldly realism.

THE RENAISSANCE

A renaissance in its true sense never existed in Germany. The main reason for the fact that artistic developments in Germany did not parallel those in Italy during the fifteenth and sixteenth centuries is that the German and Italian artists drew their inspiration from entirely different sources. In Germany, one important prerequisite for a *renascitur,* a revival of Classical forms, was missing: that of a Classical past to which such a movement could relate. If there ever was a renaissance north of the Alps then it belonged not to the era around 1500 but to the time of Charlemagne, when great artists and scholars were invited to revitalize the spirit of Late Classical times. But the Carolingian renaissance was in no way a new beginning, it was a fading out of Early Christian and thereby Late Classical forms and ideals. From there German art took a different course and by turning away from Classical ideals, by creating its own, non-Classical forms, achieved true greatness. Italy never severed her link with the past and consequently her contribution to Western European art during the Middle Ages was modest. When at the beginning of the fifteenth century the medieval world crumbled, the Italians had their Classical past to fall back on and as a result they were able to take the lead in that artistic and intellectual movement which much later became known as the Renaissance.

German artists had no Classical past to which to relate—the greater part of Germany had never even come into direct contact with ancient Roman culture—and at the end of the Middle Ages efforts in Germany were directed towards the preservation of a heritage from the most recent past. This was expressed by the continued development of proven forms. The *Quattrocento,* that glorious century of Early Italian Renaissance, produced a last flowering of medieval art in Germany, the Late Gothic, during which period the new reality remained unrecognized. There was no radicalism in German art in this century and no bitter conflict between tradition and progress; there was a gentle merging of old and new.

In Italy the Renaissance broke through with revolutionary force and met with no resistance. Popes and princes, citizens and artists competed with each other to glorify the new era and to enjoy worldly pleasures. Inspired by the artistic, moral and social freedom they unhesitatingly discarded the outworn forms of the Middle Ages and, through the revival of Classical

ideals, developed a new feeling for life which found its most perfect expression in their art.

No parallel development took place in Germany. The Humanism of pre-Reformation days was erudite and serious, but lacked the youthful freshness and beautiful spontaneity that was needed to create a vision of a better future from the ruins of the past. This lack of vitality is demonstrated by the nearly complete decline of German architecture. The few sacred structures which date from the fifteenth century (the Stiftskirche in Stuttgart, and the Heiligkreuzkirche in Gmünd, for example) are products of a tired imagination. Although based on Gothic concepts, they lack the essential upward drive. The structures are squat, their vaults and arches broad, their pillars and ribs stocky and lifeless. The serene harmony of contemporary Italian architecture, with its balance of horizontal and vertical lines, was neither intended nor desired. These buildings express a narrow-minded piety that bears no relation to the medieval longing for the hereafter.

After the Reformation the building of churches suffered a complete decline in Germany. The Protestant part of the country was content with existing structures which, after they had been stripped of their ornaments and pictures, conformed in their spareness to the declared Protestant aim of austerity. In the Catholic south the widespread conservative attitude of the clergy may have been responsible for the fact that the adoption of Italian Renaissance concepts was not encouraged and nobody drew the architectural consequences of the changed intellectual climate.

As far as civil architecture was concerned the picture was somewhat more positive. Towards the end of the Middle Ages the growing influence of the middle classes began to assert itself against the authority of the clergy, and a number of town houses, merchants' offices and town halls were constructed. But although the secular character of these buildings was very obvious, they nevertheless failed to develop an independent style of their own. The extent to which civil architecture was dependent on sacred architecture is illustrated by the refectory of Marienburg Castle (see p. 44). This large hall is reminiscent of Gothic hall-churches in design and structure: a row of slender pillars divides the room into two aisles, the vault is supported by fan-shaped ribs, and pointed window arches are set into the heavy walls. The Town Hall at Frankfurt, the famous Römer (see p. 43), provides another example of this interdependence; its graduated façade is similar to that of many fourteenth-century Franconian churches.

Right: Bremen, Town Hall, 1405—1409. Rebuilt in Renaissance style by Lüder von Bentheim 1609—1613. In front: the Rolandsäule, 1404

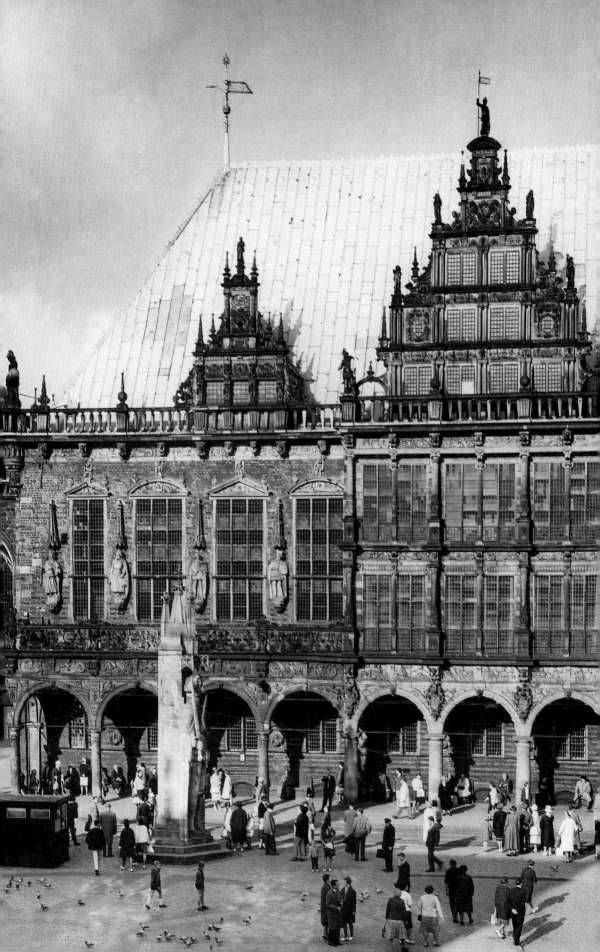

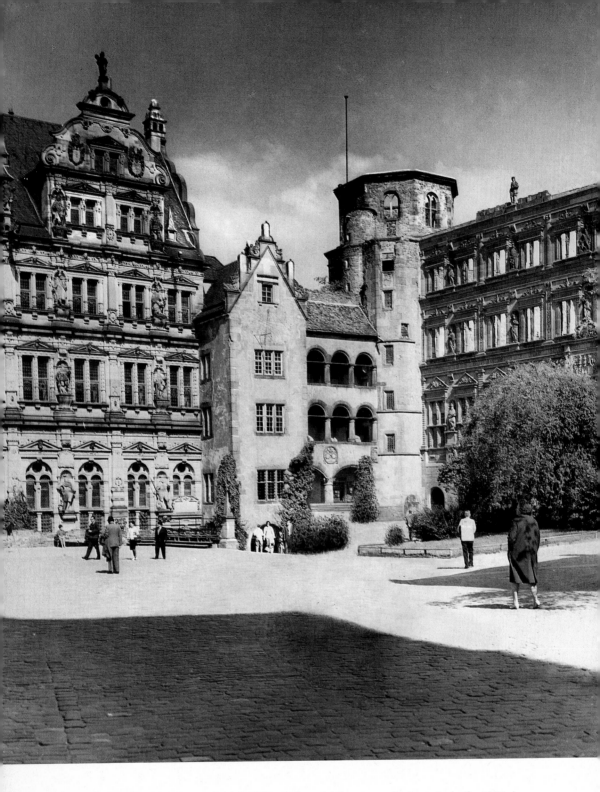

Heidelberg Castle. Ott-Heinrich's Palace (right part of picture), built 1556 in Renaissance style. The original medieval fortified castle was frequently rebuilt over the centuries

Right: Augsburg, Town Hall, 1615—1620 by Elias Holl (1573—1646)

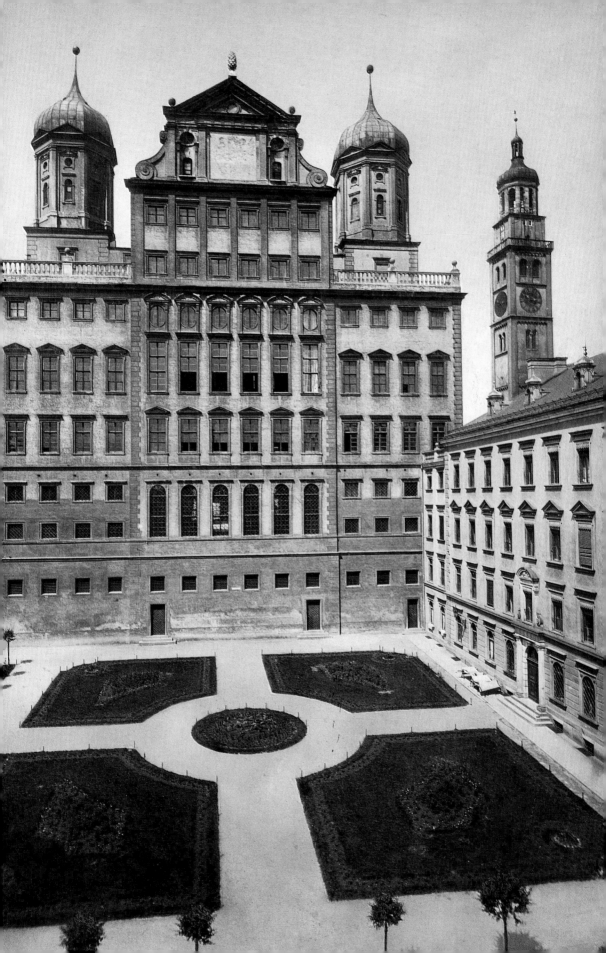

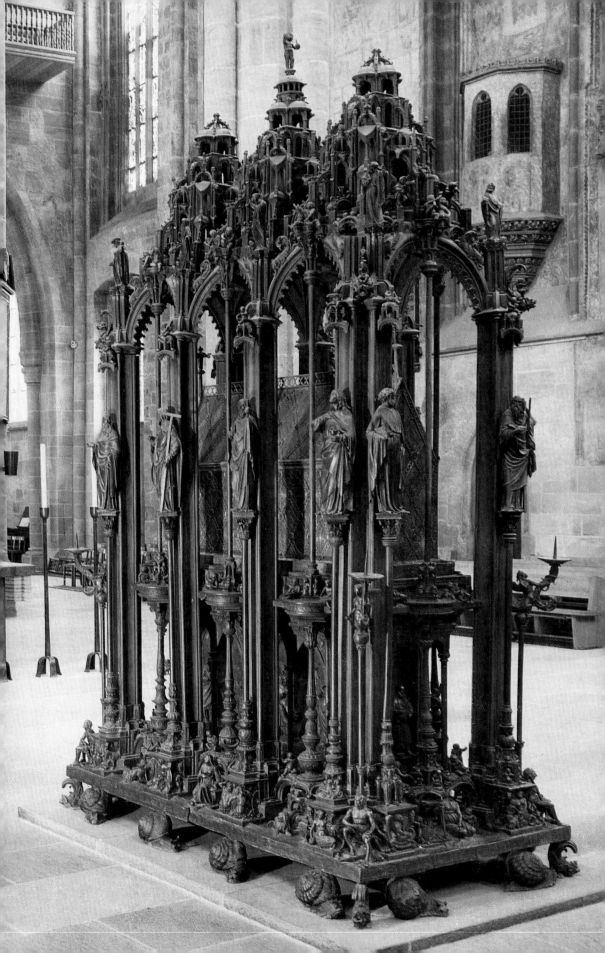

In Italy the development of Renaissance architecture brought with it the emergence of a clear distinction between sacred and civil structures. As the individual became more aware of his importance he wanted to assert his personality in all spheres. The manner of dressing grew more decorative and sumptuous, the living habits more opulent and luxurious, and an increased intellectual independence brought with it an interest in all branches of the arts and sciences. It follows that this new attitude to life demanded a more representative setting; the modest town house with its utilitarian dimensions and furnishings proved too constricting for the rich merchant or banker, and monumental civil structures began to make their appearance next to sacred structures. During the Middle Ages the former had been modelled on the latter. With the Renaissance the Italians developed an independent secular style in order to demonstrate the rejection of the omnipotence of the Church. The artless houses were replaced by magnificent *palazzi* which rich patricians now had built as a matter of course, just as the princes in the old days had constructed their castles and fortifications.

For a long time Germany and neighbouring countries north of the Alps refused to accept the intellectual, rational ideals of the Renaissance. Only Renaissance ornamentation was adopted to begin with and used for the decoration of Gothic structures. Traditional façades, terminated by pointed gables, were enriched by pilasters ending in turret-like needle-sharp obelisks that projected beyond the edge of the gable. Following Italian examples, the big rectangular windows were surmounted by segmental or triangular pediments and occasionally a balustrade decorated with figures was placed along the edge of the roof (see Bremen Town Hall, p. 69). Irregular medieval ground-plans continued to be used, as is evident in the castle at Heidelberg, which consists of several loosely grouped structures (see p. 70). The old fortified castle, built around 1200, was enlarged in Italian Renaissance style by the Elector Palatine Otto Heinrich in 1556—1559. The architect, whose name is not known, used a whole range of Greek and Roman designs in an attempt to give the structure a Classical character. Ionian and Corinthian pilasters carry a Doric frieze; pediments over the windows are supported by three variously decorated pillars and carry medallions portraying Classical heroes; sculptures of figures from ancient myths are placed in niches between the windows; and on the lower storey pilasters of rough-hewn, square stone are reminiscent of the Rustica of Florentine *palazzi*. This confusing ornamentation has nothing in common with the clear pattern of Italian Renaissance façades. In Italy ornamentation and articulation form part of an overall architectural concept,

Left: Peter Vischer the Elder (about 1460—1529): Shrine of St. Sebald, 1508—1519. Nuremberg, Sebalduskirche. Bronze cast

whereas in Germany the ornamentation is in no way related to the structure, which merely supports a wide-ranging and fantastic decor.

The Town Hall at Augsburg (see p. 71), which was completed in 1620 by Elias Holl, is the only one among a great many Northern European civil structures that could claim to belong to Renaissance architecture in the Italian sense. The clearly conceived regularity of the square ground-plan is subdivided into rectangular state rooms on the one axis and two facing staircases on the other. In the corners of this cross, which is formed by the state rooms and the staircases, square offices are provided for the administration. The square pattern reappears on the façade: height and width are of equal dimension and the central section which houses the council chamber also forms a square that is framed by mouldings and pilasters. Apart from a sparing use of cartouches on the uppermost storey, no ornamentation decorates the façade, which is given its rhythm by the meaningful alternation of differently sized windows. Only the gable surmounting the central section represents a concession to German taste. The overall impression conveyed by the structure is one of great elegance achieved through the balanced proportions and the harmonious interplay of horizontal and vertical lines. Immediately after the completion of the Town Hall at Augsburg the Thirty Years War broke out, which brought architectural activities to a complete standstill.

A characteristic example of German Renaissance sculpture is the Shrine of St. Sebald by Peter Vischer (see p. 72). The work of other eminent contemporary sculptors, such as Riemenschneider and Stoss, was not influenced by the Renaissance revival of Classical forms and ideals and is, therefore, considered a last flowering of the Gothic style. Peter Vischer and his sons, on the other hand, were more receptive to new developments. From the mid-fifteenth century the Vischer family ran a flourishing bronze foundry in Bamberg, which gained such fame that it was visited by princes and potentates from all over Europe, although important works by Peter Vischer the Elder could be found in Poland, Bohemia, Hungary, in the Palatinate and at the courts of princes everywhere in the empire. The Shrine of St. Sebald, destined for the church of the same name at Nuremberg, was originally designed in 1488 in purely Gothic style with a top of three crowning spires. When the monument was finally commissioned in 1507, Vischer decided to give it a more Classical aspect. The result is a strangely confusing system of round arches surmounting a dome-like baldachin, suggesting that Vischer was not familiar with current Italian forms of sculptural ornamentation. His son, Peter Vischer the Younger, created the figures of the twelve apostles; their well-balanced proportions and the solemnity of their bearing demonstrate his endeavour to overcome medieval concepts. On the reliefs along the base of the shrine scenes from the life of

St. Sebald alternate with half-naked figures portraying representations of Classical mythology; these are considered the work of Hermann Vischer the Younger, who is documented to have been in Rome and Toscana in 1515. Thus the Shrine of St. Sebald shows the gradual infiltration of Italian sculptural concepts and at the same time illustrates the incapacity of German artists to fuse these new ideas into a unified sculptural composition. Through its elongated shape and its confusing wealth of figural and ornamental details, the general impression conveyed by the Shrine of St. Sebald remains Gothic.

The paintings created during the period of transition from medieval to modern frequently expressed that conflict between tradition and progress which predominated at the turn of the century. Albrecht Altdorfer's famous Battle of Alexander (see p. 77) incorporates the most important aspects of this transitional style. A huge panorama of depth and width is presented from a high viewpoint, which demonstrates conclusively that the third dimension has been opened up to painting and that flat medieval scenes, 'sealed' by a gold sky, have become a thing of the past. A cosmic background of dramatic clouds, bizarre mountain ranges, glittering surfaces of water and scattered islands, is irradiated by the setting sun. The figurative scene stretches in an unlimited variety of gradations from the foreground to the coastline in the middle distance: a fortified town, steep rocks surmounted by castles, meadows, fields, paths and trees encircle the teaming throng of two armies, that of the Macedonian king, Alexander, and that of the Persian king, Darius. The soldiers are painted with a miniature precision that conveys their human insignificance in relation to the surrounding cosmic magnitude; this indicates an underlying metaphysical intention but it also illustrates the current artistic endeavour to combine medieval descriptive details with the three-dimensional ideas of space developed by the Italians.

Landscapes had been portrayed in Northern European painting long before Altdorfer. They dominate the figures in a number of enchanting illuminations of secular texts from Burgundy, and the Netherlandish painters Hubert and Jan van Eyck introduced the landscape into panel painting. However, the Netherlandish school merely used nature as a background to give their pictures an impression of spacial depth and made no attempt to fuse it with the scene in the foreground. A further step in the development of landscape painting was taken by the Swiss artist Konrad Witz, who replaced the fantastic landscape by a topographically identifiable interpretation. But even his very realistic portrayals of nature such as that of Lake Geneva in The Miraculous Draught of Fishes (see p. 61) are only used as a background and the theme of the painting is conveyed by the figures in the foreground.

This no longer applies in the case of The Battle of Alexander (see p. 77). Altdorfer communicates the dramatic mood through the landscape, against which the battle itself seems more an assembly of tin soldiers. Worldly events, the struggle between two big armies, are but a pale reflection of what is happening in the sky; it is here that Altdorfer conveys the conflict between light and darkness, between day and night, between sun and moon.

Altdorfer's origins explain his close communion with nature. He was probably born at Regensburg and virtually never left his home in the wooded valley of the Danube. His best paintings are those in which he freely expresses his feelings, isolated from the art activity of his time and unhampered by the formal problems which concerned his contemporaries. He has been credited with founding the tradition of European landscape painting. By creating landscapes without figures he established an artform which has survived to this day, despite the many changes which painting underwent during the intervening centuries.

Although Altdorfer had no direct successor, his style nevertheless had a wide influence. He was the principal representative of the Danube style, a type of painting characterized by the importance of the landscape over the figures and objects. This intimate feeling for nature displayed by the Danube artists was largely responsible for their rediscovery by the nineteenth-century Romantics, who regarded the Danube school as a romantic movement. Quite convincing similarities can indeed be found between the paintings of the nineteenth-century Romantics and those of the early sixteenth century, particularly in the way landscape is used to express the meaning and convey the mood of the picture.

Lucas Cranach the Elder can to some extent be considered the immediate forerunner of the Danube style. Little is known of his early development but it is assumed that, during his years of travel, he visited the important artistic centres of southern Germany. He was extremely receptive and was able to absorb a variety of influences which he then transformed into his own, very individual style. While his early pictures clearly show the influence of Dürer and Grünewald, he later tended more towards the Netherlandish painters and Holbein. His work covers a wide variety of subjects: the female nude appears as frequently as the portrait, and mythological or allegorical scenes are as numerous as religious ones. Ideologically he did not

Right: Albrecht Altdorfer (about 1480—1538): The Battle of Alexander, 1529

Page 78: Lucas Cranach the Elder (1472—1553): Rest on the Flight to Egypt, 1504

Page 79: Mathis Gothart-Nithart, called Matthias Grünewald (about 1475—1528): St. Anthony's Temptation. Panel from the Isenheim Altar, 1512—1515

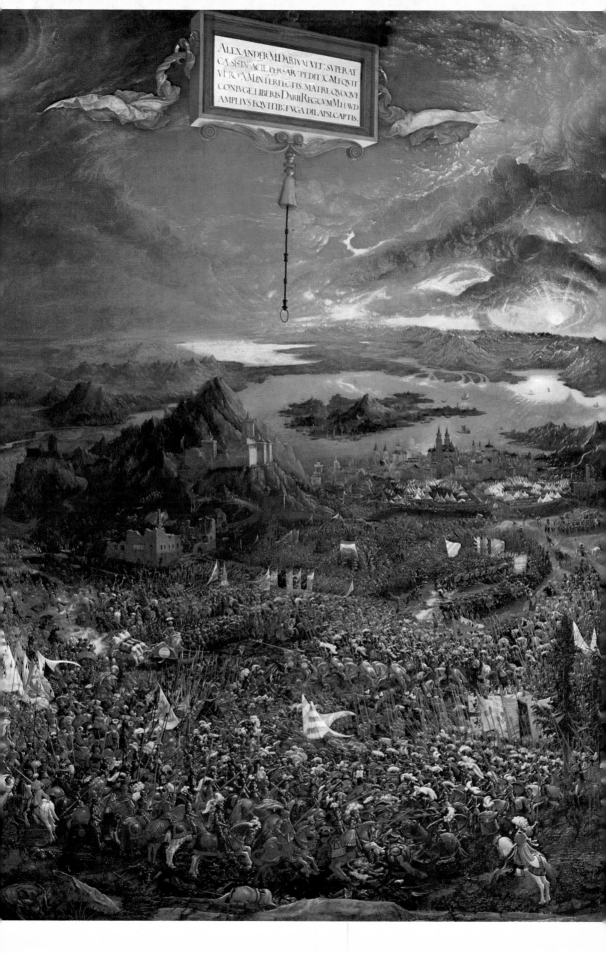

ALEXANDER M·DARIVM·VLT·SVPERAT
CÆSIS IN ACIE PERSAR·PEDIT·C·MLEQVIT
VERO·X·M·INTERFECTIS·MATRE·QVOQVE
CONIVGE·LIBERIS·DARII·REG·CVM·M·H·AVD
AMPLIVS·EQVITIB·FVGA·DILAPSI·CAPTIS.

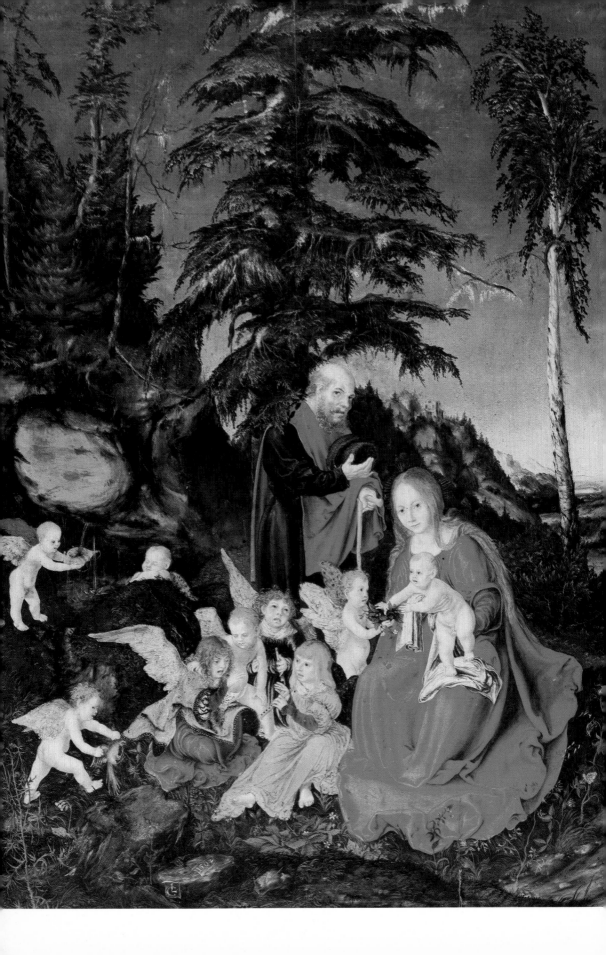

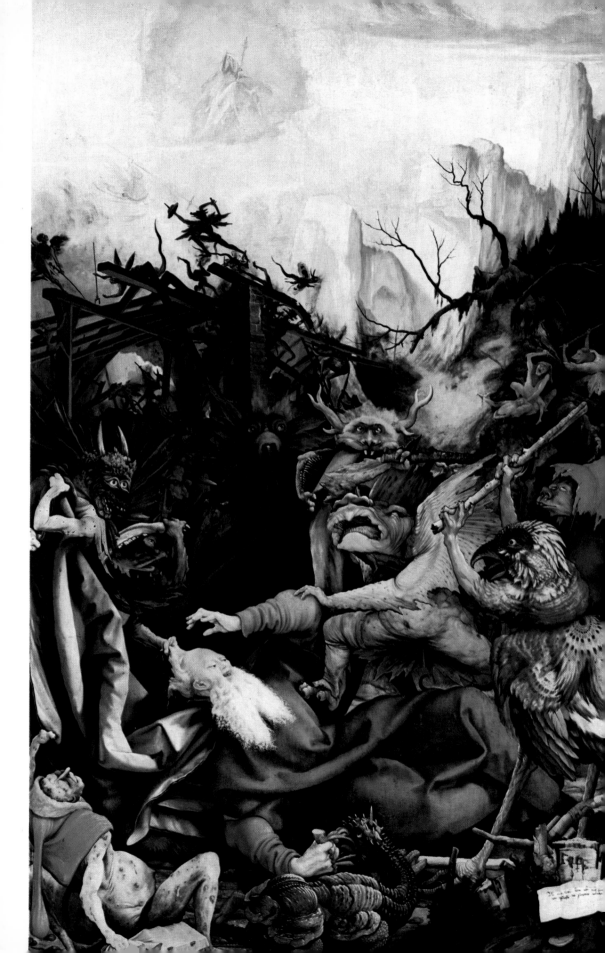

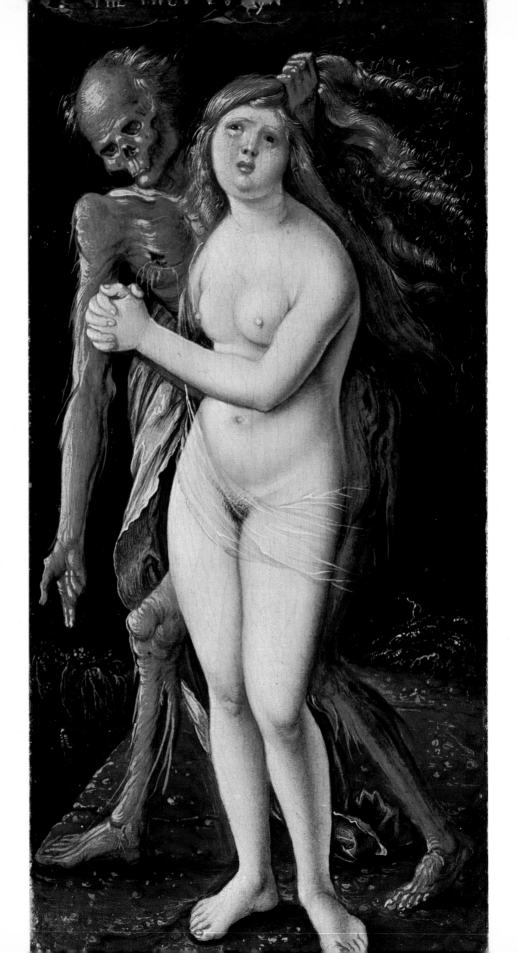

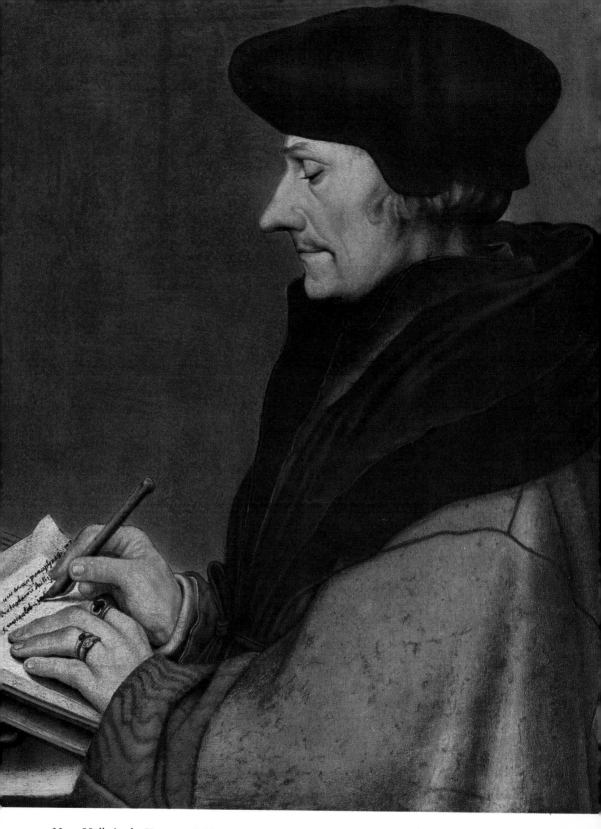

Hans Holbein the Younger (1497—1543): Erasmus of Rotterdam, 1523

Left: Hans Baldung Grien (1484—1545): Death and the Maiden, 1517

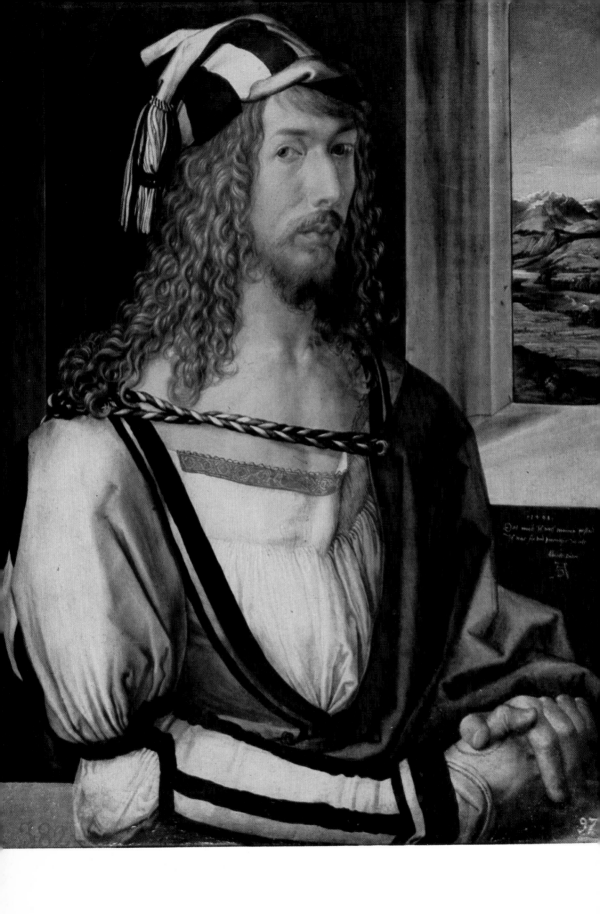

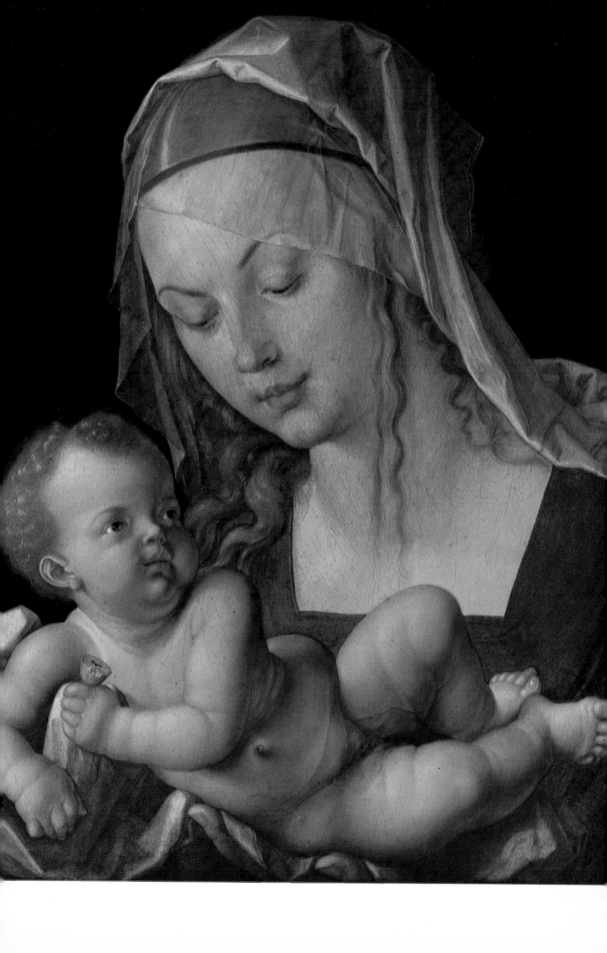

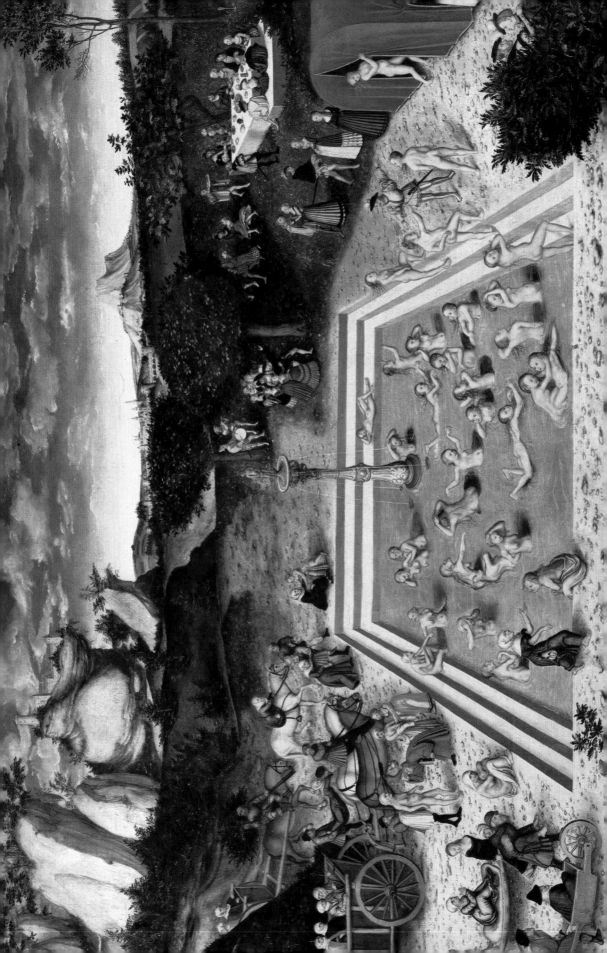

limit himself either: although he was considered one of the most ardent supporters of the Reformation he nevertheless continued to paint altarpieces for Catholic churches and portraits of Catholic princes. His refusal to commit himself has often been interpreted as fickleness, his phenomenal productivity as a purely commercial compulsion, and the variety of his themes as intellectual superficiality. But this assessment does not do justice to the personality of Cranach as a man or as a painter. He represented a new type of artist, not previously known, who was no longer the upright artisan committed to the predominant ideology of his time, but an independent individual with an alert and critical mind, able to absorb many different and contradictory ideas and incorporate them in his work without prejudice and without personal involvement.

These attitudes made Cranach a true representative of the Renaissance, a man who had taken the decisive step into modern times, although his work remained in many ways firmly rooted in tradition. Thus the angels in his painting Rest on the Flight to Egypt (see p. 78) are reminiscent of those by masters of the 'soft' Gothic style for whom an assembly of angels was an indispensable accompaniment to every portrayal of the Virgin. But Cranach interprets them quite differently. The heavenly bodies of medieval traditions have become friendly playfellows, little rogues who want to attract the attention of the Infant Jesus: one is bringing flowers, another has caught a bird which he attempts to hold in a very rough way, yet another is fetching water in a shell, and a little one has fallen asleep behind a rock. Three somewhat older angels are trying to please the Infant Jesus with a song and the apparent differences of opinion among these heavenly figures bring them down to the level of human bickering. This is an irreverent variation of a theme which at that time was still taken very seriously. Mary, obviously exhausted from the hardships of the flight, trustingly enjoys the shelter which the peaceful clearing offers her at the moment. Joseph, on the other hand, remains mistrustful; his fearful questioning eyes seem to ask for help and information regarding possible dangers, and the fact that he has kept his hat and staff shows he is ready to continue the flight at any time. But his caution seems unnecessary, for a deep magical peace pervades the scene: the tall weatherbeaten fir-tree conveys a feeling of security, the extensive view is felicitously reassuring, and the carefree bustle of the angels promises the Holy Family every protection.

Left: Lucas Cranach the Younger (1515—1586): The Fountain of Youth, 1546

Page 82: Albrecht Dürer (1471—1528): Self-Portrait, 1498

Page 83: Albrecht Dürer (1471—1528): Madonna with the Pear, 1512

The subject of fear is one of those characteristically German themes which can be found in German paintings and sculptures from early Ottonian miniatures to the present. The fear of demons, of the unpredictable forces of nature, had taken such deep root in primitive countries, frequently overwhelmed by natural disasters of all kinds, that at least during the Middle Ages even Christianity could not eradicate this constant dread. On the contrary, the church skilfully re-interpreted the fear of demons and other mythical ideas in a Christian way and thereby fused pagan superstitions with the Christian faith. The celebration of Christmas at the time of the pagan festival of solstice is only one of many examples.

This pagan fear of demons frequently manifested itself in German medieval art. The stone-carved animals, the frightening, fantastic figures on Romanesque structures, were not inspired by the Gospels, but taken from pagan myths, and their purpose was to exorcize the demons, literally locking them in stone. Gothic paintings and sculptures show less preoccupation with pagan themes; as a result of the simultaneous advance of religion and civilization north of the Alps people felt more secure. But although the sensitive and poetic late medieval representations of the Virgin and saints ignored the existence of demons, they continued to exist in people's subconscious. At the beginning of modern times a confrontation with the realities of this world woke people from the dream of a higher existence that their faith and civilization had promised them. This search for the new realities produced an increased awareness of man's impotence in the face of supernatural forces at a time when the chains of the collective bondage of religion and serfdom were being rejected. While in Renaissance Italy this striving towards freedom led to a greater self-confidence and a new awareness, the Germans feared the chaos that might lurk behind this glittering façade.

The subject of fear is only hinted at in Cranach's Rest on the Flight to Egypt, but it becomes a terrifying reality in Hans Baldung Grien's Death and the Maiden (see p. 80). A young girl of sensual beauty and grace is grabbed by a horrible skeleton to be pulled into the abyss. The movement of the bodies and the pointing hand direct the eye towards the grave and express in graphic terms what the inscription reads 'Hie must Du yn' ('here must thou enter'). The greenish shadow covering the blooming body and the tears disfiguring the girl's face indicate the inevitability of her fate. The new interest in anatomy, which stimulated Italian painters to portray beautiful nudes, led German artists to a pessimistic *memento mori*. Certainly for many who dealt with such sombre themes, this was merely a pretext to paint the human body in all its sensual beauty, without running the risk of being accused of impropriety. Hans Baldung Grien was anything but a morose moralist. Self-confident and flexible, interested in all formal problems and yet not creating them himself, gifted and full of ideas, he ab-

sorbed the new developments of his time without completely divorcing himself from tradition. His choice of subjects was as unlimited as that of Lucas Cranach, and with the latter he shared an interest in the female nude. But Baldung Grien was a diligent pupil of Albrecht Dürer and therefore, unlike Cranach, aimed at an anatomically correct portrayal of the human body, without adopting Dürer's slightly pedantic realism. Baldung Grien also achieved greatness in the field of graphic art. His works include many interpretations of The Dance of Death and The Witches' Sabbath; this preference for demonic themes was again inspired by an interest in portraying the human body in all its movements and contortions.

Visions of a tortured and torn world, which are so contrary to the image created by the Renaissance, frequently appear in the works of Grünewald, who for that reason has been called 'the last medieval mystic'. A preoccupation with suffering is characteristic of his work: among twenty-two authenticated paintings there are no less than six Crucifixions, two Lamentations of Christ, and one Mocking of Christ. Fear, darkness, destruction and desolation were the main themes of his pictures, even if the subject matter required a more positive interpretation, as for instance the portrayals of the Annunciation, Nativity and Resurrection on the inside panels of the Isenheim Altar; these are painted in violent colours permeated by a visionary light which is more frightening than pleasing. The Isenheim Altar, Grünewald's major work, was created between 1512 and 1515 for the Monastery of St. Anthony at Isenheim, which was directed at that time by Guido Guersi, a highly cultivated Italian. The monastery attracted many famous artists; Martin Schongauer, for example, had painted a picture for the high altar in 1470.

Grünewald created a folding altar-piece, consisting of a pair of fixed wings and a double pair of folding wings, thus enabling the showing of appropriate scenes on different liturgical occasions. When both pairs of folding wings are closed the centre panel represents the Crucifixion, and the fixed wings to either side portray St. Sebastian and St. Anthony. Opening the first pair of folding wings reveals the Nativity on the centre panel, flanked by representations of the Annunciation and the Resurrection on the outer panels. When the altar-piece is opened for the last transformation the carved shrine becomes visible in the centre and to either side the now exposed inner surfaces of the second pair of folding wings show St. Anthony's Temptation and St. Anthony's Discourse with St. Paul. St. Anthony's Temptation (see p. 79) is depicted by Grünewald as an infernal procession of demonic figures who beset the saint, a fantastic bestiary of murderous, gruesome fiends and spawns of hell, personifications of forces of nature taken over from pagan times.

The medieval legacy and the pioneer spirit of modern times reached their most perfect synthesis in the works of Albrecht Dürer. The characteristic

features of medieval German painters—their gift for idyllic description, their religious fervour combined with keen observations of everyday life, and their ability to permeate worldly themes with subtle moral undertones—are all present in Dürer's work, but he transcends their provincial limitations and achieves new greatness. His constant, diligent search for new experiences and his complete impartiality in confronting them, make the Nuremberg master unique in his time. At the age of nineteen Dürer left the workshop of his teacher, Michael Wolgemut, and went to Basle, the centre of the Humanist movement, where he made a name for himself as a woodcutter. Four years later he travelled to Venice. The colourfulness of the Venetians and the linear composition of Florentine paintings greatly impressed the young artist, but after returning to Nuremberg he subjected his Italian experiences to close scrutiny before accepting them and incorporating them into his own paintings. His studies of nudes, although inspired by the Italians, were carried out in a much more scientific way and his famous *Treatise on Human Proportions* excels Italian works of artistic theory in clarity and logic. By taking countless measurements of the naked body he hoped to find a mathematical formula for it, and his absolute certainty in the interpretation of the human figure and its movements is the result of these endeavours.

Dürer's numerous drawings and watercolours demonstrate the extent to which his artistic progress was furthered by constant, detailed examinations of his surroundings and by close observations of nature in particular. At the age of eighteen he painted The Wire Drawing Mill (see p. 93), a scene just outside the gates of his home town, a picturesque setting on the river amidst green meadows and gentle hills. The mill does not exist any more, but due to Dürer's precision it has been possible to determine its exact location. In the upper left-hand corner stands the 'Spitteler Tor', the western gate of Nuremberg; the church in the centre is St. Leonhard and from there the meadows, known as 'Hallerwiesen', descend to the river as they do to this day. The dull overcast sky produces a solemn light, which subdues the colours and avoids exaggerated effects of light and shade while at the same time providing good visibility. Despite certain inaccuracies of perspective as far as the framework house, the footbridge and the little wall to the left are concerned, the picture conveys the vivid impression of a personal experience, a description of nature based on precise observation without idealistic intentions.

The directness of Dürer's observations, so effective in the realistic portrayal of landscape, led to further, more detailed discoveries and to the ultimate perfection of Renaissance realism with his Great Piece of Turf (see p. 96). A tiny part of nature, detached from the earth as if by accident, becomes a work of art. The thicket-like impenetrability of the natural wilderness in the lower half is slowly transformed until every blade and

Albrecht Dürer
(1471—1528):
Jacob Fugger.
Woodcut

IACOBVS·FVGGER·CIVIS·AVGVSTÆ

leaf stands out in harmonious order from the luminous background. Insignificant details become enlarged and the wonder of nature in its primitive variety is experienced intellectually as well as emotionally.

Dürer displayed a much closer relationship to nature in his drawings and watercolours than in his paintings, not only because he considered silver-point or brush and watercolours as better media for the reproduction of spontaneous impressions than oil paint, but because at that time paintings were expected to convey something beyond mere description. Therefore the Self-Portrait (see p. 82) painted in 1498 must not be regarded as a faithful likeness but as an attempt to present himself in as favourable a light as possible. The carefully rendered modish details of the distinguished costume indicate his taste and style of life, his critical, slightly arrogant expression denotes self-confidence and inner nobility, and the very conspicuously placed signature, the well-known Dürer monogram, confirms that he no longer thought of himself as an anonymous artisan; an explanatory note above the signature reads 'I made this after my likeness, I was six and twenty years old'. He adopted the use of landscape to create an impression of width from the Italians; the South Tyrolean landscape itself is an allusion to his first journey to Italy.

At the age of forty, when Dürer stood at the height of his fame, he returned to the conventional theme of Madonna and Child. This could be interpreted as a sign of conservatism in the mature artist, but in fact his Madonnas—there are altogether seven paintings which were created at quite different times—were a way of testing new artistic experiences on a well-known subject. His portrayal of the Madonna for The Feast of the Rose Garlands, created in Venice in 1506, shows a regal figure surrounded by saints and angels, whereas in the painting Madonna with the Pear (see p. 83) she is presented simply as a mother, without mystical symbols, but with a supernatural glow achieved by artistic means alone. A limited use of colour preserves the intimacy of the narrow picture; the luminous blue effectively accentuates the subdued warm skintones and the golden yellow of the head-dress. An enlivening effect is achieved by the contrast between the Madonna's reserved expression and posture and the Child's robust, unrestrained vitality. This vitality is further accentuated by the strong modelling of the Child's body, which is thereby brought to the forefront of the picture. The Son of God has become man.

One of the great achievements of the Renaissance was the discovery of man as an individual, which was given expression in contemporary portrait paintings. Like most Renaissance ideas the art of portrait painting had its origins in Italy but was later brilliantly mastered by Hans Holbein the Younger. Although born and raised in Germany, Holbein the artist belonged to Europe, the Europe of the Renaissance and of Humanism, the

Der Krämer.

Hans Holbein the Younger
(1497—1543): The Pedlar.
Woodcut from The Dance of Death

Europe that produced Erasmus of Rotterdam, Francis I of France, Sir Thomas More, Henry VIII and Melanchthon. Holbein was a German by origin, but his development needed more scope and greater freedom of movement than were offered by the provincial narrowness of his native country. He therefore undertook frequent long journeys to northern Italy and France and sought the friendship of the great Humanists in Basle, Rotterdam and London. Even after entering the services of Henry VIII he insisted on maintaining personal contact with other European cultural centres.

One of Holbein's most salient characteristics was his open attitude toward the world around him, which during his lifetime often brought him the reproach that he was unstable. He certainly was less settled than other German artists, such as Dürer, but was not prepared to tie himself down. It was held very much against him, for instance, that despite the promise of an important commission, he returned to England and refused to grant the Basle councillors their urgent request that he should settle in his home town. But a man who had come into close contact with so many intellectual and political influences in Europe necessarily outgrew any form of middle-class thinking, and Holbein's artistic achievements are proof of this. What fascinated him the most were the men and women of his time, whom he portrayed with great diligence: self-confident princes, scholars und philosophers, men of the world and wealthy merchants, fashionable ladies, and women in the intimate circle of their families. He always painted them from the safe distance of a keen observer, completely concentrating on his subject and denying himself any personal involvement. As a result of this modest attitude towards his models Holbein was able to create pictures of immense documentary value; his paintings speak for themselves. He painted three portraits of a scholar whose advice and judgement were sought by eminent statesmen and church dignitaries: Erasmus of Rotterdam (see p. 81). Although Holbein usually preferred to present his subjects full face, he shows Erasmus in profile which, no doubt, was intended to demonstrate his intellectual independence. One who is to be portrayed full face necessarily reveals himself, he must pose in some way or other in order to show himself in a favourable light, whereas presentation in profile permits the model to ignore the artist. In Holbein's portrait of Erasmus this turning away does not seem arrogant but is explained by the scholar's intense intellectual concentration, which is conveyed by the taut facial expression and the writing hand. His sharp features denote a critical mind, his hands sensitivity and indecision, the characteristics of a carefully deliberating scholar. His attire of simple style and costly cloth indicates a feeling for the beauty of simplicity and good taste, while the three rings on his finger reveal that even the great Erasmus was not free from vanity. Holbein's splendid characterization is borne out by historical accounts, which tell of Erasmus

openly opposing the papacy and yet refusing to give Luther his requested support, because the reformer's religious radicalism and intolerance were too much in conflict with Erasmus's own Humanist ideals of moderation and compromise.

The growing fanaticism of the Protestants was to be one of the main reasons for the sudden decline of German painting. When Erasmus wrote to Holbein in 1526 that the reformed Basle was no longer favourable to the arts, he was referring to the Protestant aversion to pictures in general. The Protestants barred religious themes from painting. Therefore the Church to a large extent ceased to commission works of art, and even rich princes and merchants withdrew their patronage after the Peasant Wars and tightened their purse-strings so as not to arouse the fury of the impecunious. The visual arts were largely deprived not only of their ideological but also of their economic basis. Holbein's decision to settle in England must be seen in the light of these developments.

Thus two trends became apparent in the second half of the sixteenth century which occasionally were followed by one and the same artist, sometimes even simultaneously if the need arose: a strongly moralizing, somewhat morose style of painting, which was intended as a concession to the Protestant aims of spiritual reformation, and a court art which was orientated towards the Italian Renaissance and expressed the rulers' ever increasing desire for pleasure. Both trends are characterized by a superficiality which stands in complete contrast to the seriousness of painting in Dürer's time.

Lucas Cranach the Younger, son of the Elder Cranach, was one of the principal representatives of this period, which to some extent constitutes a parallel development to Italian Mannerism. Apart from his moralizing, allegorical works, such as Caritas and Allegory on the Creed, and some excellent portraits, he created several humorously gay genre pictures, of which The Fountain of Youth (see p. 84) is one of the most entertaining. Old sick women are brought on wagons, in wheelbarrows and on stretchers to a rejuvenating bath from which they emerge with new beauty on the other side. The old peasants, tired of their loathsome wives, obviously

Right: Albrecht Dürer (1471—1528): The Wire Drawing Mill, 1489. Watercolour and gouache

Page 94: Albrecht Altdorfer (about 1480—1538): St. Christopher, 1510. Pen drawing in black with white highlighting, on green tinted paper

Page 95: Hans Holbein the Younger (1497—1543): Charles De Saulier, Sieur De Morette, 1534/1535. Black and coloured chalk, Indian ink applied with pen and brush on pale pink tinted paper

Albrecht Dürer (1471—1528): Great Piece of Turf. Watercolour and gouache

expect no other reward for their troubles than to be rid of the old women at last. After their metamorphosis the young ladies are received by cavaliers who hurry them away to be clad in beautiful gowns and join in a gay life of dancing, drinking and merry-making.

A specialized field in which the German masters of the fifteenth and sixteenth centuries excelled was the graphic arts. Many painters of that time achieved greatness in this field and frequently the importance of their drawings and engravings surpassed that of their paintings. Thus Dürer's watercolours (see p. 93 and p. 96) should not be regarded as mere studies for paintings in oil; they are works of art in their own right. The same applies to Altdorfer's representation of St. Christopher (see p. 94). Purely graphic means, the clear stroke of the pen and white highlighting, are employed to elucidate the legend. The titanic nature of the saint rises in a dramatic movement of the interplay of lines against a miniature-like landscape which takes no part in the figurative scene. The white highlighting is accentuated by the green tinted coating of the paper and gives the group a ghost-like plasticity which is emphasized by the flat, static background of vertical and horizontal lines. The legend of St. Christopher, who is nearly brought to his knees by the burden of his vocation as the bearer of Christ, is transformed into a visual experience.

The importance of engravings increased during Dürer's time. The oldest graphic technique, the woodcut, was at first merely intended for the reproduction of pictorial ideas. After the invention of the printing press the woodcut took the place of the painted miniature and consequently gained in artistic importance. Engravings also required less time and material than paintings, so that the artist could afford to carry out formal experiments without having to consider the taste of a patron. Because it was able to be reproduced so easily, the new artform spread rapidly.

Thus the influence of the graphic arts increased and began to set the style for other artistic developments. This explains its tremendous importance in Germany and its complete independence from painting. The young Dürer started his artistic career as a woodcutter in Basle, where he was entrusted with book illustrations. He considered this a completely valid medium for expression and frequently returned to it later (see Jacob Fugger, p. 89). His woodcut series (Apocalypse, Great Passion, Life of the Virgin, and Little Passion) belong to his major graphic works, which contributed as much to his fame as did his painted pictures. Other masters of this time, Cranach, Altdorfer, Grünewald, Baldung Grien and Holbein (see p. 90), also left extensive collections of engravings. Prints were much sought after, even by art connoisseurs outside Germany, and the high reputation of German artists in France, Italy and the Netherlands was to a considerable extent due to the artistic quality and excellent craftsmanship of German engravings.

THE BAROQUE AND ROCOCO

With the death of Holbein in 1543, one of the most glorious periods of German art came to an end. It was followed by a period of artistic vacuum which, because of the religious conflicts of the Reformation and the resulting chaos of national disunity, lasted for two hundred years. Of all European nations the Germans were most affected by these unfortunate religious quarrels, because their country was divided between Protestantism in the north and Catholicism in the south. At the Council of Augsburg (1555) an armistice was negotiated, but the terms on which it was based contained the seeds of new conflicts and these eventually led to the Thirty Years War (1618—1648). *Cuijus regio, ejus religio* was the theme of the day: in other words, people were expected to take the creed of whomever happened to be their ruler. This unstable situation, the lack of political continuity and the absence of a common ideology created a wholly unfavourable climate for the development of new artistic ideas. Consequently the beginnings of Baroque must be traced to Italy. There the Church did not split into two hostile camps but came under the firm spiritual rule of the Jesuits, the leaders of the Counter-Reformation, whose activities were not directed against the pope, but against the scandalous life some of the popes led, and the worldly spirit of the Renaissance church in general. As the major initiators of the Counter-Reformation the Jesuits had a decisive influence on the intellectual, political and cultural development of the West.

Stringent measures were introduced by the Jesuits that seemed like a return to the Middle Ages: a revival of the Inquisition, censorship of printing, and constraint on the arts and sciences. However, after the first fifty years the Counter-Reformation lost its initial severity and a new spirit, in no way reactionary or restorative, asserted itself, which found expression in the Baroque. Unlike the transcendental approach of the Middle Ages or the intellectual approach of the Renaissance, the Baroque transformed religion into an emotional experience. Through architecture, sculpture, painting and music it appealed to the emotions and attempted to convey a feeling of the supernatural. In dream-like visions that surpassed any natural worldly beauty the artists expressed their concept of the almighty power of God. Devout piety combined with an emphasis on the emotions became a characteristic feature of the Baroque.

The exuberance of Baroque churches celebrated the victory of the established religion over dissenters; the unlimited splendour of Baroque palaces paid homage to totalitarian power. Absolute monarchs competed with the triumphant Church in spectacular displays of luxury, and secular art reached a position of equal importance to that of sacred art. Both secular and sacred Baroque developed more rapidly in Italy and Spain where the authorities encountered least opposition, and later also in France where, under Louis XIV, Absolutism flourished in its purest form.

In Germany only the Catholic south was affected by the Counter-Reformation and it was not until the beginning of the eighteenth century that the Baroque began to take root north of the Alps. In the second half of the sixteenth century, St. Michael, the Jesuit church in Munich (see p. 102), became the first German sacred structure that showed some essentially Baroque stylistic elements. The architect, Sustris, who originated from the Netherlands and was trained in Italy, modelled it in many respects on Il Gesu, the Jesuit church in Rome. St. Michael has a tunnel-vaulted nave without aisles that continues uninterrupted through the transept into a narrower chancel and gives the structure a strong sense of direction. A dynamic spatial impression is created by introducing the light through large openings over the side chapels; from there it flows in broad streams into the interior without touching the vault and creates a lively contrast between the mysteriously dark vaulted ceiling and the radiantly illuminated chancel and window arches. Rich stucco and a wealth of sculptural ornamentation articulate the solid architectural forms and give the interior a nearly festive gaiety which cannot be found in the clearly

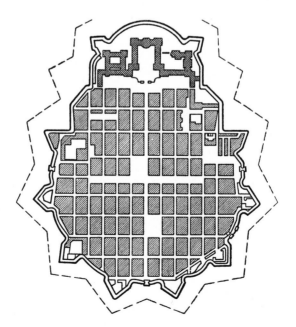

Mannheim,
Baroque Town Plan,
begun 1652.
Palace 1720—1760

structured dignity of Renaissance churches. But despite this dynamic treatment of light and space Sustris had not completely outgrown the Renaissance, as can be seen from the static solidity of the structure and the consistently straight lines of mouldings, transverse arches and wall surfaces. It was the architects of the Late Baroque who resolved this conflict with a dynamic concept that enveloped the whole structure.

St. Michael at Munich was a promising beginning of Baroque architecture in Germany, but there it was to remain for the time being. The Thirty Years War put an end to all artistic endeavours and during the seventeenth century Germany took no part in the development of Baroque. While Bernini, Maderna, Rainaldi and Borromini perfected the new style in Italy, as Jules Hardouin-Mansart did in France and Christopher Wren in England, Germany was immersed in the chaos of the longest war in her history. When after the Westphalian peace treaty political and economic conditions gradually became more stable and artistic pursuits, which had long been neglected, were slowly taken up again, it became apparent that the war had completely isolated Germany artistically. No German craftsmen were available with experience or independent ideas who could tackle new tasks; architects from other countries had to be called in, particularly from Italy. In Munich Agostino Barelli built the Theatinerkirche, Enrico Zuccalli was active in Schleissheim, Gaetano Chiaveri worked in Dresden (see p. 106) and Antonio Petrini in Würzburg. During this period more churches were built by Italian architects in Germany than in Italy. Emperors, princes, and ecclesiastic and civil authorities engaged the best foreign artists and gradually a new generation of German architects was trained by them. At the beginning of the eighteenth century German craftsmanship was once again able to contribute to international artistic developments and German artists soon displayed a wealth and variety of ideas which, in many respects, made the Late Baroque a typically German architectural style.

The Benedictine Abbey at Melk on the Danube (see p. 101) was designed by Jakob Prandtauer, and construction began in 1702. The architect took up an idea that goes back to Late Romanesque and Gothic churches, the two-tower façade, and, by the dynamic rise of twin towers, successfully eliminated the secular aspect of contemporary Italian church façades. Prandtauer further emphasized the upward movement of his design by situating the monastery on the crest of a steep rock at the banks of the Danube; the structure's reflection in the water creates a theatrical effect that is characteristic for the dramatic, all-embracing concepts of the Baroque. Because of the limited space available the monastery buildings flank

Right: Melk, Benedictine Abbey, begun 1702 by Jakob Prandtauer (about 1660—1726)

Munich, Jesuit Church of St. Michael, 1583—1597 by Friedrich Sustris (about 1540—1599)

Vienna, Belvedere, 1714—1723 by Johann Lukas von Hildebrandt (1668—1745)

Würzburg, Prince Bishop's Palace, 1719—1744 by Johann Balthasar Neumann (1687—1753).
Garden façade

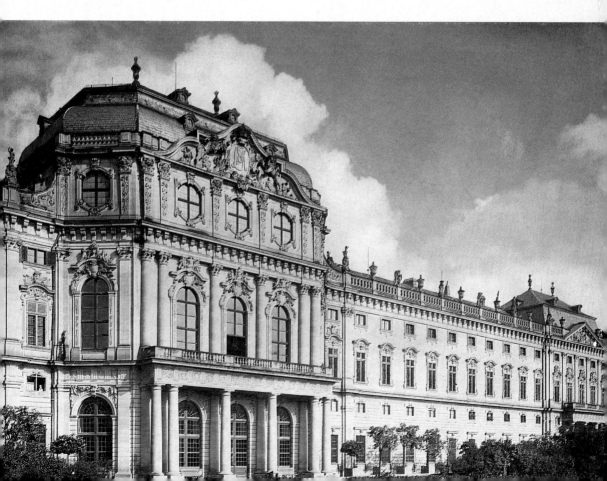

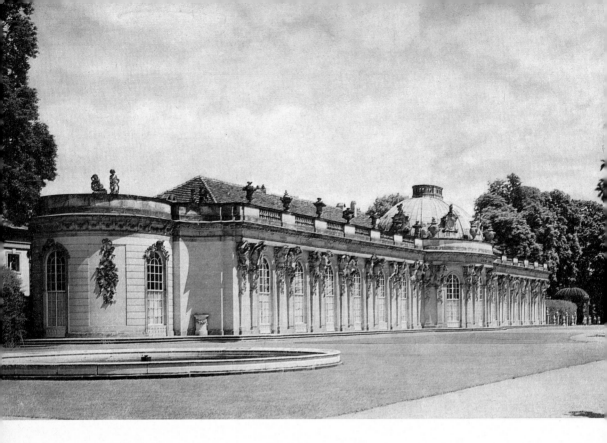

Potsdam, Sanssouci Palace, 1745—1747 by Georg Wenzeslaus von Knobelsdorff (1699—1753)

Munich, Nymphenburg Palace, built and enlarged 1663—1728. Garden façade

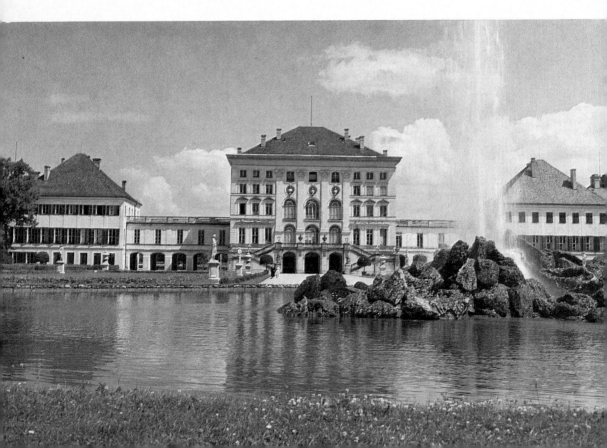

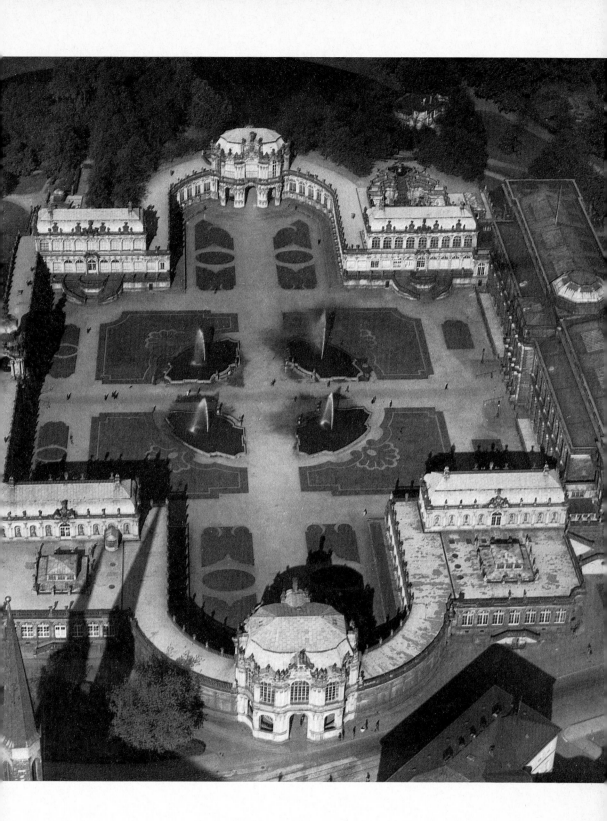

Dresden, Zwinger, 1711—1722 by Matthäus Daniel Pöppelmann (1662—1736)

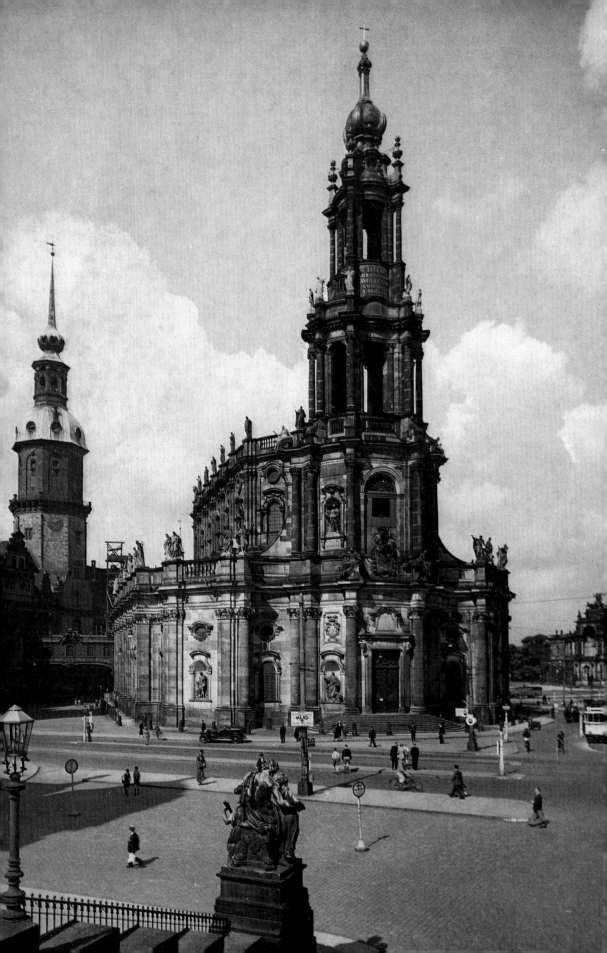

Vierzehnheiligen, Pilgrimage Church, 1743—1772 by Johann Balthasar Neumann (1687—1753)

Left: Dresden, Hofkirche, 1738—1755 by Gaetano Chiaveri (1689—1770)

the church to both sides and stretch behind it to the east. Large regular windows articulate the wall surfaces and partly eliminate the monumental impression created by the structure's imposing position. This nearly paradoxical interplay of grace and solidity, of weightlessness and mass, of compact walls and transparent glittering windows, indicates that Baroque monasticism in Germany delighted in the things of this world in a way quite foreign to Latin countries.

Balthasar Neumann's Pilgrimage Church in Vierzehnheiligen near Bamberg (see p. 107 and p. 111) also has a massive two-tower façade, which is enriched by a variety of windows and a convex central section. In spite of this essentially plain exterior, the interior is most gracefully composed of elaborately intertwined ovals and circles. The ground-plan (see p. 111) shows an oval chancel, circular transepts, and a nave consisting of two consecutive ovals, one the size of the chancel oval, the other considerably larger, which are linked by two smaller ones; these manifold interpenetrations of ovals and circles make the interior comparable to a Bach fugue. The large central oval is enclosed by columns and surmounted by a shallow dome and in its centre, as the dominating focal point of the church, stands the altar of the fourteen saints. Although the old basilican plan of nave, aisles, transept and chancel is recognizable on the ground-plan, the vaulting of the interior links individual units so closely that separate spatial elements are hardly recognizable. Variety has become unity and the ideal of an absolutely homogenous structure is achieved to perfection, at the same time presenting a wealth of surprising movement.

Vienna, Karlskirche,
begun 1716 by Johann Bernhard
Fischer von Erlach (1656—1723)

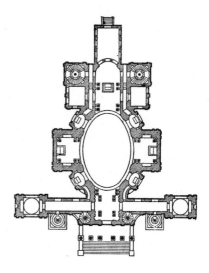

Left: Die Wies, Pilgrimage Church, 1746—1754 by Dominikus Zimmermann (1685—1766)

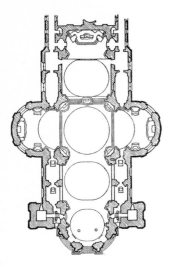 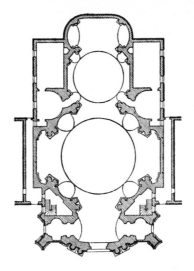 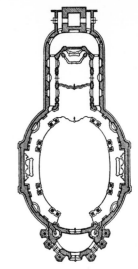

Ottobeuren, Benedictine Abbey, 1737—1766 by Johann Michael Fischer (1692—1766). Ground-plan

Berg-am-Laim, St. Michael, 1738—1742 by Johann Michael Fischer (1692—1766). Ground-plan

Die Wies, Pilgrimage Church, 1746—1754 by Dominikus Zimmermann (1685—1766). Ground-plan

The oval ground-plan, one of the most original inventions of Baroque architecture, resolved the old conflict between central construction and the longitudinal plan which had dominated sacred architecture since Early Christian times. St. Peter's in Rome underwent many changes during its construction because no decision could be reached whether preference should be given to the central plan proposed by Bramante and Michelangelo, or the more conventional longitudinal plan. The oval has the same formal infinity as the circle, but its two focal points give a sense of direction similar to that of the rectangle; it gracefully combines the central and the longitudinal plans and creates a new harmonious unit.

The designs by the South German architect Johann Michael Fischer illustrate two ways of fusing the central and the longitudinal plans. The ground-plan of the Benedictine Abbey at Ottobeuren (see p. 110) shows the centralization of a longitudinal plan, which was effected by transferring the domed crossing of nave and transept to the centre of the structure. The ground-plan of St. Michael at Munich/Berg-am-Laim (see p. 110), on the other hand, demonstrates how Fischer established the longitudinal element of a basically central structure by adding a smaller circle to the east of the domed circular central space. Dominikus Zimmermann went a step further and gave the Pilgrimage Church Die Wies (see p. 108 and p. 110) the shape of an oval which he extended by a longitudinally pronounced chancel in order to compensate for the emphasis of the central plan.

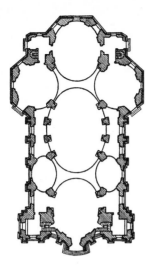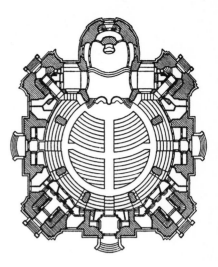

Vierzehnheiligen, Pilgrimage Church,
1743—1772 by Johann Balthasar
Neumann (1687—1753).
Ground-plan

Dresden, Frauenkirche,
1726—1738 by Georg Baehr
(1666—1738).
Ground-plan

The exterior and the ground-plan of Baroque churches indicate a desire
for unity which is repeated and becomes more pronounced in the design
and ornamentation of their interior. Early Baroque churches such as St. Mi-
chael in Munich (see p. 102) retained a basic sobriety, but their interior
suggested future developments: pictorial and sculptural ornamentations
articulate the walls and the addition of light provides a lively motion. The
Pilgrimage Church Die Wies (see p. 108 and p. 110) illustrates the extent
to which church interiors were transformed by these developments. The
walls are replaced by thin pillars and the light streams in from unsuspected
and often unrecognizable sources: it surrounds the solid shapes, makes the
gold sparkle on altars and pulpits, sweeps through the assembly of floating
angels and saints and, between sunrise and sunset, drives the shadows from
one corner of the church to the other. The stuccos and sculptures are as
unbridled and unpredictable as the light. Rich bouquets and ornaments
simulate capitals and every arch has a festive frame. But the stucco comes
fully into play only on the vaulting. As if all laws of gravity have been
overcome, shells, fruits, flowers and vines blot out the transition between
wall and ceiling and this fascinating display is crowned by ceiling frescoes.
The heavens have opened and, irradiated by a supernatural light, angels
and saints float into the church. Even the critical eye can hardly detect the
transition from painted to sculptured ornament and from that to pure
architecture. The altar seems to float down from the lofty heights of the 111

ceiling and intercedes between life on earth and the supernatural spectacle of heaven. In such a church the faithful are not humbled as in medieval sacred structures; they become part of the pageant. Those in the gallery join the angels and saints floating above, while those down below provide a living counterpart to the paintings and sculptures around them. The believer is transported in ecstasy, forgets himself, his daily life and the world around him and experiences the unlimited splendour and omnipotence of the supernatural.

This grandiose, theatrical effect of Late Baroque sacred structures was not achieved by purely architectural means; sculpture and painting also played their part. Architecture, sculpture and painting were considered independent artforms during the Renaissance, but the Baroque believed in the unification of all art. Sculpture and painting, therefore, became integral parts of an artistic creation and as such had a predominantly decorative role. This was by no means limiting; the illusory and dynamic effects aimed at by architects could only be created with the aid of highly imaginative decorations and ornaments. The perfect unity of Baroque interiors was achieved by the continuous flow from wall to wall, from the painted ceiling via flat relief and stucco to the sculpture. It is not surprising that in those days artists frequently combined several skills. One of the most important of these versatile craftsmen was Egid Quirin Asam, who created the sculpture Assumption of the Virgin (see p. 119) for the Abbey Church at Rohr in Bavaria. Rising above the figures of the twelve apostles, the Virgin, supported by angels, floats in midspace against a background of richly modelled drapes. She moves towards a transcendental world, completely disengaged from the ground where the apostles, dazzled by this miracle, are left behind. The figure of the Virgin seems to be intangible, a supernatural apparition beyond rational contemplation. A critical observer could well admire the perfect craftsmanship, but this sculpture is more than an individual work of art; it must be seen as an integral part of its surroundings, which are divested of their worldliness by the compelling vitality and beauty of this heavenly vision.

In the Abbey Church at Weltenburg in Bavaria, which was built by Cosmas Damian Asam and decorated with stucco and sculptures by Egid Quirin Asam, the interaction of architecture, sculpture and light produces very striking effects. The nave is lit relatively sparingly and the altar, backed by a massive reredos, is left in mystical semi-darkness, which is contrasted by a brilliant flow of light that pours into the space behind the

Right: Brühl, Schloss Augustusburg. Staircase, 1743—1748 by Johann Balthasar Neumann (1687—1753)

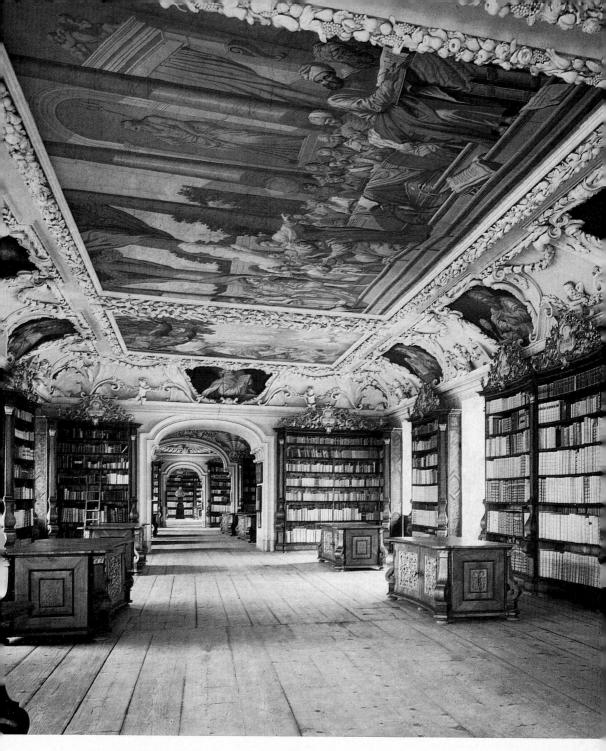

Kremsmünster Abbey. Library, built by Jakob Prandtauer (about 1660—1726)

Left: Potsdam, Sanssouci Palace. Music Room, 1745—1747

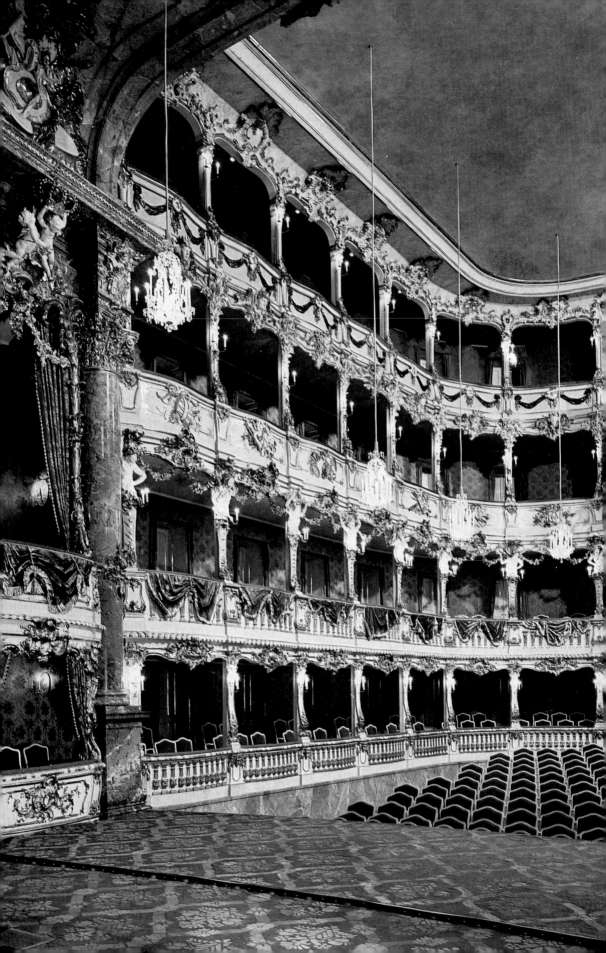

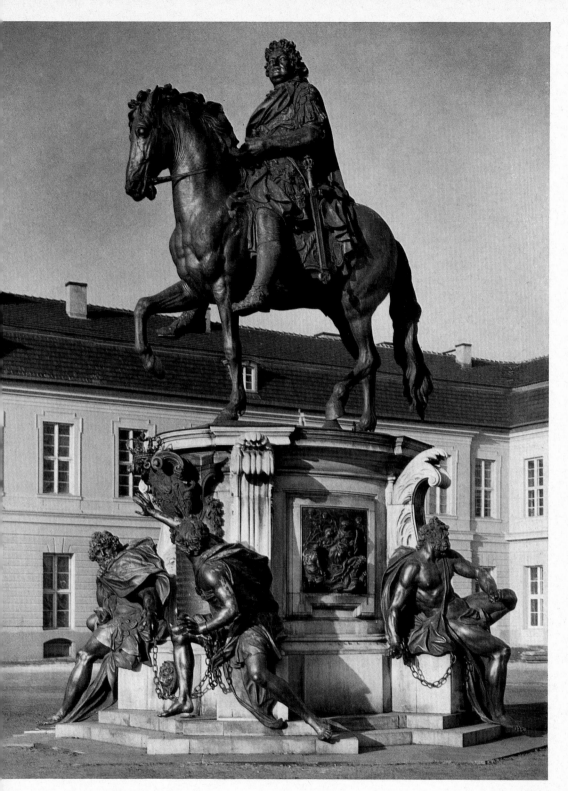

Andreas Schlüter (1664—1714): Frederick William, Great Elector of Brandenburg. Berlin, forecourt of Charlottenburg Palace

Left: Munich, Residenztheater, 1750—1753 by François Cuvilliés (1695—1768)

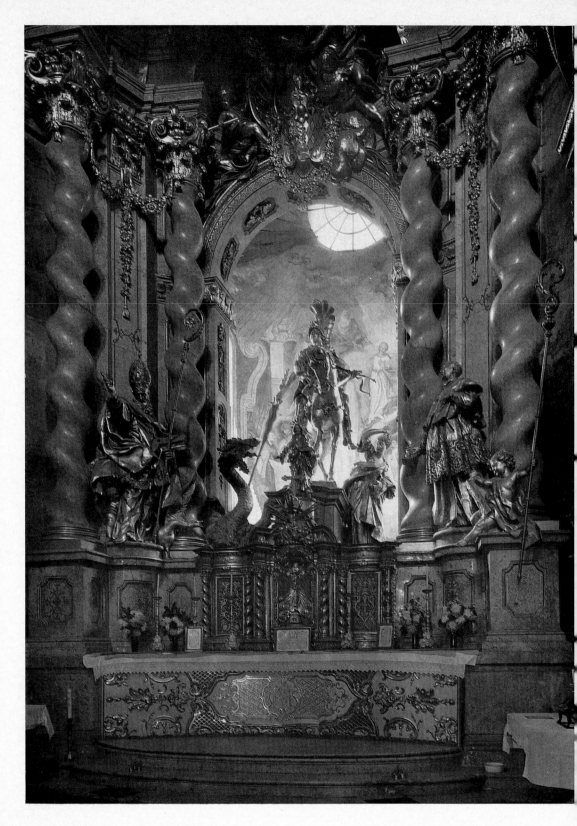

Weltenburg, Benedictine Abbey. High altar with statue of St. George by Egid Quirin Asam (1692—1750). Church built 1718—1721 by Cosmas Damian Asam (1686—1739)

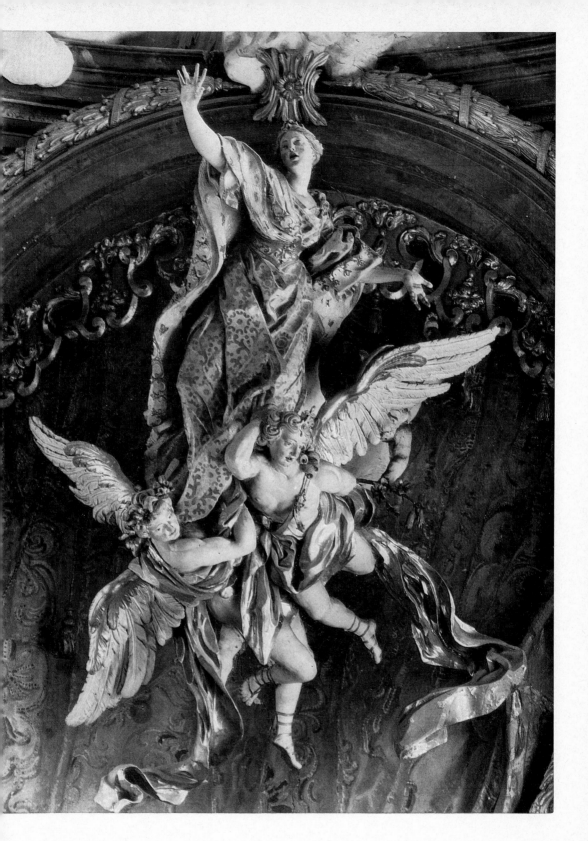

Egid Quirin Asam (1692—1750): Assumption of the Virgin. Rohr, Abbey Church. Detail from the high altar

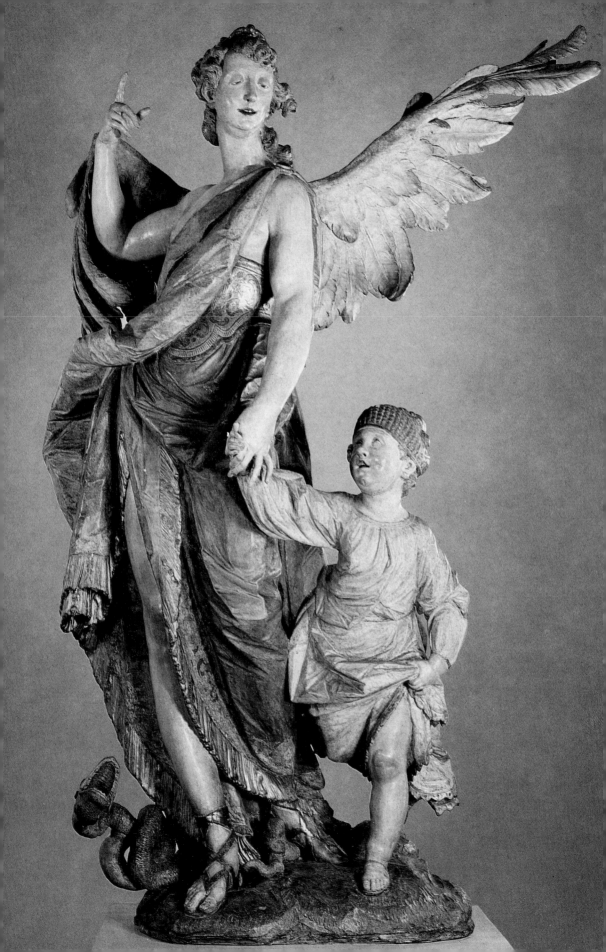

altar from enormous, skilfully concealed windows. Against this background of dazzling brightness stands a silver St. George on horseback wielding a flame-shaped sword (see p. 118). This equestrian figure, surrounded by divine radiance, appears as a supernatural vision on the stage of the altar. The religious theme of the saint bringing help and light to a world that remains in darkness is presented as a theatrical spectacle (see also Ignaz Günther's Guardian Angel in the Bürgersaal, Munich, p. 120).

Painting, too, was needed to transform the rational clarity of the structure into an irrational experience of spatial visions. The painted ceilings of Baroque churches open up an imaginary world of allegorical and celestial figures which in bold foreshortenings seem to rise steeply upwards or to tumble down on the viewer (see the Ottobeuren vault frescoes, p. 125). The real architecture is continued in a painted architecture of ingenious perspective, thereby fusing reality and illusion and achieving a spatial effect of endless width and height. Heaven and earth, our world and the world of saints and angels, cease to be contrasts; they are artistically combined in order to create a spectacle that can be experienced through the emotions. During the Baroque the fine arts were closely related to the Church, as during the Middle Ages, but now religion was meant to appeal to man's mind, soul and emotions.

The rise of Absolutism gave new significance to civil architecture and the importance of palaces equalled that of sacred structures during the Baroque. The ruler 'by divine right' was not merely honoured as the highest representative of the state, he personified the state. An absolute monarch saw his empire as the worldly image of the heavenly empire; the hierarchy of the court and of the aristocracy were analogous to the hierarchy of the Church. Civil structures, therefore, began to equal and even surpass sacred structures in splendour and dimension. A church was, after all, merely a link between heaven and earth, whereas a palace, the seat of the highest worldly power, had to be worthy of the anointed monarch.

The more powerful the monarch, the more splendid his palace. Baroque Absolutism culminated in the person of King Louis XIV of France, and his residence at Versailles represented the ultimate perfection of Baroque civil architecture. The Sun King's style of life was copied by every European prince and monarch from Madrid to St. Petersburg and their residences were modelled on the palace at Versailles. But whereas in France absolute power was concentrated in one person and therefore the strength of the nation invested in one structure, 350 major and minor German princes

Left: Ignaz Günther (1725—1775): Guardian Angel. Munich, Bürgersaal, about 1770

produced an unlimited variety of palaces without one of them approaching the dimensions of Versailles. One of them was the Great Elector of Brandenburg. A statue of this important figure was built by Andreas Schlüter (see p. 117). Andreas Schlüter, active as an architect as well as a sculptor, also designed the major part of the Palace in Berlin.

Before the court of Louis XIV had moved to Versailles in 1682, German palaces began to be built on the outskirts of German capital cities, such as Herrenhausen near Hanover, Nymphenburg near Munich, and Schönbrunn near Vienna.

Baroque palaces modelled on Versailles can easily be distinguished by their façade from Renaissance palaces, which continued to be built during that period. While the Italian *palazzo* was characterized by a severely articulated front which opened towards a modest interior courtyard, the French palace had the shape of a horseshoe that encircled a wide courtyard, the *cour d'honneur* [court of honour]. This *cour d'honneur* provided a place for the reception of guests and at the same time created a distance between the ordinary citizens and the society of the court. The major façade of the palace no longer faced the street, it faced the park at the back, where the king and his court could move about freely, untroubled by the glances of curious subjects.

Seen from the street, the Prince Bishop's Palace at Würzburg (see p. 103), built between 1719 and 1744 by Johann Balthasar Neumann, seems almost modest. The court of honour is formed by two wings that equal the central section in size and ornamentation; the porticoes, surmounted by balconies, create a deceptively intimate and simple impression. Upon entering, however, the full splendour of this impressive structure is revealed. Neumann planned to build two identical staircases, of which only one was completed, but its magnificence suffices to give the entrance hall a festive atmosphere which continues throughout the building. A massive spatial sequence flows through various ante-chambers and culminates in the splendour of the grand state room, where ceiling frescoes by the Venetian Giovanni Battista Tiepolo, who also decorated the staircase, further emphasize the gay intoxication of this architecture.

As far as the exterior is concerned, the palace's real character is shown in its garden façade which gives architectural expression to the idea of Absolutism. Like a crowned head, the central section, enriched by pilasters, cornices, engaged columns and imaginatively curved gables, rises in solemn dignity above the long wings, which are sparingly decorated with delicately shaped gables over the windows of the main storey. The palace at Würzburg is one of the most perfect examples of a Baroque palace in Germany.

The ostentatious king of Saxony and Poland, Augustus the Strong, was one of those who wished to emulate the Sun King, but his ambition to make Dresden into the most splendid capital of Europe was never realized. Only

one of his many projects reached completion during his lifetime, the Zwinger (see p. 105), a combined orangery and grandstand for tournaments and pageants which was intended to form part of a palace stretching across the river Elbe. A square ground-plan is extended on two opposing sides by swinging galleries where large windows open out on a delicate Baroque garden. Two pavillions, situated in the vertex of these galleries, display a wealth of sculptural ornamentation; caryatids, apparently forgetting the burdens they are carrying, chat animatedly with each other while rich fantasy designs of coats of arms, fruits, vases and abstract patterns link portals and windows. This ornamental gaiety continues inside the pavillons; the lower storey consists of a lively confusion of concavities, miniature balustrades and winding stairs which lead to an equally richly decorated small state room on the upper storey. The layout and ornamentation of this irresponsible scheme charmingly express the playful spirit of the Rococo.

The Palace of Nymphenburg (see p. 104), which now lies within the city limits of Munich, was begun in 1663. The Italian Barelli designed it as a cubical structure and modelled his superbly simple façade on that of Italian Renaissance *palazzi*. A clearly delineated central section houses the state rooms, which are accessible by an outside twin staircase, while the living and sleeping quarters are situated on either side. In order to give this rather mansion-like structure the character of a Baroque palace in the French style, two flanking pavillions were added in 1702; somewhat later these were linked with the original structure by arcades. In further imitation of the spirit of Versailles a number of little annexes were erected in the park: the Pagodenburg in 1716, the Badenburg in 1718, and finally the Amalien-burg, which was designed by Cuvilliés in pure Rococo style. Big water-works and fountains contribute to the charming vitality of the layout, which is based on a happy harmony between the architecture and its sur-rounding, carefully planned gardens.

The Palace of Sanssouci at Potsdam (see p. 104) was completed only fifty years after Versailles but it in no way represents a monument to ab-solute power. Frederick the Great himself provided his architect, Georg Wenzeslaus von Knobelsdorff, with sketches for this structure; what he wanted was not a spectacular setting for ceremonious court life in the style of Louis XIV, but a modest residence where he could enjoy the leisurely life of a private individual. In contrast to the self-aggrandizing attitudes of absolute kings, Frederick saw himself as the first servant of the state and regarded his royal position as a hard duty.

Sanssouci is a one-storey building that differs from High Baroque palaces in so far as the central part, in this case a small, round, domed hall, is faced by two lower and open pavillions which, as continuations of the wings, stand independent of the main structure. This principle is characteristic for monarchs of the Age of Enlightenment, who were less dominated by the

123

spirit of Absolutism than by the idea of individual freedom. Not only the modest size of Sanssouci but the whole layout of its interior illustrates this turning away from the outward manifestations of unlimited power. No provisions were made for big public audiences or for a large court society. The palace was designed to accommodate only a few chosen political advisers, friends, artists, philosophers and scholars whom the king wanted to receive. Frederick said about Sanssouci that 'it invites us to enjoy our liberty'. Baroque princes would hardly have admitted, except to themselves, that liberty was something to be enjoyed.

The spirit of the Rococo expressed itself in pastoral idylls and romances as well as in the skilful transformation of natural landscapes into planned gardens and in a preference for smaller, more intimate structures. The names of these, Monrepos, Solitude, Eremitage and Sanssouci, demonstrate the need felt by their owners to withdraw from formal court life in order to enjoy in solitude their elaborately planned gardens. Lukas von Hildebrandt designed a small garden palace for Prince Eugen in Vienna, the Belvedere (see p. 103), which was constructed between 1714 and 1723, prior to the completion of Schönbrunn, the summer residence of the Austrian emperor on the outskirts of Vienna. Although Belvedere does not show the same measure of restraint as Sanssouci, the absence of the court of honour nevertheless indicates a departure from the French concept. A pleasing feeling of movement is achieved by the fusion of several different elements: the single-storey gabled portico leads into the central section, which is flanked on either side by broad imposing wings that convey an impression of self-confident authority without being in any way presumptuous, and two one-storey buildings of different widths lead to four turret-like pavilions which in their monumentality give the structure the character of a fortified castle. A number of ideas are marvellously combined to form a charming unit in which the spirit of the Rococo manifests itself through a lively grouping of contradictory forms.

The Rococo produced no architecture of its own but was expressed mostly in the smaller scale of the structures and the ornamentation of their interiors. Despite its swinging movement Baroque ornamentation was ordered and regulated. It served the enrichment and accentuation of architectural parts and was fused with the architectural framework, consequently it was always symmetrical. Rococo ornamentation, on the other hand, was the imaginative product of an exuberant mood; it developed new forms which were based on the asymmetrical shape of the shell and therefore called *rocaille*. This led to the expression 'Rococo' as a description of

Right: Johann Jakob Zeiller (1708—1783): Vault Frescoes at Ottobeuren Abbey Church, painted 1763—1766

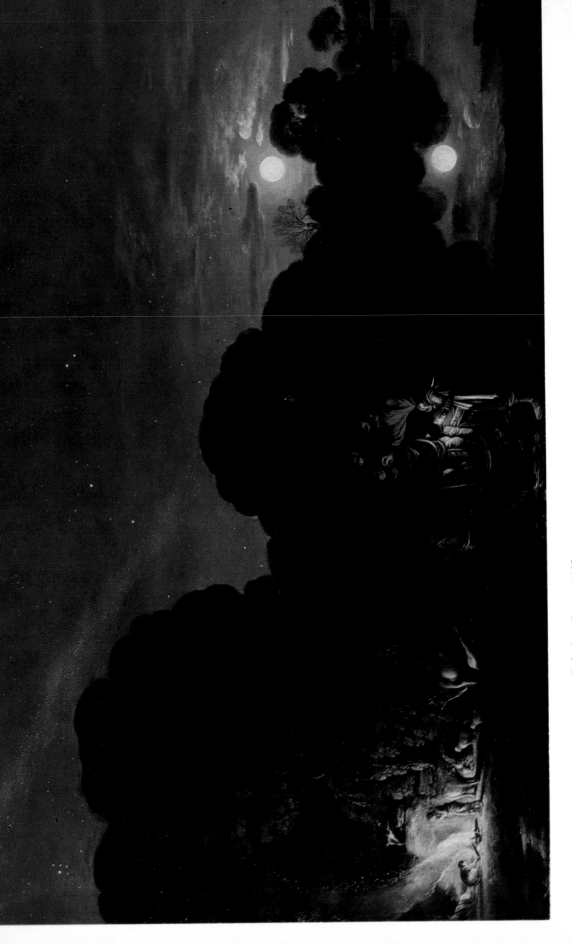

Adam Elsheimer (1578—1610): Flight into Egypt, 1609

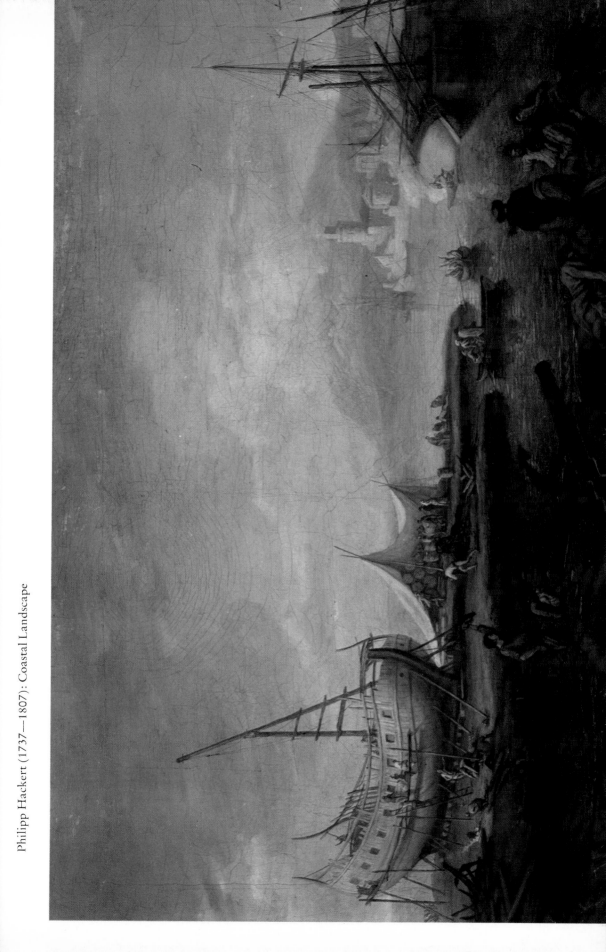

Philipp Hackert (1737—1807): Coastal Landscape

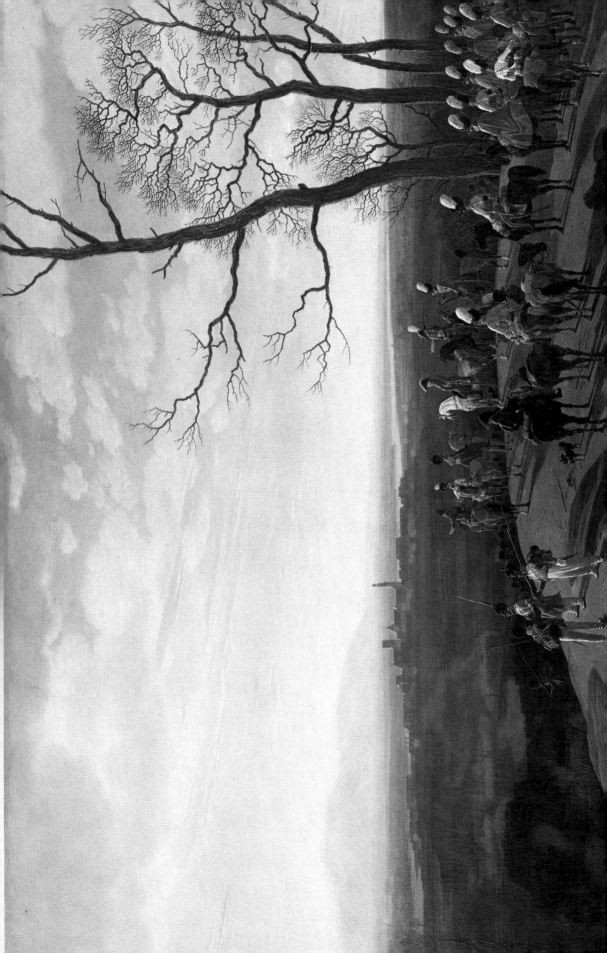

the style which, by its mere sound, expresses the frivolous ease of that epoch.

The music room of Sanssouci Palace at Potsdam (see p. 114) is a principal example of the formative force of the Rococo. The basic concept of the structure is simple and severe, without architectural refinements. The ceilings and walls are mere carriers of decoration which by its inventiveness gives the room a flourishing charm and succeeds in hiding its unassuming character. The ceiling ornaments overhang the walls and join with those surrounding the mirrors; they spread autonomously over the whole room, encircle wall sections and door frames, wind across pictures and mirrors, include furniture and wall brackets, then break off in amusing contortions to take up the game once more in some unexpected place.

The Residenztheater in Munich (see p. 116), one of the few remaining Rococo theatres in Germany, was built by François Cuvilliés. It achieves its festive gaiety only through ornamentation; the solemn balustrades of the boxes in the stalls preserve a certain dignity, but this impression changes in the dress circle where exuberantly untidy, carved wooden drapes overhang the balustrades, and herms, carrying the weight of the second storey, seem to delight in the spectacle around them. This burlesque game ends in the stylish, delicate ornamentation of the upper circle, after reaching a climax in the theatrical decor of the stage box in the dress circle, which has been turned into a theatre within the theatre, where the princely spectators turn into actors.

Similarly, Rococo staircases are grandiose stage sets on which members of the court acted out their lives. Balthasar Neumann's staircase at Schloss Augustusburg in Brühl (see p. 113) is filled with charmingly animated figures which, although placed under the soffits of stairs and ceiling, seem to belong more to the real life on the stairs than to the inanimate structure. By the juxtaposition of columns and caryatids, of architectural and figural supports, Neumann intended to create a close link between the structure and the courtiers, whose colourful costumes added further splendour to this magnificent staircase.

The interior of the library at the monastery of Kremsmünster (see p. 115) presents a delightful mixture of functional details and fatuous architectural ornaments. Purposeful dignity prevails along the plain high bookshelves that line the walls, but towards the top these end in playful openwork carvings, and rich stuccos frame the colourfully painted ceiling which seems to tear open the room as if the stale scholarly air had to be let out. A time of self-mockery had started, life consisted of games and dances, hardships were the subject of derision, entertainment became the purpose of life. This

Left: Wilhelm von Kobell (1766—1853): The Siege of Kosel. 1808

gay dream continued until the French Revolution, in 1789, destroyed it overnight.

In the field of painting Germany played a very minor role during the Baroque. One of the few painters who gained recognition among the international artistic elite was Adam Elsheimer. Although his output was small, his paintings heralded future developments: artists like Rembrandt, Rubens and Claude Lorrain in particular were considerably indebted to him. Unfortunately his work remained totally unknown in Germany and he had no followers there; this was due to the fact that at the age of twenty he left Frankfurt, his home town, to travel via Munich and Venice to Rome where he died at the early age of thirty-two. His limited output and his preference for a small format are further reasons for this lack of general recognition.

The Flight into Egypt (see p. 126) is set in a wide, open landscape, not unlike that of medieval German Biblical representations, but in Elsheimer's picture a new poetic mood links landscape and figures. The night acts as a protective cloak for the fugitives, for whom guidance in the darkness is provided by various sources of light. Even the threatening darkness of the trees loses its danger and instead offers refuge, protection and security. Background and foreground gently merge and the absence of any detailed description as well as the linking medium of light give a high degree of unity to this night scene.

Apart from Elsheimer, Germany did not produce many painters of more than regional importance during the seventeenth and eighteenth centuries with the exception of some artists in the Catholic south. Painters such as Rottmayr, Troger, and Maulbertsch were important representatives of the religious Baroque and successfully competed with the Italians.

The painters of the Protestant north were strongly influenced by the neighbouring Netherlands and frequently developed middle-class characteristics. In Johann Philipp Hackert's Coastal Landscape (see p. 127) objects and figures are depicted with an undramatic matter-of-factness which is effectively contrasted by the softly, delicately painted background. Hackert, like his contemporaries, drew inspiration from a number of different sources. He worked for many years at the court of the king of Naples and as a result became familiar with Italian masters, but his pictures also show an indebtedness to Netherlandish paintings and to Claude Lorrain's landscapes. Anton Raphael Mengs, whom the German scholar Johann Joachim Winckelmann praised as 'the greatest artist of his period and perhaps the following period', was equally receptive to outside influences. While in France the Rococo was still at its height, Mengs rejected the sensuous imagery of the Baroque and tried to emulate the great masters of the Renaissance. Mengs thereby became a forerunner of Classicism.

THE NINETEENTH CENTURY

The varied and often contradictory artistic forms of the nineteenth century and the absence of a general continuous artistic development can be understood only by taking into consideration the political and economic events of that period, which completely changed the social and intellectual structure of Europe. The French Revolution ended the traditional supremacy of kings and princes, but this gain of freedom meant a loss of inner security. With the end of Absolutism new leaders were needed to give intellectual guidance and take political responsibility. Although the motto 'liberty, equality, fraternity' was understood everywhere in Europe, the general political unrest showed that it was easier to formulate an idea convincingly than to carry it out. The revolutionaries had thought that the bourgeoisie would replace the aristocracy as the ruling class, but the transition from subject to self-governing citizen was not an easy one and frequently resulted in a new form of absolute power, exemplified by the rise of the citizen Napoleon to emperor of France.

Even before the French Revolution a change of mood had made itself felt in the arts. Towards the middle of the eighteenth century, when social conventions had become governed by a strictly stylized etiquette, representatives of the *Sturm und Drang* movement vehemently rejected the superficiality of contemporary life. The Age of Enlightenment had relied on the power of the intellect, but this was now being challenged by the 'natural genius'. The stiff, bewigged Rococo cavalier was replaced by the man who wanted to give direct expression to his feelings. This emphasis on the emotions found its ultimate expression in the Romantic movement which, particularly in Germany, dominated literature and the fine arts until well into the second half of the nineteenth century. A balance to this unrestrained emotionalism was provided by a simultaneous Classical revival with its ideals of Classicism.

Johann Joachim Winckelmann, who led the first excavations at Pompeii, published his *History of Ancient Art* in 1763 and thereby helped to initiate the Classical revival. In this work, which was translated into every European language, he compared 'the confusion of forms, the immoderation of expression and the bold fire' of Baroque with the 'noble simplicity and tranquil greatness' of the ancient Greeks, who, he suggested, were the only

models worthy of imitation. He also pointed out the lack of stability and order of the *Sturm und Drang* in comparison with the balanced harmony of Classical art. Goethe was much influenced by the Classical spirit as is evident from the change of emphasis in his work after his first journey to Italy. The Classical and the Romantic spirits constituted two opposing poles between which the arts fluctuated with searching uncertainty.

The reason for this uncertainty was the loss of that solid framework which the monarchical and ecclesiastic hierarchies had provided up to the end of the Rococo. The emerging middle classes, in an attempt to assert themselves, began to take an interest in their national history and in the artistic achievements of the recent past. But while this preoccupation with the ancient Greeks, the Middle Ages and the Renaissance provided a wealth of models, it also created a new dependence and prevented the development of original ideas which could interpret contemporary events and give artistic expression to the spirit of the time.

This lack of original ideas partly explains the absence of a general artistic style, but another factor must also be taken into account. After the aristocratic hierarchy had broken down and the Church had ceased to be such a powerful institution, there was no single authority to set a trend and style in the arts by commissioning large works of art. The new patrons were individual members of the middle classes, and monumental works of art were therefore replaced by those more suited to the private requirements and limited means of the individual. Architecture therefore gradually lost its prominent position among the fine arts and painting took the leading role. No other period in history is characterized by such architectural poverty as the nineteenth century.

As painting became more and more orientated towards private patrons, it lost contact with the broader public and developed in isolation, often in opposition to public opinion. Artists refused to make concessions and the public, not understanding their pictures, refused to buy them. In the past painters had enjoyed general approval and were celebrated and promoted by an art-loving community; now they became outsiders for whom the general public felt at best pity, but mostly only disdain. The underrated artist took his revenge by turning against society, either with sharp criticism or by deliberate aesthetic provocation, with an art for art's sake. Thus an unfortunate gulf developed between artist and society which has continued to widen to this day and has caused countless misunderstandings between the creative artist and the middle-class public.

Right: Berlin, Brandenburg Gate, 1788—1791 by Carl Gotthard Langhans
(1732—1808)

Munich, Glyptothek, 1816—1830 by Leo von Klenze (1794—1864)

Karlsruhe, Classicist Church, 1807—1815 by Friedrich Weinbrenner (1766—1826)

Berlin-Tegel, Humboldtschlösschen, rebuilt 1822 by Karl Friedrich Schinkel (1781—1841)

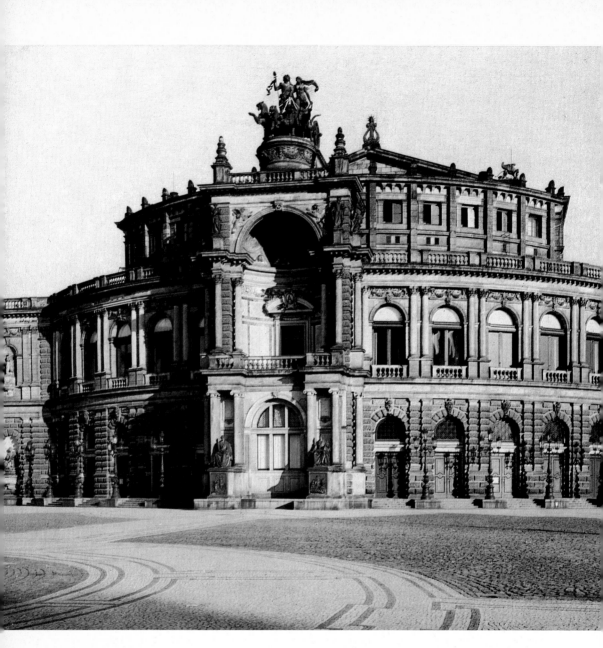

Dresden, Opera House, 1837—1841 by Gottfried Semper (1803—1879)

Right: Berlin, Werdersche Kirche, built by Karl Friedrich Schinkel (1781—1841).
Watercolour by Johann Friedrich Stock, about 1840

Befreiungshalle near Kelheim/Danube. Built by Leo von Klenze 1850—1863

Lübeck, Schabbelhaus. Room in Biedermeier style

Berlin-Tegel, Humboldtschlösschen. Display of Classical sculptures

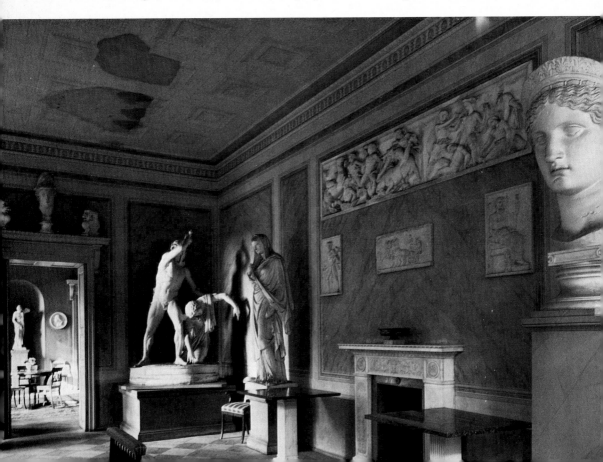

This change was a gradual one, though, and architecture still retained its leading role among the fine arts during the early part of the nineteenth century. Classicism replaced the frivolous style of the Rococo and strove towards a new beginning. While the Renaissance had been inspired by ancient Roman works of art, Classicism returned to the original sources of all Classical art and took its models from the ancient Greeks. But a faithful imitation of architectural forms and details could not be regarded as a new style heralding the future and it could not lead to a new beginning; it merely represented a return to the forms of the past. Although Classicism was hailed as a manifestation of middle-class republican opinion, it in fact owed its origins to an elite, no longer the aristocratic elite, but an intellectual elite, the Humanists, the exponents of the Classical revival. Therefore Classicism cannot be regarded as an expression of middle-class ideals; it was at best an aesthetic revolution, a declaration of war on the Rococo.

Heavily ornamented façades were out of favour and buildings with clearly defined outlines and smooth, sober wall surfaces were once again preferred. The column was considered the noblest of architectural forms; it was placed in solemn rows along the façades and surmounted by triangular pediments. This design, which is modelled on that of the Classical temple, remained an architectural feature all through the century.

Friedrich Weinbrenner's Classicist church at Karlsruhe (see p. 134) is enriched by a portico that carries a broad entablature which is decorated by garlands and continues around the building, whereas the columns, in the manner of a Greek prostyle, are limited to the façade. No connection whatsoever exists between the actual structure of this very conventional church and its Classical outer appearance; the interior in no way corresponds to the exterior which has been merely 'dressed up' in the manner of a temple and thereby expresses the main preoccupation of the time, that of creating a dignified impression.

Classicist structures in Prussia display considerably greater originality. The Brandenburg Gate (see p. 133) was built between 1788 and 1791 by Carl Gotthard Langhans and although it is based on Classical concepts it nevertheless displays a considerable degree of independence. Langhans combined the idea of the Roman triumphal arch with that of a Greek temple, whereby the openings of the broad gate are created by the wide distance between the columns. The structure was designed as a feature of municipal

Left: Christian Daniel Rauch (1777—1857): Detail from equestrian statue of Frederick the Great. 1839—1851. Bronze

Page 139: Gottfried Schadow (1764—1850): The Crown Princess Luise of Prussia and her sister Friederike, 1795. Marble

architecture, but compared to the gigantic Arc de Triomphe in Paris it seems modest in dimension and form and aptly demonstrates the frugal spirit of Prussia.

One of Berlin's most beautiful Classicist structures is the Humboldt-schlösschen in Tegel (see p. 135), which was rebuilt by Karl Friedrich Schinkel in 1822 for the Prussian minister and philosopher Wilhelm von Humboldt. No purpose had to be fulfilled other than that of building an intimate structure for a private individual. Schinkel therefore was un-hampered by official taste and could express his own ideas on the revival of Classical forms. By the agreeable proportions of individual structural units and their harmonious relationship to each other he achieved a re-strained monumentality. The horizontal emphasis of the broad central section is balanced by the verticality of the wings and a completely self-contained unit is thereby created, similar in concept to that of ancient Greek civil structures, yet of a very individual outer appearance. The walls are smooth and free of ornament, only fine, flat mouldings and pilasters produce a meaningful articulation. This small palace combines grace with utility, dignity with modesty, and a knowledge of Classical forms with new free-thinking attitudes. Thus as early as the first quarter of the nineteenth century, Schinkel rejected the restrictions of historicism and adapted Classical forms to meet individual requirements (see also p. 138).

Schinkel recognized the increasing importance of technology and economics. On his travels he studied constructions made of iron and glass in Paris and admired the growing industry and its 'thousands of smoking obelisks' in England. As early as 1827 he designed a department store for Berlin and stressed its functional aspect by big windows and narrow undecorated strips of wall. This design which was never carried out heralds our modern industrial structures of steel and concrete, whose beauty lies in their functional utility and not in extraneous ornamentation.

But the time was not yet ripe for such revolutionary ideas. It took nearly another century before architecture shook off the shackles of misinterpreted traditions and created its own modern style; until then it remained subject to historicism, and that period counts among the darkest chapters of German architecture. The Classicists, in turning to ancient Greece, had tried to discover the origins of European culture. But pure Classicism was of comparatively short duration; by becoming the official style of Napoleon's time it had been compromised, so to speak, as an expression of imperial power. With Napoleon's defeat during the Wars of Liberation (1813—1815), national consciousness awoke everywhere in Europe, particularly amongst German speaking people; this led to a widespread interest in their own past, which was taken up by the Romantics, whose efforts were directed towards a revival of the medieval spirit. The young Goethe had been one of the first to express these sentiments when, in 1771, he wrote his famous

essay, *On German Architecture,* which contained a hymn-like praise of the Strasbourg Cathedral. In the early part of the nineteenth century the enthusiasm for the Gothic was as widespread as the enthusiasm for Greece that Winckelmann had initiated.

Even the Classicist architect Schinkel was influenced by this medieval revival and dreamt of a Gothic national cathedral. He submitted two designs for the Werdersche Kirche in Berlin (see p. 137), one in Gothic style and one in Classicist style, using the same basic structure. This juxtaposition of different designs was characteristic for the nineteenth century, when leading architects were expected to master every style. The South German architect Friedrich Gärtner designed three dominating structures with completely different façades for the Ludwigstrasse in Munich: the Siegestor resembles a Roman triumphal arch, the Feldherrenhalle is based on the Early Renaissance Loggia dei Lanzi in Florence, and the university is built in strictly Romanesque style. Only a few years before, Leo von Klenze had modelled the Classicist Glyptothek in Munich (see p. 133) on a temple of the muses.

One aspect of historicism was the concept that the façade should express the purpose of the structure and this type of architecture was, therefore, called *architecture parlante.* The temple façade of the Glyptothek (see p. 133) indicates that it houses masterpieces of Classical sculpture; the Befreiungshalle near Kelheim on the Danube, built by Klenze (see p. 137), suggests the victorious fight against Napoleon; and the earnest dignity of a university was, in the opinion of the time, best expressed by the Romanesque style. In fact, however, the interior of these buildings in no way corresponds to their exterior and the insincerity of this *architecture parlante* thereby becomes obvious. The façade is merely a sign announcing the purpose of the building rather than the expression of an actual governing spatial concept.

The famous architect Gottfried Semper built the Dresden Opera in 1837 —1841 (see p. 136). In this impressive building he reworked traditional elements into an individual composition. Semper, who had studied the humanities before turning to architecture, was also a theoretician of the highest order. He had a profound influence on the development of architecture in Germany. He accurately described the contemporary architectural scene: 'The young architect travels through the world, fills his sketchbook by copying all kinds of things and then happily returns, confident that a commission for a Valhalla à la Parthenon, a basilica à la Monreale, a boudoir à la Pompeii, a palace à la Pitti, for a Byzantine church, or even for a bazaar in the Turkish style won't fail to turn up.'

These commissions did not, in fact, fail to turn up, but after 1850 the stylistic confusion increased. The *architecture parlante* had at least retained a thematic connection between the façade and the purpose of the building,

but complete arbitrariness reigned during the second half of the nineteenth century. Theatres, railway stations, post offices, factories, even prisons were built in Romanesque, Renaissance or Baroque style, and the façades of big apartment houses became the scene of an unrestrained imitative drive, while behind these houses dark airless yards bred misery and despair.

The engineering constructions of the early twentieth century gave the first indication of a modern objectivity which, however, was not generally accepted. The following edict was issued in the year 1912: 'New churches are to be built in Romanesque or Gothic style or in the so called transitional style. For our area the Gothic style is considered most suitable. In recent years some architects seemed to favour later styles or completely modern designs. In future no building permission will be granted for these except under very special circumstances.' This regulation may seem incomprehensible today, but the city of Cologne, where this edict was issued, must be forgiven because there historicism did achieve a positive result: the completion of the cathedral which had remained unfinished for three hundred years. Upon the discovery of the original plans the missing section between the chancel and the western façade was erected with great technical skill and remarkable sensitivity and the towers were brought to their full height. No other epoch before or after would have had the incredible patience or born the immense expense of such an impressive accomplishment.

At a time when the arts were dominated by a Classical revival, sculpture, which had been the most important medium of artistic expression for the ancient Greeks, naturally gained in importance. On his travels, the Classically orientated artist filled his sketchbooks with drawings of ancient Greek and Roman statues and the art lover, in the absence of originals, decorated his house with plaster copies. Wilhelm von Humboldt's impressive collection of plaster casts can still be admired in Tegel (see Humboldtschlösschen, display of Classical sculptures, p. 138). At that time a state-owned company for the manufacture of plaster casts was founded in Berlin which to this day supplies half the world with copies of sculptures and reliefs from every artistic period. The desire to imitate found a legitimate outlet in the plaster cast which was purely reproductive, but imitation produced less fortunate results when formulated in creative sculptural terms. Many artists chose models of Italian origin, which were mostly inferior copies of Greek originals, with the result that imitation was being imitated.

Furthermore the Classicists completely misunderstood the meaning of ancient Greek and Roman statues by blindly accepting Winckelmann's view that the ideal beauty of Classical sculptures was the expression of a superior and noble spirit. They saw the 'Apollinic' in Greek art, but they 144 overlooked the 'Dionysiac' and failed to recognize that ideal beauty can

Johann Heinrich Wilhelm Tischbein (1751—1829): Detail from Goethe in the
Campagna, 1787

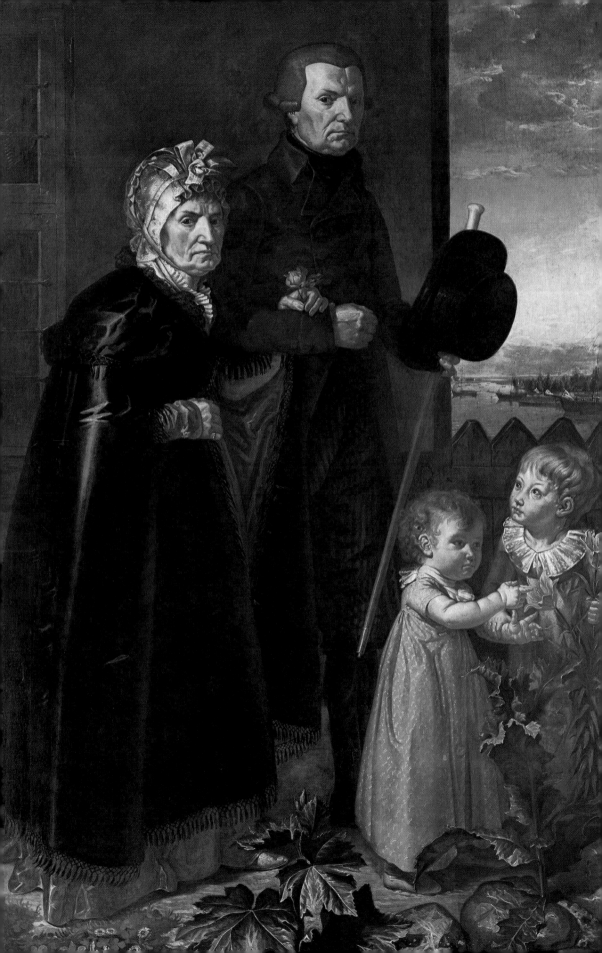

only be attained by experiencing the passions, conflicts and torments of human existence. Consequently they strove for an aesthetic perfection through the balanced proportions, the appealing smoothness and the noble harmony of Classical sculptures.

The Italian Antonio Canova and the Dane Bertel Thorwaldsen were among these idealists, whereas the Berlin sculptor Gottfried Schadow openly attacked this blind veneration of Classical culture: 'There is no abstraction and there should be none, either in nature or in art. Beautiful, ideal humanity does not exist, only exquisitely beautiful human beings.' His keen sense of reality is strongly expressed in a number of highly individualistic portrait sculptures such as those of the Princesses Luise and Friederike (see p. 139). Only the girls' dress is Classical and slightly idealized. Their natural affectionate embrace is seen in purely human terms and absolutely true to life; it joins them like real sisters, intimate but not overly interested in each other, each following her own thoughts, inseparable only because familiar habits unite them. Each is a personality in her own right: Luise anticipating the future burdens of her royal office, Friederike more carefree, private, childish.

Schadow's pupil Christian Rauch succumbed to the pressures of an important commission and abandoned his teacher's realism in favour of a more pleasing idealization. Among his best works are a number of portraits on monuments and mausoleums. The equestrian statue of Frederick the Great (see p. 140) in Berlin presents the Prussian king in the pose of a great military leader; only the facial expression shows the monarch as a philosopher and representative of the Age of Enlightenment. Schadow at the end of his life ironically commented on the increasing intellectual shallowness of contemporary sculpture which was expressed by the charm, smoothness and pathos of his pupil's work. The middle classes, however, found these sculptures pleasing and soon parks, gardens, public squares and fountains abounded with such monuments.

The Classicist style found little following among German painters, but the work of contemporary French artists, consisting mostly of historical tableaux, shows how unsuited these intellectual and literary concepts were for painting. The humanistic and liberal ideals of German Classicism found expression in such famous works of German literature as Goethe's *Tasso*

Page 146: Philipp Otto Runge (1777—1810): Parents of the Artist, 1806

Page 147: Carl Gustav Carus (1789—1869): Boating on the Elbe, 1827

Left: Caspar David Friedrich (1774—1840): Chalk Cliffs on Rügen, 1818

and *Iphigenie,* but there was no corresponding expression in the pictorial arts. Painters of that time portrayed warm-hearted human scenes without achieving anything universally valid. The rediscovery of ancient Greece and Rome and the imitative ideals of Classicism failed to inspire German painters, and what eventually led to a break with the past was a new interpretation of nature. During the Rococo stylized landscapes were used as an elysian stage for pastoral idylls and romances. This artificial view of nature was decisively rejected by Ferdinand von Kobell, who was born in 1740. Although he, at first, was a follower of the Netherlandish and Italian landscape painters, he later disassociated himself from them and, regardless of current fashions, developed his own interpretation of nature. From about 1780 he no longer painted imaginary scenes but portrayed actual events. His clear, wide landscapes are free of affectation and pathos and avoid the sentimentalism which predominated later during the Romantic.

Wilhelm von Kobell enriched the realistic portrayal of landscape, which his father had perfected, with a subjective expression of atmosphere, but he too attempted to describe nature objectively. In his Siege of Kosel (see p. 128) the combination of Classicist figures and a Romantic presentation of nature produces a very charming effect. Unlike Baroque painters, who used diagonal lines to heighten the spatial dynamic, Kobell built his landscape on a system of verticals and horizontals and thereby attained that harmonious balance which was a main concern of Classicist art. The representation nevertheless conveys a very natural, lively atmosphere which is achieved by the masterful introduction of light; a low sun produces a pleasing interplay of light and shade on the promontory in the foreground. Officers and soldiers look into the wintry sun and at the town of Kosel before them, seemingly admiring the softly illuminated landscape that stretches into the hazy distance. A less war-like picture of a siege has rarely been painted.

Joseph Anton Koch was a highly accomplished master of landscape painting who combined keen observation with great sensitivity. He wrote: 'Art is more than mere imitation. Even when art appears natural it should transform nature by formulating it stylistically.' Motivated by the desire for absolute validity he presented neither an objective description nor a poetic atmospheric image, but a subjective symbolic interpretation which portrayed nature's perpetual renewal, regularity and simplicity.

Even in his drawings and watercolours Koch expresses this characteristic attitude and formulates what he has seen in strongly individualistic terms. In his study Schmadribachfall (see p. 153) he refuses to exploit the possibilities of the medium; instead of working with a wet brush to obtain the picturesque intermingling of tones and the transparent effect of watercolours, he applies them heavily, like oils, and completely covers the paper. The white snowy mountain tops and the white foam of the waterfall are

not the white paper showing through, but a heavy layer of white paint. The solid forms thereby achieved and the landscape's vertical structure give the picture an impressive monumentality. Even in this small format, 41 cm × 49 cm, Koch has convincingly conveyed the feeling of grandeur of alpine scenery.

Koch's influence on the next generation of German landscape painters was considerable. Among his admirers were Preller, Fohr (see p. 154), Overbeck, Richter and Carl Rottmann. The latter he met in Rome, where many of Germany's leading artists congregated at the time. Rottmann was attached to the court of Ludwig I, king of Bavaria, who had commissioned a picture of Palermo and who later sent Rottmann to Greece in search of suitable motifs for a fresco cycle which was to decorate the Royal Garden Arcades in Munich. During this journey Rottmann made a watercolour drawing of the island of Santorin (see p. 156), which had appeared out of the sea during a volcanic eruption in 1540 B.C. This titanic aspect of nature constitutes the theme of Rottmann's study; the rising smoke is a symbol of the eruptive forces that once created the island. Bizarre naked rocks, magically illuminated by a thundery light, stand in front of a dark bank of clouds which throws deep shadows onto the water. The bleakness of the island is accentuated by the minute size of the village perched on the rock, and the harshness of the landscape is matched by the nearly tectonic structure of the picture which leaves no room for a poetic mood. Even the reflections on the water are made rigid by the horizontal structure of the surface, and the predominantly cool tones underline the heroic mood that lies over this bay.

A picture which most superbly expresses the concepts of this age is Johann Heinrich Tischbein's Goethe in the Campagna (see p. 145). The painting represents the mature poet, ennobled by his journey to Italy where he encountered the Classical past. Goethe is shown in the pose of a Humanist, a citizen of the world, against an Arcadian background, which symbolizes his longing for Greece. It was this portrait of Goethe, one of the most eminent figures of German literature, which made Tischbein famous; the rest of his work would only barely have earned him credit as a talented portrait painter. Tischbein had the good fortune of meeting Goethe in Italy and they soon established a close friendship. In January 1787, three months after his arrival in Rome, Goethe wrote enthusiastically: 'The strongest attraction that Italy holds for me is Tischbein.' And a few weeks earlier Tischbein had noted: 'I have started a portrait; I shall make it life-size and show him sitting on the ruins, lost in thought, reflecting on the destiny of man.'

The dimensions of this powerful picture are 164 cm × 206 cm. Tischbein started the portrait without Goethe's knowledge but subsequently obtained the poet's expressed approval. The wide white travelling cloak evokes the

151

Roman toga, the broad-rimmed hat effectively surrounds the face with dark shadows and, as Tischbein had intended, the poet's expression conveys a reflective mood. Goethe himself never saw the finished picture; he left Rome before its completion and the portrait remained in Naples until 1887, when it was brought to the Staedelsches Kunstinstitut in Frankfurt.

While the Classicists strove for order and regularity, which they hoped to achieve through clarifying reason, the Romantics took a subjective view of life and advocated simple piety and a return to the emotions. Romanticism cannot, however, be regarded as a reaction to Classicism. The Classicists' preoccupation with ancient Greece and Rome was no less sentimental and fanatical than the Romantics' enthusiasm for nature and their rediscovery of medieval ideals. Tischbein's portrait evokes Classical themes but the sentiments expressed are those of a Romantic; it does not show the poet's relationship to the past but instead expresses pictorially the unresolved ideas regarding the origins of poetic inspiration.

The Romantics viewed God, man, nature and culture as a single experience, communicated through the emotions, and regarded the world as a poetic harmony in which contradictions and contrasts, the conscious and the unconscious, merged and complemented each other. This subjective emotional reality was not governed by any rules of religion or society; it was created by the imagination and expressed itself in totally subjective ways. Therefore the Romantics were, at first, unable to find a common theme. They believed in individualism and personal originality, but these attitudes by their very nature could not be adopted by a group and consequently Romantic artists in their self-imposed isolation were often prone to melancholy and sadness.

The difference between the ordered view of the Classicists and the purely subjective view of the Romantics can clearly be seen by comparing Kobell's Siege of Kosel (see p. 128) with Boating on the Elbe by Carl Gustav Carus (see p. 147). In Kobell's picture the eye can roam freely from the magnificently clad horsemen in the foreground to the town, silhouetted in the middle ground, or to the misty, mountainous background. Carus, on the other hand, uses the structure of the boat to narrow down the picture, and forces the eye to travel in a given direction, at the same time challenging

Right: Joseph Anton Koch (1786—1839): Schmadribachfall, 1794. Watercolour over pencil drawing, heightened with white

Page 154: Karl Philipp Fohr (1795—1818): The Ruin at Fragenstein, 1815. Watercolour

Page 155: Caspar David Friedrich (1774—1840): Winter, 1826. Brush and sepia over pencil drawing

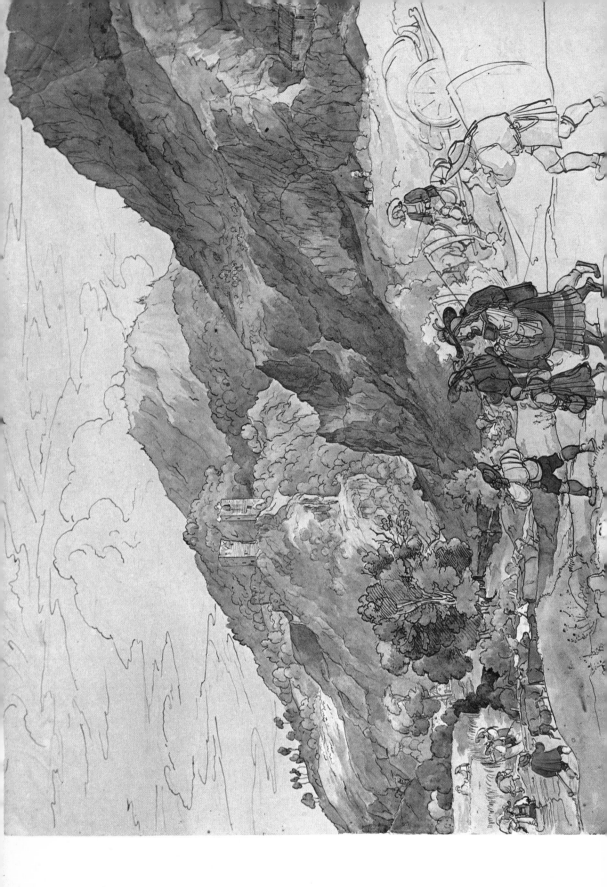

the spectator to identify the two figures from behind. The artist thereby presents a very personal impression and does not hesitate to falsify reality in order to make his theme pictorially explicit. The Elbe is depicted as an almost invincible surface of water behind which the towers and domes of Dresden flash like a fatamorgana in the midday haze. The girl's posture suggests a longing which is directed towards a dream city, not towards the real Dresden; she is spatially isolated from the viewer as well as from the oarsman, she is removed from reality and freely follows her dreams. Carus presents nature as seen through the eyes of a dreamer, no longer unreflected, no longer without prejudice. The girl, in turn, is revealed through the poetic mood of the painting; she has been assigned the role of mediator between landscape and viewer.

Man's dialogue with nature is one of the predominant themes of Romantic paintings. Numerous attempts had been made in the past to include man in the presentation of nature but the connection remained a loose one. Either nature served merely as a pleasing background for figurative scenes, or landscape paintings were enriched by groups of figures in order to enliven the picture through colour and movement and create an impression of spacial depth. The Romantics not only made the human figure an inseparable part of the composition, they went even further and attempted to involve the viewer. In Carus's picture the empty space next to the girl is intended for the viewer, from there he can participate in the experience of nature and peacefully follow his thoughts and dreams. Carus was what one calls today a Sunday painter. He studied medicine at Leipzig and from 1815 practised gynaecology at the surgical academy of Dresden, where he was appointed Royal Physician in 1827. His writings on psychology and other subjects were highly respected not only in medical circles but among representatives of the Romantic movement. Caspar David Friedrich in particular repeatedly quoted Carus's views on aesthetics.

The works of Caspar David Friedrich represent the Romantic attitude in its purest form. Unlike Carus he showed decidedly melancholic tendencies without, however, indulging in any form of sentimentality. His melancholia stemmed from a deep, simple piety, an insatiable longing for the infinite, and an unfulfilled desire to understand the whole universe, but these yearnings also were his source of inspiration. His paintings always portrayed human beings in contrast with nature, against whose strength and force man is totally powerless.

Friedrich saw man as a transient part of creation and nature as infinite and everlasting. In his drawing Winter (see p. 155) landscape and figures

Left: Carl Rottmann (1797—1850): Santorin Island. Watercolour over pencil drawing

are thematically fused to convey the meaning of the picture. A setting moon over the sea establishes the basic mood for this melancholy contemplation of the ephemeral aspect of human life and endeavour. The ruins of a church loom behind the little graves and to the right two broken dead trees are symbolically silhouetted against the sky; in the foreground an old couple are digging a grave in the moonlight. The infinity of sea, sky and moon is contrasted by the finite aspects of life on earth. The monochrome tones of this sepia drawing give the scene a universally valid meaning.

Less pessimistic, but suffused with romantic poetry, is the painting Chalk Cliffs on Rügen (see p. 148), which illustrates Friedrich's abilities as a landscape painter. His description of nature shows that his eyes and heart have remained open to the wonders of creation. From a clearing on high cliffs three wanderers admire the view of the sea far below. In the foreground every leaf and blade of grass is depicted in minute detail and the hard, sharp outlines of the chalky rocks are drawn with great precision; only the soft and unformed surface of water in the background fades gently into the distance and fuses with the misty sky at the horizon. By placing two small sailboats on this infinite stretch of water, Friedrich expresses his longing for the unreachable; they symbolize man's insignificance in the face of nature.

Despite their personal, emotive language Friedrich's descriptions of nature found an immediate response, whereas the heavily symbolic representations of the North German Romantic painter Philipp Otto Runge had a very limited appeal. 'It is a vain hope', he wrote resignedly, 'that the public might understand us. Individual relationships alone are possible, they are indeed what sustain us.' Therefore his pictures convey most strongly the Romantics' self-isolation; they express in a deeply tragic mood the loneliness of man in a world threatened by dark forces.

The large painting of his parents, his eighteen-month-old son and his three-and-a-half-year-old nephew (see p. 146) is anything but a touching family idyll. The deep seriousness of the old couple seems to affect the children whose faces are reserved, almost sad and tired, and the pathos of the scene is increased by the addition of a lily and a thistle, symbols of innocence and of the difficulties which these children will have to face in life. Even a view of the open landscape does not add gaiety to the picture; dark clouds in the evening sky bode little good for the coming day. But it nevertheless remains a moving picture, which expresses the love and respect of a son for his parents. There is no bitterness in these faces marked by a hard life. The erect figures reveal the dignity and pride of human beings who, even in their old age, are strong and indomitable. Their Sunday clothes accentuate the nobility of their appearance and are an outward sign of their inner attitude. The calm natural way in which the woman

leans on the arm of the man conveys the warm intimacy of this couple who have gone through life together and to whom the happiness of a joint old age has been granted.

The high ideals of the Romantic were soon discarded. Their world-embracing emotions were replaced by a more personalized, intimate happiness, and the large-scale view of nature was transformed into a contemplative idyll. The past, the world of fairy-tales and pious legends, provided an escape from the miseries of the present and artists were inspired by sweet dreams of fairies, dwarfs, saints and princes. These attitudes were expressed by Ludwig Richter and Moritz von Schwind, whose works presented a happy, peaceful picture of life. Schwind's real achievement, however, was not the charming genre pictures but his illustrations of fairy-tales; his importance equals that of the Grimm Brothers as far as the revival and preservation of German fairy-tales are concerned.

Carl Spitzweg's pictures describe the quiet happiness that flowers in seclusion, far from the problems of this world. The romantically idealized past did not inspire him, he was only interested in his contemporaries, particularly members of the middle classes, the people after whom the period 1815—1850 was later called *Biedermeier*. Carl Spitzweg described this world with inimitable charm, not as a critic, or by satirizing it, but as a smiling observer. He showed affection, coupled with poetic irony, for odd, quaint, and even scurrilous characters whom he discovered in remote corners of the city, in backyards, and in the narrow rooms of old houses. The titles of his pictures, The Cactus Lover, The Poor Poet, The Love Letter, The Lover of Books, might just as well be titles of short stories.

In The Stage-Coach (see p. 166) Spitzweg depicts an episode in the life of the inhabitants of a remote, narrow alpine valley. Full of curiosity, they have assembled to watch the heavily loaded, rocking coach climb the steep path; they readily lend a hand to assist the poor horse which does not seem to be able to manage on its own. It provides them with a few moments of gay distraction and an opportunity to come into direct contact with this emissary from the outside world. But soon the coach will disappear behind the next bend of the road and the valley will once again return to the deep quiet peace which, even in the midst of all this commotion, lingers over the steep rocks.

The strong emotional content of the picture is conveyed not only by the contrast between the small figures and the powerful scenery, but also by the extremely subtle painting technique. The use of diffused cool tones accentuates the majestic size of the background while the warm, glowing colours of the foreground create a vivid impression of bubbling movement and lively intimacy. The dazzling light of a friendly summer's day which illuminates the scene gives a soft glow to the mountain slopes and produces amusing reflections in the foreground. Earlier Romantics portrayed the

meeting of man and nature in a melancholy fashion, but not Spitzweg, whose paintings create an atmosphere of happy harmony.

Another prominent artist of the mid-nineteenth century was Alfred Rethel, who received his early training under Wilhelm von Schadow at the Düsseldorf Academy. Skilled as a draughtsman as well as a painter, his series of woodcuts of the Dance of Death is considered his masterpiece (see p. 163).

Towards the middle of the century this peaceful life of the *Biedermeier,* of small pleasures enjoyed in the comfort and privacy of the home (see also p. 138) was disrupted by political events. The Revolution of 1848 in France had its repercussions in Germany and, after decades of political passivity, a wave of unrest swept across the country which unmistakably announced the beginning of the industrial age. The aims of these new revolutionary movements were considerably more realistic and tangible than those of 1789 had been. Instead of liberty, equality and fraternity, the people now demanded freedom of the press, freedom of assembly, the introduction of universal franchise, and the protection of the rights and interests of the workers, that new social class which had emerged as a result of the industrial revolution. The idealism of the early nineteenth century, which had turned to the past in an attempt to find new standards, was replaced by a new realism, and this soon became the accepted theme for literature and the fine arts. With the invention of photography by Daguerre in 1839, the artist's eyes were opened to the value of objective reality, which up to now had been rejected as trivial and therefore not worthy of representation. Aesthetic and historic ideals were rejected and, not wishing to replace these merely by a new set of ideals, a number of artists attempted to keep their paintings free of any ideology and to represent only what actually existed.

Realism first started in France and was immediately accepted there, whereas in Germany a great deal of importance continued to be attached to a picture's narrative and idealistic content. Adolph von Menzel never had a public show of his realistic pictures during his lifetime, and a critic's comment on Karl Blechen's paintings was 'they hit you in the eye'. The artists themselves were undecided. Part of Menzel's work belonged to the new Realism, the rest remained completely under the influence of the *Biedermeier.* His illustrations to Kugler's *History of Frederick the Great* are Rococo-like historical pictures which despite their exceptionally high artistic merit belong to the past. Karl Blechen also oscillated between Romantic and Realism. Many of his landscape paintings are pure descriptions of atmosphere but he also painted Rolling-Mill near Eberswalde, which shows all the ugliness of a landscape dominated by smoking chimneys, and he thereby created the first industrial painting. But while Blechen only described the outside of a factory, Menzel, a little later, went right inside

Hans Thoma (1839—1924):
Mystery Dragon.
Drawing for an illustration

this new industrial world, and in his picture The Rolling-Mill, described the dirty, unhealthy atmosphere of a factory and the workers' heavy labour. This representation was not intended as social criticism, Menzel wanted neither to warn nor to create heroes, he merely wanted, as a painter, to state the facts as they were. This objective way of seeing things, like a reporter, reveals Menzel as a true Realist, who denies himself any intellectual interpretation of his subject in order to preserve its reality. Nevertheless, Realism never became an end in itself for Menzel, who always remained highly individualistic; without falsifying reality he submitted it to a process of abstraction by eliminating trivialities and stressing its purely pictorial aspects.

In his picture Interior with the Artist's Sister (see p. 168) Menzel devoted all his attention to light and the many effects it creates. The lamp in the background throws a bright circle of light on table and ceiling while its frosted glass shade provides evenly diffused light for the rest of the room. In the foreground a candle illuminates the sister's face from below and produces golden reflexes on the door frame. The quiet, nearly *Biedermeier* mood of the scene is contrasted by the moving play of light and shadow in which the details of figures and objects become less recognizable. With generous open brush-strokes the artist unhesitatingly sums up the trivial

161

and lingers lovingly on the round, soft face of the girl who looks dreamily out of the picture. The great attraction of his painting lies in the ephemeral quality of the scene: the distribution of light and shade as well as the girl's position, half in, half out of the door, exist for just that moment; the artist underlines this fleeting aspect through a nearly impressionistic technique.

If Menzel is described as a master of Realism then this is the result of a need for classification, which does not do justice to his personality and versatility. The South German Wilhelm Leibl, on the other hand, was a true Realist. 'Man should be painted as he is, the soul is included anyway.' This pronouncement of Leibl's is a clear rejection of the painting of ideas but also of the painting of atmosphere, which Menzel continued to practise. Leibl painted what he saw, avoiding any intellectual or artistic revaluation of reality. On the contrary, he absorbed it with photographic objectivity and reproduced it faithfully, detail after detail, thereby transforming reality into good, competent painting. Leibl's famous picture Three Women in Church (see p. 169) constitutes the epitome of German Realism. Any attempt at an anecdotal or allegorical interpretation such as 'three phases of life' is inappropriate in view of Leibl's exact rendering of realistic details. He lavishes the same attention on every grain of wood, each fold of the dresses, every characteristic of the cloth, as on the faces and hands of the women. This complete equality in the treatment of figures and objects is an entirely new attitude of reality. For Leibl reality was a complex unit, in itself worthy of portrayal and therefore able to exist on its own without narrative or idealistic content.

In view of the perfection of photography, Realism, as Leibl understood it, seems superfluous to us, and the recent experience of *Blut und Boden* art makes his simple peasant figures seem slightly suspect. But it must be remembered that Leibl made the first brave attempt to free painting from its dependence on philosophy, literature and history. In his pictures objects and figures are purely representational and their impact is produced by artistic means alone. By abandoning narrative painting and adopting a purely representational form, he broke away from a pictorial tradition to which European painting had been committed since its earliest beginnings. The final break, however, was only to occur in our century, when not only the action but also the realistic object was eliminated from the picture.

Hans Thoma belonged to Leibl's circle for a period and created some outstanding landscapes which rate among his best Realist paintings. His scenes of the Taunus and the Black Forest present a faithful and objective description of nature, but at the same time the artist permeates the visible reality with strong feelings and his pictures express an almost romantic enthusiasm. In his Landscape in the Taunus (see p. 167) the clarity of the atmosphere and the summer light are enchanting and reveal the topo-

Alfred Rethel (1816—1859): Dance of Death, 1849. Woodcut

graphical features in every detail, while the figure of the wanderer adds a
subjective note to this realistic portrait of nature. Seen from the back the
figure not only serves to increase the depth of the picture but also provides
an emotional link between the viewer and the landscape. Contrary to
Leibl, who wanted to reproduce reality unreflected, Thoma's intention was
to paint not the outer appearance but 'the inner picture, that develops
during the active process of seeing, which we call fantasy or imagination'.

The French Impressionists often called themselves Realists and in that
wider sense the main representatives of German Impressionism, Max Lie-
bermann, Max Slevogt, and Lovis Corinth can also be regarded as Realists.
During his early years Liebermann, the oldest of the three, was influenced
by Courbet, Millet and Leibl and he frequently chose a subject which, at
that time, was by no means regarded as worthy of representation: the
working man. He painted artisans, peasants, workers, and women in
factories, in the fields and at their housework; he painted them in an un-
sentimental, naturalistic style which brought him the reproach that he was
acting as an apostle of ugliness and poverty. Liebermann abandoned these
hard, realistic themes only after an extended journey to the Netherlands. 163

The discovery of the great Dutch masters of the seventeenth century was as important to his further development as the experience of the very flat landscape near the sea where wind, humidity and light produce constant changes of atmosphere. The influence of French Impressionism on Liebermann manifested itself in his use of lighter, friendlier colours. At that time, in the nineties, he also abandoned the pedantic description of detail in favour of a sketchier interpretation, frequently described as Impressionist, although the correct use of that term refers only to colours and application of paint and not to the total concept. Liebermann in his overall concept always adhered to objective reality and never adopted the subjective attitude of French Impressionists.

In Liebermann's painting Papageienallee (see p. 170), the bright summer light which flows through the leafy dome of the avenue diminishes the plasticity of the figures, although their outlines remain clear and distinct. Even the colours retain their value, although the thick foliage acts as a green filter and tints the neutral light of the sun. Renoir would have used the green light to produce those green reflections on the white dresses which his contemporaries ironically referred to as 'mildew'. Liebermann, however, gives these bright shadows a yellowish lilac colour which provides a pictorial contrast to the luminous green of the lawn and the trees.

Although Liebermann's painting technique and palette were Impressionist, he developed his own way of using colour and light for the pictorial rendering of visual concepts. Similarly Max Slevogt adopted the techniques perfected by the French Impressionists in order to express his own ideas. He too had been influenced during his early years by the great Realist painter Leibl without, however, achieving the same intensity. Slevogt's further progress was decisively affected by a two-year stay in Paris as well as by a long journey to Italy. During this time he developed a preference for bright, luminous colours as well as a spontaneous, flowing brush-stroke which enabled him to transform whatever he portrayed into a purely optically meaningful experience. According to his motto 'the eye sees what it looks for' he frequently chose optically sensational themes: exotic animals, plants and fruits, but mainly the glittering world of the theatre. Its colourful atmosphere, its magic of beautiful illusions that become reality on the stage, corresponded to Slevogt's own artistic inclinations. He shared his love for the theatre with the French Impressionist

Right: Anselm Feuerbach (1829—1880): Iphigenie II, 1871

Page 166: Carl Spitzweg (1808—1885): The Stage-Coach, 1880

Page 167: Hans Thoma (1839—1924): Landscape in the Taunus, 1890

Adolph von Menzel (1815—1905): Interior with the Artist's Sister, 1847

Right: Wilhelm Leibl (1844—1900): Three Women in Church, 1881

Max Liebermann (1847—1935): Papageienallee, 1902

Right: Max Slevogt (1868—1932): The Singer d'Andrade as Don Juan, 1902

Degas, but while the latter was concerned with the rules governing the dramatic arts and portrayed their more formalized aspects, Slevogt was inspired by the unrestrained fantasy of the theatrical world and its unlimited possibilities of expression. Therefore he was mainly interested in the stars, the actors, the dancers and singers, whose personal friendship he sought and whose stage triumphs he described in many pictures. Among the most famous are those of the Portuguese singer d'Andrade which show the great tenor in his role as Don Juan: The Champagne Song (see p. 171), The Duel and The Graveyard Scene. These paintings are neither portraits nor documents of theatrical history, but merely describe in pictorial terms a musical and theatrical event. They lack emotional depth as a result, and in no way express an ideal; they are unproblematic, gay, full of light and colour, portraying only beauty.

The culture-conscious public of the late nineteenth century vehemently rejected Realism and the idea of art for art's sake. Leibl and Thoma recognized this when their pictures were refused by important official art exhibitions. Slevogt and Liebermann did not fare any better. In protest against the dictating of taste by the Salons, Liebermann founded the Berlin *Sezession* in 1898, which soon attracted all the progressive young artists. But criticism of Realist and Impressionist painting was voiced not only by the middle-class art lover, it also came from those artists who saw the only possibility for a renewal of painting in the return to old ideals. 'I am afraid of the unimaginativeness and emptiness which now rule the world; we must return to the old gods. It is not possible to turn to the future, for what future can be in store for the men of money and machines?' This remark by Anselm Feuerbach reveals disappointment and resignation. Recent political developments had brought about the long desired unification of Germany but they had also produced a society intent on expediency and gain.

Many artists who were disenchanted with contemporary events in Germany went to Rome. In this city, where the Classical spirit remained alive, they found inspiration and meaning for their art. The idealism, which artists such as Feuerbach, Hans von Marées and Arnold Böcklin expressed with heroic pathos, soon found a large following, and the expression *Deutsch-Römer* (Germanic Romans) was coined for them, although each of the three went his own way and they did not form a group. The artistic ideas of the *Deutsch-Römer* were not necessarily in conflict with Realism, they merely understood Realism differently than Leibl, for instance, who was accused of remaining immersed in detail. There are no inaccuracies in Feuerbach's pictures, no blurred contours, no 'brown sauce' as Böcklin once

Left: Ferdinand Hodler (1853—1918): Lake Geneva from Chexbres, 1905

described the paintings of the Classicists. Feuerbach's lines are hard and severe, the colours luminous and strong; he expresses the nobility of timeless ideas through monumentality and clarity of form. Leibl portrayed his ideal of the pure man by painting Tyrolean peasants and robust simple country women; Feuerbach used the noble figures of the Classical period to represent his ideal of humanity. It must not be forgotten that Paul Gauguin, the forerunner of modern art, spent all his life in search of the ideal image of man, which he found in the art of the ancient Egyptians and Greeks as well as among the peasants of Normandy and the natives of Polynesia.

Feuerbach found this timeless ideal human image in the person of the Roman Nanna Risi, the wife of a poor cobbler. She became his favourite model, also his mistress. Feuerbach painted her as a simple working-class woman, as Iphigenie, as Lucrecia, as Bianca Capelli; she was for him the embodiment of the Classical ideal that he wanted to realize in his art. However, Nanna the woman did not live up to her majestic noble exterior; after five years with Feuerbach she left him for a more solvent lover.

Another simple Italian girl, Lucia Brunacci, modelled for the second version of Iphigenie (see p. 165). In spite of her monumentality, which nearly fills the picture, this Iphigenie is by no means a statue without a soul. She is a woman full of dreams and longings for an unattainable world, her features are expressive, she is a human being, and yet she represents a perfect personification of Goethe's Iphigenie. Feuerbach achieved these effects by his subdued colours, by the relief-like plasticity of the folds of her dress, by the narrow format of the picture which dictates the figure's passivity. She seems to explain herself to the viewer through her proximity, but at the same time she withdraws from him again, remains isolated, follows her own thoughts. Thus she represents an ideal, the inherent and insatiable longing of man for perfection and harmony.

This strange and fascinating combination of Romantic and Classicist concepts was for the time being the last flickering of a highly strung idealistic attitude in the pictorial arts. The *Deutsch-Römer* exercised no influence on future developments because they failed to come to terms with the realities of their time.

THE TWENTIETH CENTURY

The lack of a common, unifying ideology during the nineteenth century had driven the arts into an ever increasing state of isolation. Artists either expressed their dissatisfaction by criticizing society and the world in general, which led to the birth of the caricature, or they simply turned to the old, tried ideals of the past which were divorced from the realities of the present. Long after the beginning of the industrial age with its manifold political, economic and social problems, the arts still looked to history for renewal and validation. The cathedral at Cologne was completed, banks and administrative buildings were decorated with pseudo-Classicist façades, and other structures, such as railway stations, barracks and schools, were built in a style which became known as 'railway station Gothic'. A Babylonian confusion of styles developed which took almost grotesque forms towards the end of the nineteenth century. The fact that the world had changed since the French Revolution and that it continued in a state of turmoil was practically ignored by the arts.

The problems of a rapid increase in population in the big cities, a consequence of industrialization, were neglected by creative architects. Clever financiers took advantage of it and filled whole districts with ugly apartment houses; a dispossessed and dissatisfied generation grew up in the misery of backyards and in the confined space of grey, lightless apartments, which later proved to be a fertile breeding ground of revolutionary ideas. The wretchedness of the living quarters was equalled by that of the factories. They were built as cheaply as possible, drab, ugly and unhealthy, and working-class ghettos developed, much to the discredit of the contractor who had built them and the architects who failed to provide a viable alternative. The contemporary idea of a more beautiful world based on industrial progress found expression in the unfortunate style of the years following 1870, when villas and upper-class apartment houses were pretentiously decorated like princely palaces. The broad pillars and allegorical figures of these façades consisted of cheap stucco and were nothing but a ridiculous stylistic masquerade. The desire to impress led the wealth-conscious society to excesses of tastelessness and to this day German cities are defaced by buildings from that unfortunate epoch. 'The bourgeoisie adorned themselves with the rags of princely splendour' was the sarcastic

175

remark made by Alfred Lichtwark, the director of the Hamburg museum.

Towards the end of the nineteenth century the limitations of this imitative architecture became more and more apparent. A number of young artists, eager for reform and searching for designs that were independent of the past, developed a style of architectural ornamentation which was modelled on the undulating plant motifs of the *Jugendstil*. But although these consciously anti-naturalistic, flat, stylized forms were successfully used by contemporary painters and graphic artists, they produced only an insipid, modish decor of basically conventional buildings when applied to architecture. The obvious absence of any correlation between structure and ornament was the result of the fact that the founders of the *Jugendstil* were, almost without exception, painters who came to architecture through the applied arts. Some early buildings of the *Jugendstil* period, such as those by Henry van de Velde and Hermann Obrist, are, however, noteworthy for their pleasing proportions and sparing use of ornamentation.

Many artists remained tied to the aesthetic traditions of the past and it was the engineers who, with the help of new building materials, developed revolutionary methods of construction that led to the emergence of modern aesthetic concepts.

The history of architecture is the history of a constant struggle between structural necessities and aesthetic considerations. New structural techniques invariably produced aesthetic changes, and, on the other hand, new aesthetic concepts frequently led to architectural developments. In the past, structural possibilities had been limited by the available building materials, stone and wood. Wood, being less durable than stone and highly inflammable, had lost its importance in early medieval times, and the techniques of stone construction were developed to ultimate perfection during the Gothic period. The industrial age for the first time provided architects with new materials, steel and concrete, and later a combination of the two, reinforced concrete.

But architects rejected these new building materials at first, just as they overlooked the problems of industrial society. Engineers, however, whose only concern was the technical aspect and who were not subject to aesthetic judgements, were able to make use of the new materials more freely. Thus the engineering constructions of the late nineteenth century marked the beginning of an emancipation from the domination of traditional aesthetic concepts. Daring suspension bridges, the first skyscrapers, and railway stations built of iron and glass announced a new era in which architecture became orientated to the needs of society. 'We have to emerge from the stone age if we want to have a style of our own', wrote the German politician Friedrich Naumann, who regarded the Eiffel Tower as 'that heroic poem of pure metal, that work of art without artistry'.

176

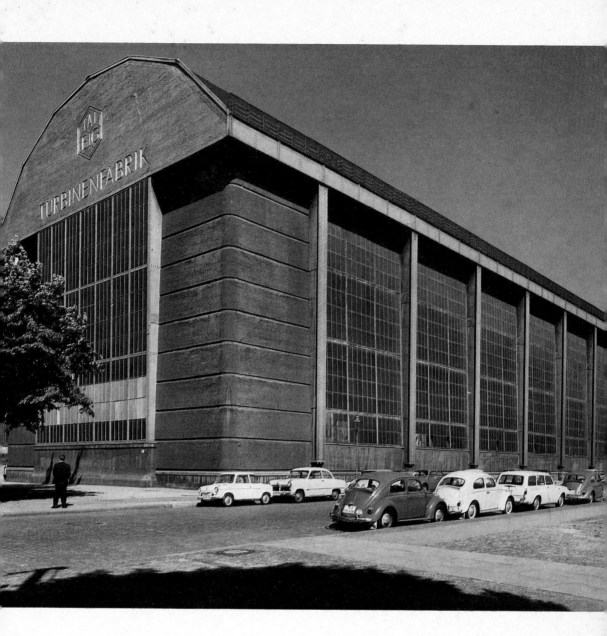

Berlin, AEG gas-turbine plant, 1908—1909 by Peter Behrens (1868—1940)

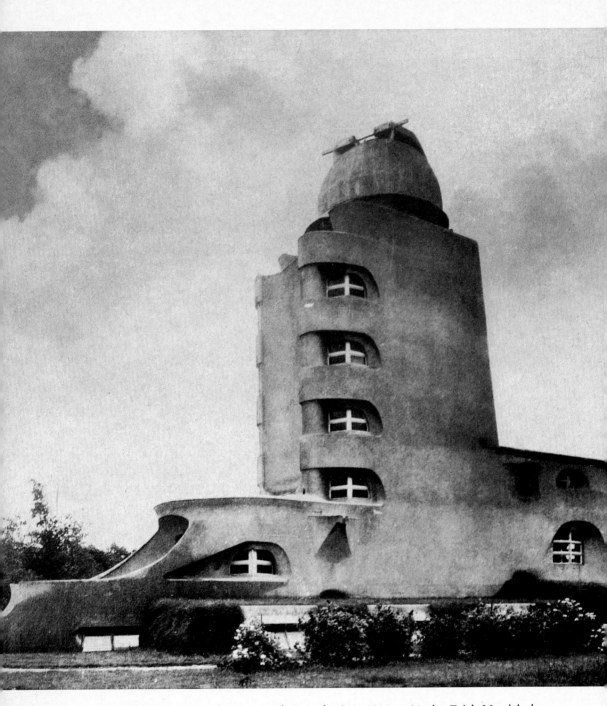

Potsdam, Einsteinturm (Institute of Astrophysics), 1920—1921 by Erich Mendelsohn (1887—1953)

Right: Alfeld an der Leine, Fagus Works, 1911—1913 by Walter Gropius (1883—1969)

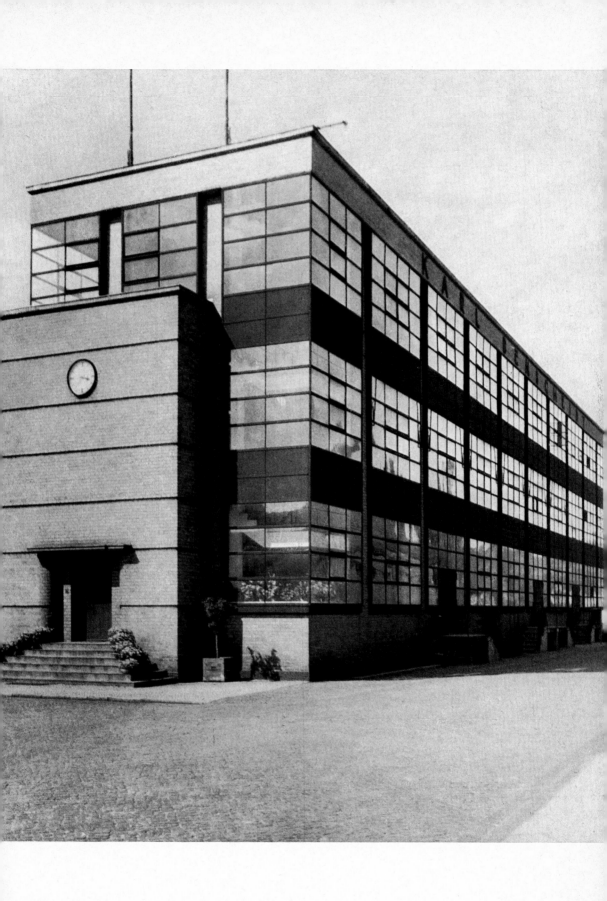

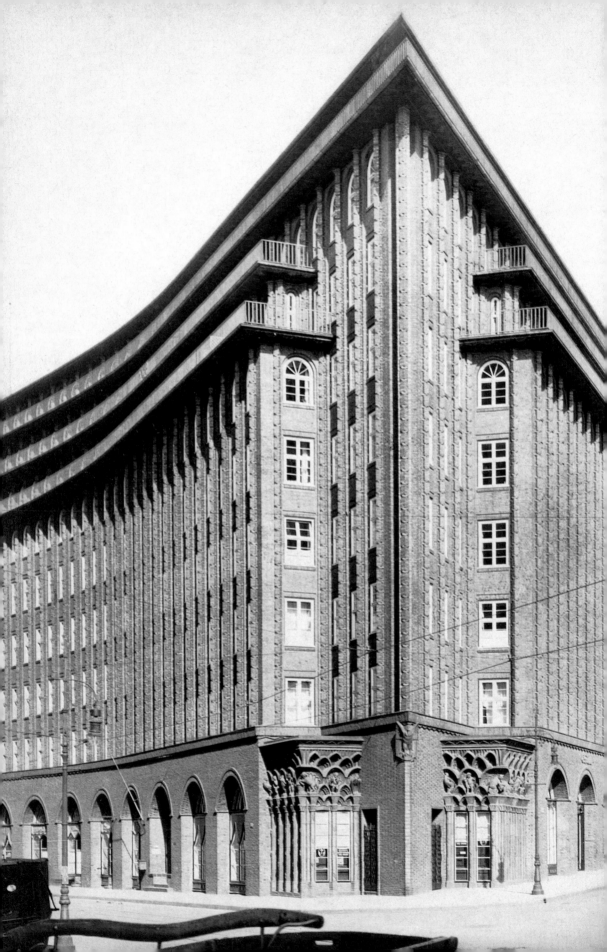

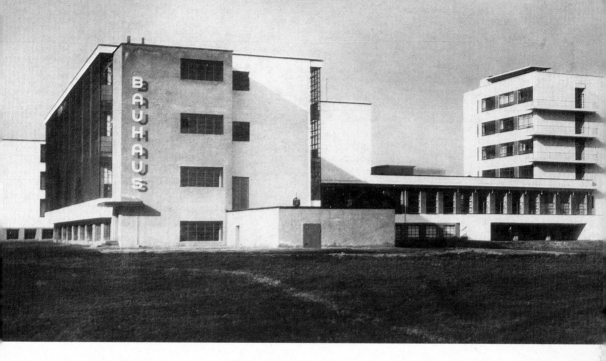

Dessau, Bauhaus, 1925—1926 by Walter Gropius (1883—1969). Back view below

Left: Hamburg, Chilehaus, 1920—1923 by Fritz Hoeger (1877—1949)

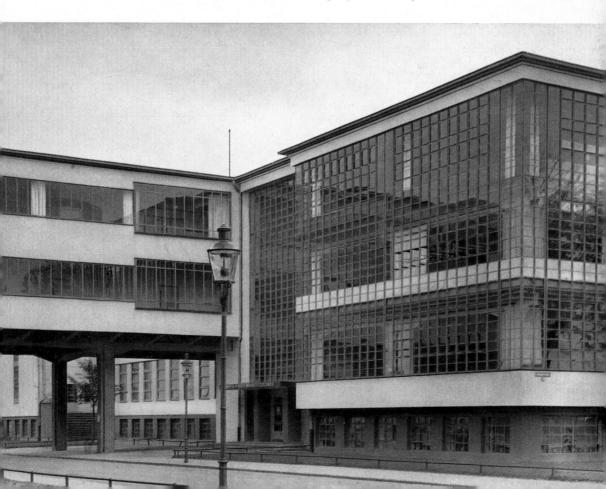

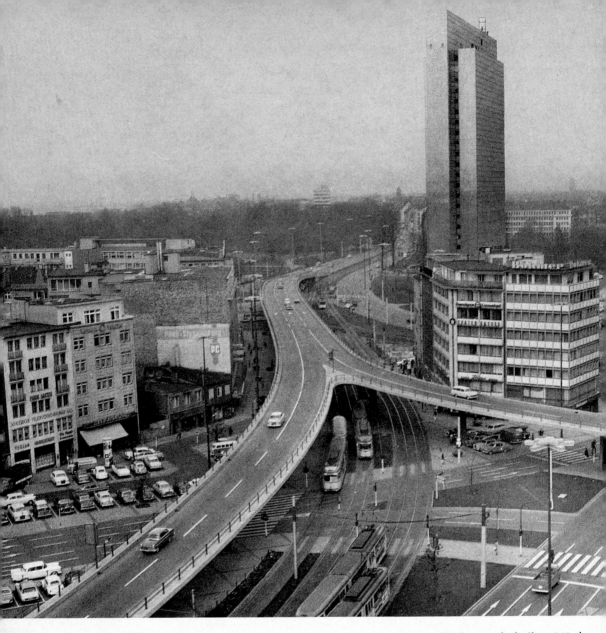

Düsseldorf, new overhead road with Thyssen House in the background, built 1960 by Hentrich and Petschnigg

Right: Hamburg-Lohbrügge, Housing Estate, 1960—1969

Berlin, New National Gallery, by Ludwig Mies van der Rohe (1886—1969), opened 1968

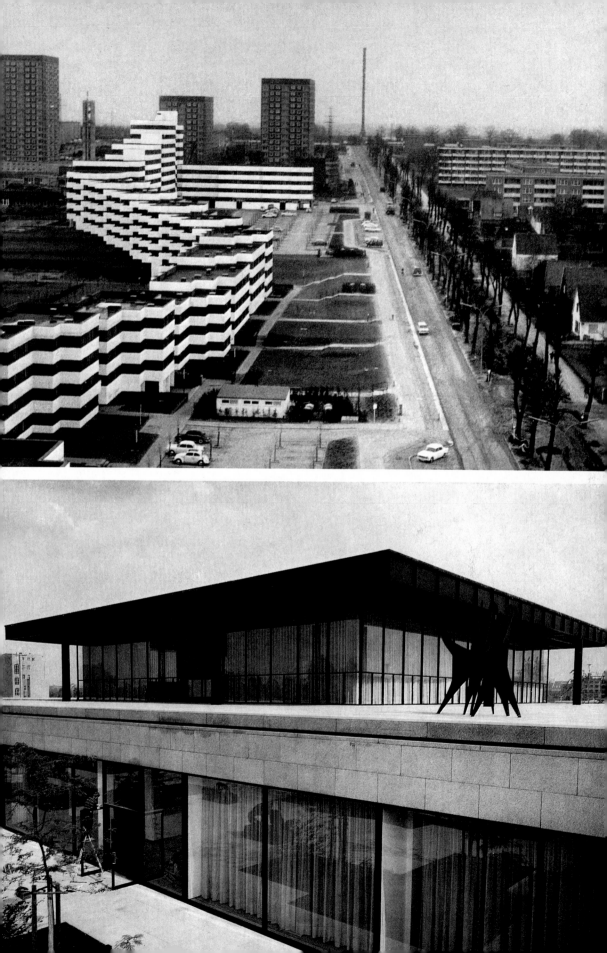

It took some time, however, before this attitude was accepted by architects, whose aversion to machine-made structures was based on the traditional view that a work of art depended on craftsmanship. The English artist William Morris saw mechanization as an evil that was threatening humanity; he never stepped aboard a train in his life and carried a spinning wheel through the streets of London, as a testimony to the traditional craft. Morris's attitude was a romantic anachronism, but his ideas continued to have their effect and were later taken up by those who sought a solution to the conflict between craftsmanship and mechanization.

The foundation of the *Werkbund* (1907) represented the first serious attempt to harmonize the ideas of artists and craftsmen with the demands of industry, to give the industrial product a satisfactory artistic form without thereby hiding its technical function. Peter Behrens, one of the founders of the *Jugendstil* who later turned to the *Neue Sachlichkeit* [new objectivity], was one of the first to put this into effect. He designed the AEG gas-turbine plant in Berlin (see p. 177), the first modern factory building, which by the clarity of its design stands up to any criticism to this day. Big windows are separated by steel ribs which broaden towards the top and carry the angulated tunnel-shaped roof. The structure is simple and straightforward: where steel is used it remains visible, and stone and glass are brought into direct contact with it; the proportions are based on practical considerations. And yet this factory is more than a mere engineering construction. The rhythmic articulation of the windows and the structure's grace, which is achieved by the use of slender supports, reveal a new aesthetic concept that combines utility and beauty. Peter Behrens continued to work for the AEG until the beginning of the Second World War and contributed a great deal to the development of industrial design. As the teacher of Le Corbusier and Walter Gropius he is considered one of the pioneers of modern architecture.

Walter Gropius is probably the most important representative of modern architecture in Germany. In 1911 he designed the Fagus Works in Alfeld an der Leine (see p. 179) and thereby created a building which for the first time expresses the spirit of present-day architecture. Gropius omitted the conventional façade and the compulsory symmetry resulting therefrom and instead designed a cubical structure that can be viewed from any side. The strong horizontal orientation of the storeys is effectively counterbalanced by the light, transparent glass surfaces of the regular windows. The workers are no longer confined behind the dark walls of a factory that stands at the back of a presumptiously solemn administrative building. The production area shows itself publicly; the workers have ceased to be

shut away in a ghetto. Such structures, which helped to eliminate the social discrimination against factory labourers, expressed the employers' growing understanding of social problems and played a part in increasing the self-confidence of the industrial workers.

After the First World War Gropius continued along the same lines and in 1919 founded the Bauhaus at Weimar. He wanted to eliminate the distinctions between structural and decorative art and revive the idea of the co-operation of all the arts to create an integral work of art. He also wanted to bridge the traditional gap between creative and applied art by establishing a positive relationship between art and industry. The machine and its products, the big factory building and the simple article for daily use were in future to be given their outer appearance by the industrial designer, who was to shape new aesthetic concepts by combining utility with beauty. A timely synthesis was in progress, the more so as those active at the Bauhaus were not engineers but artists of great individuality who nevertheless had the necessary insight into the problems posed by industrialization.

As early as the 1920s, the structural purism of the 'new objectivity' in architecture was countered by spatial and ornamental ideas that verged on the fantastic (see Erich Mendelsohn's Einsteinturm near Potsdam, p. 178). Attempts were made to adapt the broken lines of Expressionist paintings to architecture. Although most of this Expressionist architecture did not go beyond the drawing-board stage, there are a few completed projects which reflect this new effort. Poelzig's stalactite architecture in the Schauspielhaus in Berlin for instance, creates the impression of a fairy-tale cave where Bengal lighting effects transform the auditorium into an oriental dream world. The spectator, by being removed from reality, was to become more receptive of events on the stage. Similarly Fritz Hoeger's imposing Chile-haus in Hamburg (see p. 180) is not without romantic pathos. The building has the shape of an enormous ship's bow which symbolizes the open spirit of the North German harbour town. In order to express an idea the structural requirements of an office building were disregarded. The use of indigenous North German bricks cannot be considered successful, despite the fact that Hoeger sought to overcome the inherent contradiction between the small size of the bricks and the large surface of the building by alternating the smooth high wall with a sparing ornamentation of glazed coloured or canted bricks.

In 1925 the Bauhaus moved to Dessau, into a building designed by Gropius (see p. 181). The essential stylistic elements of this structure have remained valid to this day: omission of elaborate façades, lack of ornamentation, wall surfaces of mainly glass, and composition and articulation of the overall structure and of its individual parts by means of simple geometrical and stereometrical shapes such as the rectangle, the square, the

cube and the prism. What Gropius started, hesitatingly at first and keeping within controlled dimensions, later became a universally applied architectural concept. Whole cities of such uniform cubes sprang up and the same stylistic principles were used for office buildings, apartment blocks, factories, theatres, museums and concert halls. These smooth, steeply rising structures with their reflecting surfaces of glass and stone are undoubtedly imposing, but, like impersonal giants, they tower with such uncompromising monotony above the individual, that he no longer feels part of an animate world. It cannot be conducive to the development of the individual to live and work in a whole town of such concrete blocks, from which every non-functional, old-fashioned building has been removed.

Our new buildings are described as functional; they are supposed to fulfil a purpose. But while a lot of attention is given to their functional purpose, the human needs are too often overlooked. The problem of co-existence in the suburbs on the outskirts of big cities, the depopulation of city centres, and the frightening urbanization of the countryside which resulted from a misunderstood desire for spacious living, have forced town planners and architects to re-examine this concept of functionality. Many architects and contractors, when criticized, blame the aesthetic deficiencies of modern architecture on the functional requirements of modern life, but this is frequently a way of covering up their own lack of imagination, or their business efficiency in considerations of cost. For years cool, functional designs dominated domestic as well as industrial and municipal architecture (see p. 182). Gradually, however, different materials such as natural stone, aluminium, brass, ceramic tiles, wood and plastics began to be employed to face the outside of buildings in an attempt to introduce a certain animation. Similarly, the cold white-wash was replaced by warmer colours, and decorative mosaics and ornamentation were used to articulate the rigid wall surfaces, but despite this modern ornamentation the basic functional concept of the structures remained unchanged.

These attempts to enliven the cubical structure by plastic articulation were indicative of future developments. Soon architects went a step further and produced a new visual effect through a rhythmical transposition of the walls in the horizontal as well as in the vertical plane, by projection and recession and with a rise and fall of larger and smaller cubical units. The verticality of the apartment blocks in Hamburg-Lohbrügge (see p. 183) is accentuated by the interchange of black and white wall sections, whereby additional articulation is achieved by their transposition amongst each other.

In the planning of larger city housing developments the overall layout was taken more into consideration. Until a few years ago a guiding principle in the execution of such projects was the uniformity of height, with only a few tower blocks providing an enlivening element. Today units of

many different heights are juxtaposed so as to create a highly individual, movemented skyline, offering in some cases a fascinating view. Modern architecture is producing a wealth of new ideas and the development of these can be traced back to the engineering constructions and to the simple severity of subsequent designs that had been evolved by various creative artists.

Since 1945 frequent attempts have been made to create alternatives to the functional, utilitarian architecture of our century. In most recent years a number of outstanding buildings have been created which show that functional necessities are by no means in conflict with man's need for a lively spatial environment. A happy combination of modern structural techniques and architectural inventiveness is Hans Scharoun's Philharmonie in Berlin (see p. 184). From a pentagonal ground-plan rises a structure which is composed of a diversity of broken surfaces, indentations, sharp corners and other highly imaginative, bizarre spatial forms that create the impression of a folded paper shape. This wealth of ideas animates the whole building. Bull's eyes and windows of different designs are placed at varying angles and give the walls an enchanting lightness and transparency; swinging lines surround intersecting planes, diagonals alternate with horizontals and verticals, capricious interior projections are playfully transposed with staircases and balconies, and these intersections and broken surfaces continue throughout the many entrance halls, vestibules, cloakrooms and foyers. The light, coming from coloured windows, cone-shaped lamps and other unsuspected sources, further adds to the gay excitement, and repeatedly squared-off corridors lead the visitor to his destination, the concert hall. The attractive transposition of rooms on different levels invites the audience to adventurous explorations before the concert and during the interval; instead of remaining in fixed formal groups, they become a living community, and the building thereby fulfils its purpose as a meeting place, a centre of visual delights and artistic experiences.

After this light-hearted introduction the harmonious colour scheme of the concert hall receives the visitors with pleasant tranquility. The hall is as richly articulated as the foyers, but its most striking aspect is the position of the orchestra, which is not situated on a stage confronting the audience, but is placed in their midst. Orchestra and audience are treated as a community, both active participants in the artistic event. The hall resembles a coomb, with the orchestra at the bottom; the seats are placed around the source of sound, not in uniform rings or tiers, but asymmetrically, in rectangular groups that are separated by broad stone balustrades, some level, some rising towards the back.

188 Right: Ernst Barlach (1870—1938): Female Dancer. Wood

Renée Sintenis (1888—1965): Football Player, 1927. Bronze

Right: Georg Kolbe (1877—1947): Female Dancer, 1912. Bronze

Ewald Mataré (1887—1965): Pelican Feeding its Young, 1948. Bronze and enamel. Detail from the south door of Cologne Cathedral

Left: Gerhard Marcks (born 1889): Dancing Girls, 1935. Bronze

Fritz Wotruba (born 1907): Reclining Figure, 1953. Cement

Max Bill (born 1908): Rhythm in Space, 1947—1948. Plaster

Günter Haese (born 1924): Another Moon, 1963

With the Philharmonie, Hans Scharoun added a new meaning to the concept of functional architecture by making the structure the mediator between the musical masterpiece and the audience. Similarly Mies van der Rohe in his design for the New National Gallery in Berlin (see p. 183) was concerned only with the most favourable presentation of paintings and took extraordinary measures in order to achieve this. By placing the exhibition rooms underground, he eliminated one basic difficulty, which all museums invariably face, that of the changeable quality of natural light. At the New National Gallery the pictures are not affected by changes in weather and light; for the first time painted light ceases to compete with natural light. So that the visitor does not feel confined, a charming inside garden, surrounded by high granite walls, enables him to deepen the experience of what he has seen in different, though still secluded, surroundings. Over the massive complex of subterranean galleries rises a comparatively delicate temple of glass and steel. Far from evoking solemn, museum-like associations, this structure acts more as a location point for the gallery; its transparence welcomes the visitor and its harmonious classical proportions prepare those entering for their encounter with the works of art that await them. These are not the sacred halls of a temple of the muses; the light-flooded room, uninterrupted by structural supports, does not allow a feeling of any inappropriate solemnity. Mies van der Rohe, assistant to Peter Behrens and for many years head of the Bauhaus, is considered one of the most important teachers of modern architecture.

At the beginning of the century architecture and painting developed radically new concepts, but this was not true of sculpture, possibly because it had always been thematically tied to the human figure; Greek gods, saints and angels, even medieval devils were represented in human shape. Until well into the twentieth century sculptors could only express religious, social, philosophical and allegorical ideas through the human figure. What did, however, change at the beginning of the twentieth century was the human image in contemporary sculpture. While in the past sculpture had been a hymn to the beauty of the body, which in turn was held to be the mirror of a beautiful soul, contemporary artists rejected this traditional idealized human image; they created sculptures of unnatural figures with bizarre movements and cracked surfaces.

Sculptors adopted Expressionism, in fact, before this style was generally accepted by painters. Wilhelm Lehmbruck's figures, most of which date from before the First World War, describe a state of mind and thereby

Left: Hans Uhlmann (born 1900): Metal Sculpture outside the German Opera, Berlin, 1961

spontaneously take up the subject of Siegmund Freud's studies of the unconscious. Ernst Barlach's monumental figures express a deep sympathy for the sorrow and anguish of human existence, while the sculptures and engravings of Käthe Kollwitz demonstrate her preoccupation with the misery of her surroundings. Despite this obvious awareness of the present, sculptors never forgot their past heritage, for which they continued to search. During a trip to Rome, Georg Kolbe turned from painting to sculpture, and his balanced figures draw their strength from ancient Greek models. Their beauty is based less on pleasing proportions than on a fascinating interaction between tension and repose. A gentle movement flows from the legs of his Female Dancer (see p. 191) upwards and pulsates with varying intensity through every part of her body until it fades away through head and arms in a dream-like lack of gravity. The sculptures by Gerhard Marcks are less movemented and therefore closer to the Classical Greek concept of the human body, while at the same time showing a clear tendency towards abstraction in form and movement. Without adhering to natural proportions he puts together parts of the bodies of the two figures in Dancing Girls (see. p. 192) in purely plastic forms.

While Kolbe, Marcks, Edwin Scharf and Renée Sintenis (see p. 190) turned to the noble beauty of ancient Greek sculptures in their quest for the basic forms of sculptural creation, Ernst Barlach was more stimulated by the German Middle Ages, particularly by the expressive, sometimes rough monumental sculptures of Ottonian times. His massive figures, carved in wood, evoke the expressive art of primitive peoples, or the strange beauty of Russian folk art which he discovered during a journey to Russia. But the crude form which consistently ignores details is not an end in itself for Barlach; he uses it in order to express the primitive emotional strength of his figures more clearly. His Female Dancer (see p. 189), her body enveloped by a large robe and her hands firmly encircling her face, lives in a lonely world of her own where everything centres around her dancing, her art.

While German sculptors continued to use the human figure to express their ideas, sculptors elsewhere began to move away from this old dependence. The Cubistically deformed figures of the Russian Archipenko represent a development in this direction which was taken a step further by the Rumanian Brancusi, who was the first sculptor to create non-representational forms of striking simplicity, such as a carefully sculptured marble egg which he called The Beginning of the World.

The final break-through came with Henry Moore, who understood sculpture 'simply as form', namely as truly three-dimensional form that makes no distinction between the front and the back view. His further achievement was to make space itself, the space surrounding the sculpture and the space enclosed by the sculpture, into a source of energy. This question of

198

space was to become one of the main preoccupations of modern sculpture. The Swiss Max Bill created space-enclosing shapes (see p. 194) by intertwining thin sculptured planes. He thereby achieved a strong dynamic movement and a nearly floating lightness. In Moore's case the sculptured shape remains the dominant factor in the relationship of space and shape, while Bill is more concerned with space itself. A further reduction of the sculptured mass to thinner and finer forms finally led to wire sculptures which consist merely of lines that limit and encircle space (see Günter Haese, Another Moon, p. 195). In the case of wire sculptures the figure no longer consists of bodily mass but literally only of space. The development of such airy shapes seems absolutely justified at a time when science proved that mass and energy did not exist in direct contradiction to each other, but that mass could be converted into energy and energy into mass. (See also Fritz Wotruba, p. 193.)

The tendency of modern sculptors to exploit the possibilities of the third dimension has resulted in a neglect of architectural sculpture which in the past played as important a role as free-standing sculpture. The smooth wall surfaces of modern architecture, which frequently are a feature in their own right, provide little opportunity for sculptural creation. Furthermore contemporary architects consider ornaments and sculptured decor as an interference, and architectural sculpture therefore no longer has the importance it had until the twentieth century. But whenever it is necessary to enrich a structure sculpturally, the portals, or church doors, provide the obvious opportunities for such architectural sculpture, as they did in the Middle Ages and Renaissance. Not only in modern church architecture but also in the restoration of religious buildings, there lies the challenge to find new forms for the old symbols. Ewald Mataré is one of the modern creative artists who has successfully met this challenge. He designed a new portal decoration for the Cologne Cathedral in 1948 (see p. 193).

Also successful in this respect is the façade of the German Opera House in Berlin, where Hans Uhlmann's metal sculpture (see p. 196) is most effectively set against a rough wall-finish of pebbles in concrete which, in turn, is powerfully accentuated by the sculpture; architecture and sculpture complement each other without either losing its individuality. The motif of vertical and horizontal bonding of the wall surface is taken up and dynamized by the sculpture in variations of free form. The sculpture's thin vertical lines are effectively contrasted by the broad structure and its horizontal lines are reduced to slanted wing-like stumps which produce an effect of upward movement, not unlike that of a flying missile. The apparent lack of gravity is underlined by the solid structural background.

For a long time German twentieth-century painting and graphic art were overshadowed by French art and were not given the international

recognition which they deserved. Ten years ago French paintings fetched sensational prices on the international art market while German pictures were ignored and, to a large extent, were unknown. German Expressionists were not considered to have any significance as far as European artistic developments were concerned and German Impressionists were dismissed as mere epigones of the French. Recently, however, the situation has changed. After a few successful exhibitions in Paris, London, and New York modern German art suddenly received world-wide recognition; at auctions lively bidding by dealers and collectors produced prices which previously were only obtained for Old Masters, and art critics have tried to make up for decades of neglect by detailed and informed appreciations.

The artistic life in France had always profited from the traditional centralization of the country and the resulting importance of the capital. Paris had for many centuries been the political, economic and cultural centre of France and as such had attracted the country's intellectual elite. The literary *salons* of Paris were the cradles of French literature, and Montmartre became the Mecca of painters and sculptors; artists were formed by the response, criticism, stimulation and success they found in Paris.

In Germany the situation was quite the opposite. Since the early nineteenth century many academies had been founded in provincial capitals; they competed with each other and this federalistic attitude survives to this day inasmuch as the provinces retain their cultural independence. When comparing Germany to France this lack of centralization may be deplored, but it was shown clearly during the time of National Socialism where a centrally directed cultural programme can lead. The existing structure has, in many respects, proved beneficial. Although artistic concentrations like the one in Paris further the development of important movements, they can also stifle individual ideas by tempting artists to follow the general trend. It was due to its cultural federalism that a great variety of stylistic forms developed in Germany at the beginning of this century.

The origins of modern painting in German-speaking countries are closely linked with events in Munich and Vienna that led to the formation of the *Jugendstil* movement shortly before the turn of the century. The name had

Right: Wassily Kandinsky (1866—1944): The Looking Glass, 1907. Coloured linocut

Page 202: Wassily Kandinsky (1866—1944): Composition with Blue Spot, 1923. Watercolour and Indian ink

Page 203: Paul Klee (1879—1940): Motif from Hamammet, 1914. Watercolour over pencil drawing

been adopted from the Munich art magazine *Die Jugend* [Youth] which was founded in January 1876; the *Jugendstil* became known as Art Nouveau in France, Modern Style in England and Arte Joven in Spain. The *Jugendstil* was primarily taken up by the applied arts: architecture, fashion, book illustration and other crafts. Painting and the graphic arts profited only indirectly from its ornamental wealth; it enabled them to express abstract reality through flat, purely decorative forms. The influence of this style on modern painting was not recognized for some time, mainly because the intertwined, ornamented motifs soon appeared in excess on purely industrial objects.

The Swiss painter Ferdinand Hodler was one of those who used the surrealist, symbolic strength of the *Jugendstil* for the abstraction of reality. His symbolistic, figural compositions were enthusiastically received in Vienna, the home of the *Jugendstil* movement, where the fifty-year-old artist finally found the recognition for which he had struggled in vain in his own country. Although his more mannered compositions and overloaded backgrounds did not stand up well to the test of time, his portraits and particularly his landscapes of Lake Thun, the Bernese Alps, the Engadin and Lake Geneva are highly regarded today. They are free from any mystical ideology and successfully present his artistic ideas of transposing the reality of nature into a higher artistic reality. His picture of Lake Geneva from Chexbres (see p. 172) forces the landscape into an ornamental pattern. The short vertical lines of the grass in the foreground are contrasted by a system of horizontally graduated shapes which he fills with glassy, delicate colours. The cloud bank at the upper edge of the picture is as much part of this carefully constructed spatial composition as the cumulus clouds on the horizon, even the glaring light serving the artistic clarification of form. And yet Hodler does not falsify the character of the landscape; on the contrary, this picturesque exaggeration heightens its significance.

Egon Schiele, a principal exponent of the Viennese *Jugendstil*, who was strongly influenced by Gustav Klimt, employed other means to create such ornamental representations. In his The Artist's Mother Asleep (see p. 209) a variety of flat, abstract coloured shapes constitute a two-dimensional background from which only the female head emerges. Despite the fact that such interpretations are otherwise foreign to the *Jugendstil*, this picture symbolically expresses the idea of a human being threatened by hostile forces and therefore links Schiele with Symbolists such as Edvard Munch and Ferdinand Hodler, although his formal language is different.

The *Jugendstil* has frequently been dismissed as a modish curiosity of the *fin de siècle*. But its importance went far beyond this, as is illustrated

Jugendstil ornaments, about 1900

by the fact that in his early years no lesser than the famous Wassily Kandinsky was one of its enthusiastic followers; he arrived at his later, non-representational, abstract style through the *Jugendstil*. Kandinsky was an excellent engraver and before leaving his native Russia had, for some time, been in charge of an art printing shop and had gathered valuable experience in this field. He could not only realize his pictorial ideas graphically, he could also carry out the printing himself. The linocut was his favourite technique and he preferred making two plates for each block, one for black and one for colour. The Japanese woodcut, which enjoyed great popularity in Europe at that time, may well have been his source of inspiration. From this period dates The Looking Glass (see p. 201) in which Kandinsky presents a strongly stylized view of reality; broad contours divide the pink clouds into decorative patterns, the folds of the dress form ornamental shapes and its floral design merges with the flowers of the lawn. A series of coloured woodcuts which the French painter Gauguin had created in Tahiti more than ten years earlier show a very similar blending of real and ornamental elements.

German artists played an important part in the revival of graphic techniques as an independent means of expression—one of the great achievements of contemporary art. In 1905 a number of young artists in Dresden, most of them self-educated men, founded a society which gained world fame, called the *Brücke* [Bridge]. What brought them together was their revolt against the artistic establishment; they wanted to eliminate the restrictions of artistic tradition and teaching in order to be able to create freely. The graphic arts, particularly the woodcut and the linocut, seemed to them the most suitable media for the expression of their pictorial concepts. These techniques demanded a radical simplification of forms and a turning away from traditional, representational interpretations; as a result,

206

members of the *Brücke* looked to primitive art for inspiration and they found their own ideas confirmed by expressive crude Negro sculptures and Etruscan demon figures. Representations of external forms no longer satisfied them; they wanted to expose the hidden passions and emotions, the primitive expressions, unfalsified by civilization, of hope and fear, love and hatred, desire and despair (see p. 216).

The engravings of the *Brücke* artists are characterized by heavy angular lines, and in their paintings loud colours are applied broadly with a rough, dry brush. Realistic details are ignored and the pictures and prints, therefore, have an aggressive, insistent, poster-like quality that is most expressive. Ernst Ludwig Kirchner was one of the principal exponents of this Expressionism. During his *Sturm und Drang* period, before the First World War, he painted pictures full of angry social criticism and even his watercolours of landscapes convey a tremendous creativity and leave little room for idyllic contemplation. His Valley near Davos-Frauenkirch (see p. 211), which dates from after the First World War, is a primitive picture of nature full of bizarre shapes and contrasts. To underline this impression Kirchner uses unnatural colours and destroys any romantic sensibility with massive, broad brush-strokes that reduce reality to a monumental simplicity. As a result the picture is more a physiography than a traditional landscape reflecting a human mood.

Kirchner, Bleyl, Heckel and Schmidt-Rottluff founded the *Brücke* in 1905. Max Pechstein joined one year later but in 1908 he moved from Dresden to Berlin and his friends followed him there in 1911. Max Pechstein was the first Expressionist who found unanimous approval among art critics and who made a commercial success of painting. His pictures were pleasing in the best sense and yet powerful and compelling. A further explanation for his lasting popularity was the fact that his work contained no provocative or controversial elements and expressed none of the biting criticism with which other *Brücke* artists frequently offended the public. Pechstein's work is free of any anti-social tendencies; he saw the world as an artist and his revolutionary ideas were confined to artistic matters. His painting Fishing-Boat (see p. 220) does not represent the heroic battle of man against nature but is an interpretation of primitive force itself. Boat and men are fused into a dynamic unit, mast and ropes tower over them like the point of an arrow. The picture conveys a dramatic impression of movement which is created not by the bodies of the oarsmen, but by the diagonal position of the parallel oars and by the exciting use of colour. Although strictly ordered by robustly simplified outlines, the palette seems in a turmoil and expresses the unchained elemental ferocity of nature.

Expressionism became the predominant style of post-war years. After 1918, when Germany was shaken by political, economic and social disturbances, Expressionism fulfilled an important task as an art of alarm,

entreaty and accusation. Many pictures predicted future political catastrophies with nearly prophetic foresight; the first unmasking caricatures of Hitler were drawn by George Grosz as early as 1926, and his pictures of social criticism (see p. 214) portray the reverse side of the 'golden twenties', in which the nationalists were already at this time setting the scene of the following decades. Carl Hofer was painting ruined cities and burning towns long before the bombs descended on Germany. Already in 1916 Otto Dix, with sketches and drawings he had made in the trenches on the front, had vividly expressed the horrors of war. His Shelled House (see p. 212) symbolizes a world of total chaos: wild and strange fragments of a former order—walls, floors and ceilings—lie hopelessly scattered and destroyed.

Max Beckmann also interpreted the theme of threatened humanity, but in a more general and timeless fashion: figures on circus-like stages, chained to each other, their faces mask-like and frozen, their bodies wracked by passion, recur in his pictures as symbols of a subjected and merciless society. In his Apache Dance (see p. 225), a brutal masculine figure which takes up most of the canvas violently subjects those around him; one body hangs weakly and limply over his shoulders, his eyes are searching for new victims, and yet the faceless spectators seem strangely unconcerned, unaware of what is happening. Most of Beckmann's pictures are beyond rational interpretation; their metaphysical background has to be understood instinctively, the oracle-like signs and figures cannot be dissected by logic. But in this case the allusion to contemporary events is all too obvious. The picture was painted in 1938, shortly after Beckmann, who had come under pressure from the National Socialist authorities, had emigrated to Holland.

Like Beckmann, Oskar Kokoschka was able to maintain his independence of contemporary stylistic movements, although his art nevertheless reflects his time. His self-portrait of 1913 (see p. 224) clearly conveys the unrest and imminent political and social upheaval in Europe; at the same time, the searching, direct gaze implies critical self-analysis. Kokoschka's sensitive and penetrating portrayal of faces is the characteristic feature of his work. He seemed to lay bare the souls of his subjects, conveying all their anxieties and complexes.

Although Emil Nolde was a member of the *Brücke* from 1906 to 1908, he did not share their critical attitude toward contemporary life and society. The only characteristic he shared with the masters of the *Brücke* was a preference for luminous colours and big, expressive forms. He went

Right: Egon Schiele (1890—1918): The Artist's Mother Asleep, 1911. Pencil and watercolour

Otto Dix (1891—1969): Shelled House, about 1916. Poster paint on brown paper

Page 210: August Macke (1887—1914): Children and Goats on the Border of the Lake (Lake Thun), 1913. Coloured chalk and watercolour

Page 211: Ernst Ludwig Kirchner (1880—1938): Valley near Davos-Frauenkirch (Trees on the Sertigweg), 1926. Watercolour over pencil drawing

very much his own way: he travelled alone to China, Japan and Polynesia, among other places, and for long periods lived withdrawn in a small fisherman's hut on the North Sea coast. Consequently he developed a very personal style which did not relate to the big stylistic movements of his time. Apart from landscapes and religious representations he repeatedly painted flowers (see p. 204); they were for him, he said, expressions of happiness: 'Flowers grow to bring happiness to people. I paint them in the summer and thereby carry the happiness into winter.'

Besides Dresden and Berlin, Munich also became a centre of modern painting during the first decade of the century. In this stronghold of academic art with its wealth of traditions, where neither progress nor artistic originality was tolerated, another resistance movement to the artistic establishment began to develop. The *Jugendstil* had already declared war on the traditionalists in Munich and from then on more and more young artists who came to that city were no longer prepared to bow to the strict rules of professors of the Academy. With the co-operation of the Russian Wassily Kandinsky, the Phalanx was founded in Munich and through it the progressive forces met and encouraged each other. In an attempt to break with the traditional methods of artistic education members of the Phalanx opened their own art school, but they lacked a coherent programme and failed to attract important artists, so that their influence on the artistic life of the city was slight.

Unlike the *Brücke* artists, who rejected all outside influences, members of the Munich group were keen observers of contemporary developments in other leading artistic centres. They travelled to Berlin, Vienna, and above all to Paris, where they became acquainted with the two-dimensional style of Cézanne and Gauguin, with the colourful paintings of the Fauvists and with Cubist constructivism. Abstraction of form and colour emerged as a common interest and was energetically pursued. In 1909 the *Neue Künstlervereinigung* was founded under the chairmanship of Kandinsky and with the participation of Jawlensky, Kubin, Gabriele Münter and others. One year later Klee, Marc and Macke joined the group. Their first exhibition in December 1909, however, showed that some members of the group were not yet ready and able to break with the past and eliminate from their paintings all traces of realism. Therefore Kandinsky, Kubin, Macke, Marc and Münter broke away in 1911 and organized their own exhibition under the name of *Der Blaue Reiter*. In a brochure which they published at the same time Kandinsky wrote: 'The possible interpretations from which the intellect has to choose lie between two poles: complete abstraction and complete realism; from these two poles different paths lead ultimately to the same goal, and many harmonious combinations of abstraction and reality can be found between them. Complete abstraction is an endeavour to exclude the representational altogether and to interpret

213

George Grosz (1893—1959):
Evening Party, 1925.
Drawing

the meaning of the work through unrealistic forms. The theme of the
picture is best revealed by adopting that point of view and expressing it in
the picture, by reducing representational forms to a minimum and allowing
abstract units to predominate.'

In 1910 Kandinsky painted the first non-representational or, as he called
it, 'the first abstract watercolour', and the abstract style has continued to
dominate Western art ever since. Kandinsky developed some basic precepts
for his purely intuitive improvisations of colour and form and in his book
Punkt und Linie zur Fläche, published in 1926, he analysed the different
elements of his compositions. In his view the vertical line was warm, and
the horizontal line cold; the upper part of the picture conveyed lightness
and relaxation while the lower part represented concentration and mass.
He also devised rules for the use of colour: for instance, the proper shape
for red was the right angle and for blue the obtuse angle. Composition with
Blue Spot (see p. 202) was painted in 1923. In view of his theory that the
forces strive outwards to the left, he terminates the left side of the picture
with a heavy black vertical line, and the thin diagonal line in the lower
half is less firm and therefore cannot hold up the descending movement,
which only ends at the two parallel undulating diagonal lines below.

The rich inventiveness and artistic imagination of the Swiss painter Paul Klee presents a complete contrast to Kandinsky's analytical methods. Klee did not view abstraction as a way of overcoming reality, he did not even consider the possibility of a conflict between abstraction and reality. 'Art', he once wrote, 'transcends the object, the real as well as the imaginary. It plays an uncertain game with things. Children imitate us in their games and similarly we playfully imitate the forces that created and continue to create the world.' Klee arrived at abstraction through the pleasure of creating forms and shapes which were modelled neither on nature nor on man-made objects. He refused to regard abstraction as a doctrine and used it simply to express his own, very personal ideas, unhampered by the restrictions of representational obligations. Motif from Hamammet (see p. 203) was painted during a journey to North Africa where he went in 1914 with August Macke. This experience was of decisive importance for his subsequent development; there, in the colourful world of the Orient, he found his relationship to colour. He wrote in his diary at the time: 'Colour has got me. I no longer have to run after it. It has got me for good, I know it. This is my happiest hour: I and colour are one. I am a painter.' And somewhere else it reads: 'My watercolours are strongly transposed and yet they remain completely faithful to nature . . .'

Motif from Hamammet demonstrates very clearly what Klee meant by 'remaining faithful to nature'. His personal experience of this oriental world, the light, the strong colours, the strange shape of the vegetation, the foreign sounds and smells are 'transposed' by Klee into an autonomous, non-representational composition. Everything is simple, almost self-evident; three-dimensional houses become two-dimensional, the remaining representational elements, roof-gutters and windows, turn into independent shapes, and the colours find a new order which no longer follows the laws of nature, but rather the painter's own, artistic laws.

August Macke, a friend of Klee's for many years and a member of *Der Blaue Reiter,* was much more methodical than Klee in his transposition of natural objects to coloured planes. His aim was not to create a subjective, poetic analogy of reality, but to integrate representational reality into a purely decorative composition by combining several pictorial concepts. His picture in coloured chalk and watercolour Children and Goats on the Border of the Lake (see p. 210) clearly shows various, mainly French influences; to the Impressionists he owes the concept of a world irradiated by sun and light, from the Cubists he adopted the flat, two-dimensional representation, and the Fauvists taught him the use of unmixed, pure colours. Animals, trees and figures are hidden in a mosaic-like web of partly interlocking planes of colour; he leaves their discovery to chance and in the meantime delights the eye with a lively rhythm of light and colour, which changes from luminous blues on the left to brilliant greens and

Erich Heckel
(1883—1969):
Reading Aloud, 1914.
Woodcut

yellows on the right. This playful intermingling of differently shaped
coloured planes is based on a rigid system of vertical, horizontal and di-
agonal lines which imposes order and clarity, almost to a point of inter-
fering too severely with the delicate web of colours, as if the artist purpose-
ly wanted to check his imagination by introducing various rules and re-
strictions.

After a journey to Tunis in the spring of 1914 Macke lost this formal
uncertainty, and a series of magically bright watercolours as well as a
limited number of other paintings from this period show that he had over-
come outside influences and had achieved a personal style of his own. But
before he could develop this any further the First World War broke out.

Macke enlisted as a volunteer and was killed in France on 26th September 1914. His premature death was a great loss for the German world of art.

Franz Marc was one of the first German painters who totally freely used colour not to produce a similarity with nature but to heighten a particular pictorial effect. Very early in his career he came into contact with French contemporary painting and from it 'learned more in one month than in five years at the Munich Academy...' He was in close touch with the *Jugendstil* in Munich and adopted its flat ornamental forms and the pure, decorative use of colour without, however, becoming modishly elegant, as frequently was the case with other followers of this movement.

Marc met August Macke and Kandinsky in 1910 and with them produced the almanac *Der Blaue Reiter*. In it they expounded their artistic views which, without favouring a particular style, advocated a return to the simple forms and clear colourations of peasant pictures and children's drawings. His search for a primitive world, untouched by civilization, led Marc to the world of animals. He studied their behaviour and natural habitat with the patience of a zoologist, so as to be able to portray them convincingly in form and colour and, what was more important to him, to do them justice as living creatures. In order to achieve the closest possible relationship between the animal and its natural surroundings he broke up his compositions into crystalline forms; by superimposing and interlocking these he created a dense web of luminous colours which effectively integrated the shapes of plants and animals. This technique of breaking down natural shapes into geometrical planes, which were then joined to form a new, surrealistic pattern, was used by the Cubists at the end of the nineteenth century. Marc at first admired the courage with which the Cubists adopted the two-dimensional concept and rejected spatial illusion, but he soon saw the dangers of this hard, structured style and enriched the cool, passionless scheme of the Cubists by more dynamic lines and colours. He wrote: 'Those with Cubist and other programmes will, after easy triumphs, be defeated by their own superficiality.'

In his painting Foxes (see p. 219) Marc used predominantly dark tones which relate to the thicket of undergrowth, the natural habitat of these animals. Strong reds and dark greens are combined into a dense unit in which representational details become unrecognizable. Only the pointed heads of the foxes lurk in this network of colours and shapes, motionless but nevertheless ready to pounce at any moment. The crystalline broken forms are not used, as in Cubist compositions, for the systematic deformation of the representational but as a camouflage, a pictorial interpretation of natural conditions.

Despite his progressive techniques Marc was a mystic, related in spirit to Francis of Assisi, for whom animals were creatures which God had not yet expelled from Paradise. Marc had a religious attitude toward nature.

The luminous clean colours of his animal pictures, their glassy transparency and their sensitive forms indicate his longing for the perfect, natural being that lives in harmony with the divine order. By turning to nature he revealed a deep pessimism and a profound hatred of civilization. This view was shared by many Expressionists but while they indicated their disgust with civilization through more or less open social criticism, Marc escaped into an inviolable dream world. 'Art', he admitted shortly before his death 'is nothing but the expression of our dreams.'

The work of Heinrich Campendonk, another member of *Der Blaue Reiter,* is much less pessimistic and problematic. His notable characteristics are a poetic, imaginative presentation and an obvious distaste for any form of theoretical experimenting, in which many of his Munich friends indulged and which often merely impeded their personal development. Campendonk loved light-hearted make-belief; he was more at home in a world of dreams and fairy-tales than in a world governed by order and reason, but this lack of formal discipline frequently worked against him. In his picture The Garden (see p. 221) various outside influences can be discerned: the broken planes of colour reflect Cubism, the surrealistic merging of ornamental, figural and representational elements into a poetic scene are reminiscent of Chagall, and the use of luminous tones indicates his association with *Der Blaue Reiter.* Campendonk combined these elements and developed a very individual style. The mysterious darkness of the forest and the jungle-like wilderness of the tall trees are accentuated by the conspicuously civilized patch of lawn and the ordered severity of the potted plants. These contrasting elements give the picture an intriguing surrealistic quality which is heightened by the two seemingly unconnected female figures. The charm of this painting lies in its inexplicability; Campendonk has created a fairy-tale world not unlike that experienced by children, where reality takes second place.

At the outbreak of the First World War *Der Blaue Reiter* disintegrated. As Russian nationals, Kandinsky and Jawlensky had to leave Germany; Klee and Campendonk served behind the lines; Marc and Macke enlisted as volunteers and were both killed on the Western Front. But the ideas of *Der Blaue Reiter* lived on and were taken up by the Bauhaus, which the architect Walter Gropius founded at Weimar in 1919 and which attracted all those German painters who felt the need for a spiritual renewal. The experience of a lost war and the resulting political, economic and social uncertainty made artists realize the need for united effort. But although the progressive forces agreed that they wanted to build a new and better world on the ruins of the old, they did not all go about it in the same way.

Right: Franz Marc (1880—1916): Foxes, 1913

Max Pechstein
(1881—1955):
Fishing-Boat, 19

Right:
Heinrich Cam-
pendonk
(1889—1957):
The Garden, 19

Left:
Lyonel Feininger
(1871—1956):
Barfüsserkirche at
Erfurt, 1927

Oskar Schlemmer
(1888—1943):
Scene on the
Stairs, 1932

Max Beckmann (1884—1950): Apache Dance, 1938

Left: Oskar Kokoschka (born 1886): Self-Portrait, 1913

The Expressionists sank into deep pessimism and invoked the horrors of the recent past and conjured up visions of new terrors, some turning to biting social criticism, tearing open wounds that might have been left to heal and posing questions without providing an answer.

The members of the Bauhaus attempted to overcome this artistic pessimism and nihilism by adopting a more positive attitude toward the problems of the present. Their principal task was the renewal of architecture. They recognized that in order to create a new society people had to be provided with better living conditions. To satisfy the need of the industrial age for self-expression, blocks of flats and factories had to combine utility with beauty. But this applied not only to architecture; the building of a better world had to be a joint venture to which sculpture, painting, the dramatic arts, photography, film-making, typography and other crafts contributed their share. The Bauhaus artists saw as their aim the elimination of the traditional rivalries between the arts and the crafts, between creative and applied art. Its members included painters of the stature of Paul Klee, Lyonel Feininger, Oskar Schlemmer and Wassily Kandinsky. Through them the Bauhaus became famous, and the modern teaching methods they developed were taken up by many European art schools and academies.

Lyonel Feininger, born of German parents in the United States, was the only painter who belonged to the Bauhaus from its inception in 1919 until its disbandment by the National Socialists in 1933. Although the progressive aims of the Bauhaus, the fusion of art and technology, were foreign to his nature, his paintings nevertheless express his belief in the modern world. He adopted the Cubist technique of reducing representational forms to prismatic, geometrical shapes, which he used not to deform, but to artistically dominate reality. As early as 1907 he wrote: 'I envisage quite different qualities of light and tone than before, and new possibilities of transposition, but I find it nearly impossible to digress from the reality to which one is accustomed. What one has seen has to be inwardly crystallized and transformed.' He pursued this concept all his life. Apart from a few fruitless attempts at abstraction he always accepted reality, without confining himself to representational limitations. In severely geometrical schemes he softened the representational aspect through space and light effects. Feininger's pictures are not soulless constructions; more than any other contemporary artist he used modern, Cubist compositions for entirely romantic interpretations. By superimposing subtle veils of colour and light he created effects which previously had been achieved only by the French Impressionists.

Left: Willi Baumeister (1889—1955): Standing Figure with Blue Plane, 1933

His Barfüsserkirche at Erfurt (see p. 222) seems illuminated from an invisible source of light which has passed through coloured glass filters of varying density and size. Perspective is hinted at but the vanishing lines break off unexpectedly; they shift from their axis and are overlapped by other lines that belong to different spatial constructions. Two-dimensional and three-dimensional shapes appear next to each other and representational forms stand adjacent to purely abstract ones. Feininger has created an edifice of light and colour, a dream creation without substance which is nevertheless firmly anchored by its clear construction and appeals to the senses by its harmoniously balanced tones.

Oskar Schlemmer was more consciously committed to the constructive ideas of the Bauhaus. He was in charge of ballet and modern theatre and was therefore concerned with the interaction of human figures and space. He envisaged a ballet of statuettes, whose disembodied figures merged completely into the geometrical construction of space and whose movements repeated the surrounding spatial rhythm. Some of these ideas are expressed in his Scene on the Stairs (see p. 223). The steps and the horizontal and vertical delineation of the windows represent the three-dimensional element and the well-shaped bodies constitute a variation on that theme. The banister represents movement; this motif is repeated by the moving figures and varied by the different angles of the bodies.

A desire for clarifying order also characterizes the work of Willi Baumeister. Although he belonged to the non-representational school of German painting, he nevertheless organized his fantastic pictorial inventions in a highly disciplined way. The playful lines of his composition Standing Figure with Blue Plane (see p. 226) are set against a background of coarse-grained sand. Baumeister combines painting with sculptured relief, thereby relating the picture to architecture and clearly demonstrating his intention of bringing together the three main artforms: painting, sculpture and architecture. This idea was taken up enthusiastically by the Bauhaus and has often been used since: the graffiti which enliven the façades of modern buildings are a development of Baumeister's technique.

The height reached in German fine arts during the first three decades of our century can be compared only with that achieved in Dürer's time. This fact has only now, half a century later, been fully recognized. Modern art draws its strength from these pre-war sources without, however, being in any way imitative. On the contrary, the wealth of ideas of modern painting, although based on the solid foundation of preceding styles, shows no sign of decreasing, indicating that the artistic revolution, which swept away the traditionalism of the nineteenth century, has lasted to this day. We can be confident in our hopes, therefore, that the arts will continue to build on the foundations laid at the beginning of the century and will find the widespread recognition which has been denied them for so long.

INDEX

Numbers in bold type refer to pages with illustrations

Illustrations credit:

(The numbers refer to pages)